THE BEST OF

Wedding Photography

TECHNIQUES
AND IMAGES
FROM THE PROS

BILL HURTER

AMHERST MEDIA, INC. ■ BUFFALO, NY

Copyright © 2005 by Bill Hurter.
All rights reserved.

Front cover photograph by David Beckstead.
Back cover photograph by Marcus Bell.

Published by:
Amherst Media, Inc.
P.O. Box 586
Buffalo, N.Y. 14226
Fax: 716-874-4508
www.AmherstMedia.com

Publisher: Craig Alesse
Senior Editor/Production Manager: Michelle Perkins
Assistant Editor: Barbara A. Lynch-Johnt

ISBN: 1-58428-154-5
Library of Congress Card Catalog Number: 2004113069

Printed in Korea.
10 9 8 7 6 5 4 3 2 1

Notice of Disclaimer: The information contained in this book is based on the author's experience and opinions. The author and publisher will not be held liable for the use or misuse of the information in this book.

Table of Contents

W e live in the midst of a great renaissance of wedding photography. It is a time when divergent styles collide with changing attitudes to produce the finest imagery this genre has ever known. At this crossroads, it is indeed a pleasure to be writing a book with the title *The Best of Wedding Photography*. At no other time since photographers began recording the wedding ceremony to preserve its history has the style and artistic merit of wedding photography been so remarkable.

■ THE EVOLUTION OF WEDDING PHOTOGRAPHY

In the earliest days of photography, weddings were photographed in styles that captured the bride and groom in stuffy, overly formal poses. Even with the emergence of the wedding album, which incorporated group portraits of the wedding party and the bride and groom with family members, posing remained stiff and lifeless—no doubt a by-product of the required length of early exposures. As the style and variety of wedding photography progressed, posing techniques closely mimicked the classical arts, and there remain many flawless wedding portraits in evidence today from those early years.

It is against this backdrop that wedding photography evolved—or rather, rebelled. In this early style, each shot was a check mark on a long list of posed and often prearranged images. Even spontaneous events like the bouquet toss and cake cutting were orchestrated to reflect classical posing techniques. Spontaneity and the joy of life all but disappeared from this most joyous of ceremonies! It is not difficult to see why there was an active rebellion in the world of wedding photography.

A class of wedding photographers known as wedding photojournalists, spurred on by their leader, the articulate, provocative, and talented Denis

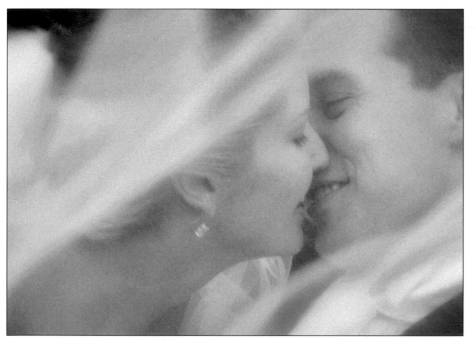

The focus of the modern wedding photograph is emotion and intimacy. Through the tools like digital capture and Photoshop, the end result is romance. Photograph by Marcus Bell.

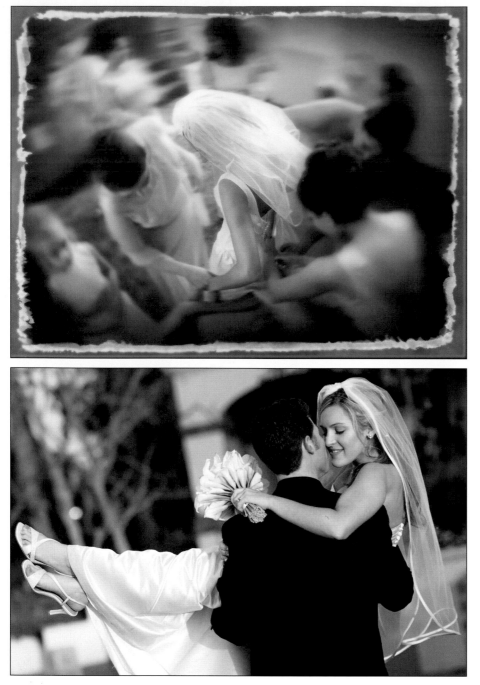

of-focus "grab shots" created by the photojournalists, and they predicted that the final days of wedding photography as a profitable and predictable livelihood were at hand.

As at many other times in history, a spirited clash of ideas and artistic differences spawned a new era of enlightenment. For the first time, brides were able to make real choices about how they wanted their once-in-a-lifetime day recorded. In addition to pristine color and a wealth of storytelling black & white imagery, brides and grooms can now choose from a diverse range of styles, imagery, and presentations. Add to the mix the incredible and explosive creativity introduced by the advent of digital image making and we now find ourselves in the midst of a true Renaissance.

Although it was once viewed as a near-deplorable way to make a living, wedding photography now draws the best and brightest photographers into its ranks. It is an art form that is virtually exploding with creativity—and with wedding budgets that seemingly know no bounds, the horizons of wedding photography seem almost limitless.

■ NOTES ON THE SECOND EDITION

The first edition of this book appeared a little more than two years ago. During that short time, I have

Reggie, rebelled against the formality of the art form. The photojournalists believed (and still believe) that capturing the emotion of the moment is the most important aspect of a good wedding image. The story of the true and natural unfolding of the day's events had to be the end result of such efforts.

Furthermore, everything about their methods and procedures was different than those of the traditional wedding photographer. They shot unobserved with fast film using available light. They used 35mm SLRs with motor drives—and flash became a last resort for the wedding photojournalist.

As you might guess, the traditionalists recoiled in horror at this new breed of photographer. They denounced the grainy and often out-

"discovered" dozens of new and amazingly talented wedding photographers, most of them of the photojournalistic persuasion. The trend away from traditional wedding photography continues—but with some surprising new twists.

The new breed of wedding photographer has no problem "directing" an image, as long as the results are spontaneous and emotion-filled. This is a surprising turn of events, considering the almost evangelical mindset of the pure wedding photojournalist. To be sure, there are many more of these kinds of photographers who exhibit the same fervor for the "captured image," but there are also a growing number of new photographers who don't particularly care if they are purists, in the photojournalistic sense.

The move away from film and towards 100-percent digital capture continues unabated, although the current breed of digital wedding photographers is aware of the increased time and effort involved in being purely digital. New methods of workflow and image editing continue to evolve and new software is helping to aid in the transition.

Also evident is a move towards fine-art imagery, complete with the elements of abstraction, symbolism, and the finer points of design. Yes, it is a changing genre, to be sure, seemingly forever redefining itself and always growing more popular among brides. The modern-day wedding photographer is among the upper echelon of the photographic elite, both in status and in financial rewards. This book, then, is a continuing celebration of this great and evolving art form and its fabled artists.

—*Bill Hurter*

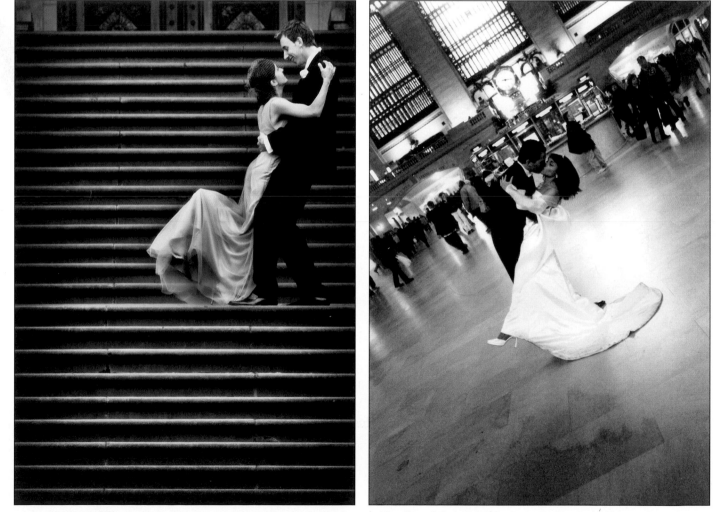

LEFT—Masters of the medium, like Yervant Zanazanian, are gifted at creating the subtle intangibles in an image. In addition to flawless posing and emotion and design, note the hourglass shaped highlight covering the steps. Artful burning-in and dodging was required to produce such a skillful effect. **RIGHT**—There are few limits to today's wedding photography. How about a posed kiss and dip in the middle of Grand Central Station? New York City wedding photographer Regina Fleming did the honors.

LEFT—The little picture is just as important to the wedding album as the big picture. Here Anne Ledbetter captures an impromptu photography lesson at the wedding. **BELOW**—The tools at the disposal of today's wedding photographer are vastly superior to yesterday's. This classic image captures the romance and mystery of the wedding by incorporating areas of softness and high contrast to define the mood of this bridal portrait. The image was captured by Steve Tarling and then treated in Adobe Photoshop until the desired mood emerged.

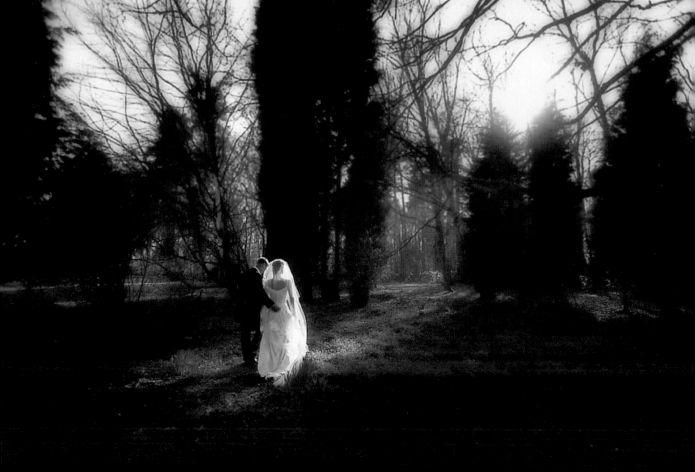

To illustrate this book, I have called upon some of the finest wedding photographers in the world. Most of them have been honored repeatedly by the country's top professional organizations, the Professional Photographers of America (PPA) and Wedding and Portrait Photographers International (WPPI). I want to take the opportunity to thank all of these great photographers for their participation in this book. Without them, this book would not have been possible. While no book can equal years of wedding photography experience, it is my hope that you will learn from these masters how the best wedding photography is created—with style, artistry, technical excellence, and professionalism.

Stuart Bebb—Stuart Bebb is a Craftsman of the Guild of Photographers (UK) and has been awarded Wedding Photographer of the Year in both 2000 and 2002, with exciting and innovative wedding albums. In 2001, Stuart won *Cosmopolitan Bride's* Wedding Photographer of the Year, in conjunction with the Master Photographers Association. He was also a finalist in the Fuji Wedding Photographer of the Year competition. Stuart works with his wife Jan, who creates and designs all their albums.

Becker—Becker, who goes by only his last name, is a gregarious wedding photojournalist who operates a successful studio in Mission Viejo, California. He has been a featured speaker at WPPI and has also competed successfully in international print competition.

David Beckstead—David Beckstead has lived in a small town in Arizona for 22 years. With help from the Internet, forums, seminars, WPPI, Pictage, and his artistic background, his passion has grown into an international wedding photography business. He refers to his style of wedding photography as "artistic photojournalism."

Vladimir Bekker—Vladimir Bekker is the owner of Concord Photography in Toronto, Canada. An immigrant from the Ukraine, Vladimir is a graduate of Lvov Polytechnical University with a master's degree in architecture, which explains why many of his wedding images include architectural details. His studio photographs over one hundred weddings a year. He has won numerous international awards for his prints and albums.

Marcus Bell—Marcus Bell's creative vision, natural style, and sensitivity have made him one of Australia's most revered photographers. It is this talent, combined with his natural ability to make people feel at ease in front of the lens, that attracts so many of his clients. His work has been published in *Black White*, *Capture*, *Portfolio Bride*, and countless bridal magazines.

Becky and Erika Burgin, APM—Becky Burgin is the mother of Alisha Todd and Erika Burgin. All three are award-winning wedding photographers. While Alisha works with husband Brook Todd, Erika works with her mom Becky in another successful wedding photography business. Both Erika and Becky recently achieved their Accolades of Photographic Mastery from WPPI.

Amy Cantrell—Amy Cantrell is a commercial, editorial, and fine-art photographer who made her reputation photographing celebrities and executives in the Los Angeles area, then became interested in photographing weddings. In 1999, she was voted Photographer of the Year by PPLAC (Professional Photographers of Los Angeles County) and is currently the president of that organization. Several of her exhibits have been reviewed favorably by the *Los Angeles Times* and other publications.

Larry Capdeville, M. Photog.—Larry Capedeville has been a professional photographer since 1973. He has received numerous awards, including the Fuji Masterpiece Award and several PPA Loan Collection Prints. He has been named one of Florida's top-ten photographers for the last ten years.

Ron Capobianco—Ron Capobianco is a professional commercial photographer whose work includes fashion, beauty, editorial, architectural, and annual-report images. This background is an asset in his wedding and portrait work, where he also strives to make people look their absolute best. His wedding work has been seen in *Modern Bride, Brides, Wedding Bells, Manhattan Bride,* and other bridal publications.

Anthony Cava, BA, MPA, APPO—With his brother Frank, Anthony Cava owns and operates Photolux Studio, originally founded by their parents 30 years ago as a wedding and portrait studio. Anthony is one of the youngest Master of Photographic Arts (MPA) in Canada and won WPPI's Grand Award with the first print that he ever entered in competition. He resides in Ottawa, Ontario, Canada.

Frank Cava—The co-owner of Photolux Studio in Ottawa, Frank is a successful and award-winning wedding and portrait photographer. He is a member of the Professional Photographers of Canada and WPPI. With his brother Anthony, he also speaks to professional organizations in the U.S. and Canada.

Jerry D—Jerry D owns and operates Enchanted Memories, a successful portrait and wedding studio in Upland, California. Jerry has been highly decorated by WPPI and has achieved numerous national awards since joining the organization.

David De Dios—When David De Dios was five, a man with a strange box asked him to look into it and smile. David was fascinated when the box cre- ated an image of him. His passion for photography was sparked and he wanted to do the same for other people. David's studio is located in Phoenix, Arizona, yet he travels to other states and throughout Mexico to photograph weddings. David is now very thankful to the man with the strange box. When David is not photographing weddings, he is photographing editorial and fashion.

Scott Eklund—Scott Eklund makes his living as a photojournalist for the *Seattle Post-Intelligencer.* He specializes in sports, spot news, and feature stories, but recently got interested in photographing weddings, deciding that his skill set was "portable." He has now won numerous awards for his wedding photography, which relies on a newspaperman's sense of timing and story-telling.

Regina Fleming—A native New Yorker, Regina Fleming has been an air- line attendant, a Wilhelmina model, a Ford Modeling Agency model, and has appeared in movies and soaps, including *One Life To Live, All My Children,* and *As The World Turns.* Considering acting her "hobby," Regina took photography seriously and earned a photography degree from the Fashion Institute of Technology in New York, then hung out her shingle the same day she graduated! She is already winning awards and turn- ing down wedding bookings.

Jerry Ghionis—Jerry Ghionis of XSiGHT Photography and Video start- ed his professional career in 1994 and has quickly established himself as one of Australia's leading photographers. In 1999, he was honored with the AIPP (Australian Institute of Professional Photography) award for best new talent in Victoria. In 2002, he won the AIPP Victorian Wedding Album of the Year award, and in 2003 he repeated that award and also earned the Grand Award in the Album competition at WPPI.

Alfred Gordon—Recognized as one of Florida's top-ten photographers in 2001, 2002, and 2003, Al Gordon operates a full-service studio and has photographed weddings throughout the Southeast. He holds the Master Photographer and Photographic Craftsman degrees from the PPA. He is also a Certified Professional Photographer from the PPA, and has earned the AOPA degree from WPPI. He received the coveted Kodak Trylon Gallery Award twice, and has images in the coveted ASP Masters Loan Collection.

Steven Gross—Steven Gross, it the owner of Real Life Weddings and Steven E. Gross & Associates Photography in Chicago, Illinois. His images have been featured on ABC's *Good Morning America,* a PBS documentary, *Esquire* magazine, and in the intro for NBC's sitcom, *Three Sisters.* He has published three books: *Zhou Brothers* (Oxford University Press, 1995), *In the Studio* (Oxford University Press, 1995) and *Black and White: Defining Moments of Weddings and Marriage* (Mohawk Paper, 2002).

Jeff and Kathleen Hawkins—Jeff and Kathleen Hawkins operate a high- end wedding and portrait photography studio in Orlando, Florida. They have authored several books, including *Professional Marketing & Selling Techniques for Wedding Photographers* (Amherst Media, 2001). Jeff has been a professional photographer for over 20 years. Kathleen holds a masters degree in business administration and is a former president of the Wedding Professionals of Central Florida (WPCF).

Tibor Imely—Imely Photography is one of the most prestigious studios in the Tampa Bay area. Tibor has won numerous awards, including his most recent: the Accolade of Photographic Mastery and Accolade of Outstanding Achievement from WPPI. Tibor was also recently presented with a Fujifilm New Approach Award for new and innovative solutions to tried-and-true photographic methods.

Claude Jodoin—Claude Jodoin is an award-winning photographer from Detroit, Michigan, who has been involved in digital imaging since 1986. He is an event specialist, as well as shooting numerous weddings and portrait sessions throughout the year.

Cal Landau—After spending 30 years trying to become a professional racing driver, Cal Landau got his start in wedding photography when someone who crewed for his racecar asked him to shoot his wedding. Cal turned him down a few times before he finally gave in. "Of course, everyone knows the rest of the story. I fell in love with this job so, at 54, I am a very late bloomer and I pinch myself every day for how good I have it."

Anne Ledbetter—Anne Ledbetter holds a BFA in visual arts and graphic design and worked as a graphic designer before becoming a professional photographer. Anne has studied under Nevada Wier, Charles O'Rear, Paul Elledge, and Barbara Bordnick, and is active in WPPI, PPA, ASMP (The American Society of Media Photographers), as well as the Atlanta chapter of APA (Advertising Photographers of America). In 2001, she received the Accolade of Photographic Mastery from WPPI.

Rita Loy—Along with her husband Doug, Rita Loy is the co-owner of Designing Portrait Images in Spartanburg, South Carolina. Rita is a 17-time recipient of Kodak's Gallery Award of Photographic Excellence, an eight-time winner of the Fuji Masterpiece Award, and has been voted South Carolina's Photographer of the Year a record seven times. She is also a member of Kodak's prestigious Pro Team.

Charles and Jennifer Maring—Charles and Jennifer own Maring Photography Inc. in Wallingford, Connecticut. Charles is a second-generation photographer, his parents having operated a successful New-England studio for many years. His parents now operate Rlab (www.resolutionlab.com), a digital lab for discriminating photographers needing high-end digital work. Charles Maring is the winner of the 2001 WPPI Album of the Year Award.

Mercury Megaloudis—Mercury Megaloudis is the owner of Megagraphics Photography in Strathmore, Victoria, Australia. The Australian Institute of Professional Photography awarded him the Master of Photography degree in 1999. He has won numerous awards in Australia and has recently begun winning competitions in the U.S. as well.

Melanie Nashan—Melanie Maganias Nashan, founder of Nashan Photographers, Inc. in Livingston, Montana, specializes in weddings but also photographs portraits, commercial work, and architecture. Her striking images have been published in *Martha Stewart Weddings*, *The Knot*, *Bride's*, *Modern Bride*, and *Sunset Magazine*. In 2003, she was chosen as one of America's top fifteen wedding photographers by *PDN* (*Photo District News*), a trade magazine.

Dennis Orchard—Dennis Orchard is an award-winning photographer from Great Britain. He has been a speaker and an award winner at WPPI conventions and print competitions. He is a member of the British Guild of portrait and wedding photographers. His unique lifestyle wedding photography has earned many awards, including UK Wedding Photographer of the Year, International Wedding Photojournalism Print of the Year, and WPPI's highest honor, the Accolade of Lifetime Photographic Excellence.

Parker Pfister—Parker Pfister, who shoots weddings locally in Hillsboro, OH, as well as in neighboring states, is quickly developing a national celebrity. He is passionate about what he does and can't imagine doing anything else (although he also has a beautiful portfolio of fine-art nature images). Visit him at www.pfisterphoto-art.com

Norman Phillips, AOPA—Norman Phillips has been awarded the WPPI Accolade of Outstanding Photographic Achievement (AOPA). He is a registered Master Photographer with Britain's Master Photographers Association, a Fellow of the Society of Wedding & Portrait Photographers, and a Technical Fellow of Chicagoland Professional Photographers Association. He is a frequent contributor to photographic publications and coauthor of *Wedding and Portrait Photographers' Legal Handbook* (Amherst Media, 2005).

Joe Photo—Joe has earned degrees in both photography and cinematography, which have trained him to be a visual storyteller. He has won numerous awards, and his wedding images have been featured in publications such as *Grace Ormonde's Wedding Style, Elegant Bride, Studio Photography & Design, Los Angeles Magazine, Rangefinder,* and *The Knot Wedding Pages.* His weddings have also been seen on NBC's *Life Moments,* Lifetime's *Weddings of a Lifetime,* and in the film *My Best Friend's Wedding.*

John Poppleton—Utah photographer John Poppleton delights in urban decay—lathe and plaster, pealing paint, weathered wood, and rusted metal. He "enjoys the color, line, and texture of old architecture." However, he also loves to create people photography—especially uniquely feminine portraiture. When the architecture of urban decay combines with elegant brides, the startling result is Poppleton's unique style.

Ray Prevost—Ray Prevost worked for 27 years as a medical technologist in the Modesto, California area. He was always interested in photography but it wasn't until his two daughters were in college that he decided to open up his studio full time. He received Certification from PPA in 1992, and his masters degree in 1996.

Fran Reisner—Fran Reisner is a Brooks Institute graduate and has twice

been named Dallas Photographer of the Year. She is a past president of the Dallas Professional Photographers Association. She runs a successful portrait and wedding business from the studio she designed and built on her residential property. She has won numerous state, regional, and national awards.

Martin Schembri, M.Photog. AIPP—Martin Schembri is an internationally recognized portrait, wedding, and commercial photographer who has been winning national awards in his native Australia for 20 years. He has achieved a Double Master of Photography with the Australian Institute of Professional Photography, and has conducted seminars on his unique style of creative photography all over the world.

Brian and Judith Shindle—Brian and Judith Shindle own and operate Creative Moments in Westerville, Ohio. This studio is home to three enterprises under one roof: a working photography studio, an art gallery, and a full-blown event-planning business. Brian's work has received numerous awards from WPPI in international competition.

Natasha Staszak—Natasha originates from Sydney, Australia, but now lives on Long Island, New York. Her background includes a BA in visual communication, for which she majored in photography. Her studies brought her to the Rochester Institute of Technology, and the home of Kodak soon became her own home when she met and later married her husband. Over the years, Natasha has developed a popular wedding photography business through word of mouth.

Scott Streble—Scott Streble is a location photographer who lives in Minneapolis, Minnesota. He received a degree in professional photography from the Rochester Institute of Technology. Specializing in photographing people with a fine-art inclination, he works for a wide range of clientele including individual wedding and portrait clients, corporations, magazines, and nonprofit organizations. His work is done predominately in black & white, and he is available for location assignments worldwide.

Steve Tarling—In 1993, Steve Tarling established A Little Box of Memories after having freelanced in travel, fashion, wedding, and industrial photography since leaving art school in 1985. Steve is a high-demand speaker in the wedding photography industry, teaching photographers about the new trends in contemporary wedding photography. Steve was Great Britain's 2003 Wedding Photographer of the Year.

Alisha and Brook Todd—Alisha and Brook Todd are from Aptos, California (near San Francisco). The couple share their passion for art in their blend of documentary and fine-art photography. Many of their weddings are done for customers who work in the design field—architects, photographers, art directors, graphic artists, and so on. Alisha and Brook are award-winning photographers in both PPA and WPPI and have been featured nationally in prominent wedding and photography magazines. They were recently selected to photograph Oprah's "Million Dollar Weddings" on nation television.

David Anthony Williams (M.Photog. FRPS)—David Anthony Williams owns and operates a wedding studio in Ashburton, Victoria, Australia. In 1992 he achieved the rare distinction of Associateship and Fellowship of the Royal Photographic Society of Great Britain on the same day. Through the annual Australian Professional Photography Awards system, Williams achieved the level of Master of Photography with Gold Bar—the equivalent of a double master. In 2000, he was awarded the Accolade of Outstanding Photographic Achievement from WPPI, and has been a Grand Award winner at their annual conventions in both 1997 and 2000.

David Worthington—David Worthington is a professional photographer who specializes in classical wedding photography. David is one of only two photographers in the Northwest of the UK to have one of his wedding photographs published in a book celebrating the best work over the last 50 years produced by professional photographers. This is indeed a fine achievement, as only 50 images were selected from entries sent from around the world. Two of David's most recent awards include the 2003 Classical Wedding Photographer of the Year (UK, Northwest Region) and the 2003 Licentiate Wedding Photographer of the Year (UK, Northwest Region).

Yervant Zanazanian, M. Photog. AIPP, F.AIPP—Yervant was born in Ethiopia, then lived and studied in Venice, Italy prior to settling in Australia 25 years ago. Yervant's passion for photography and the darkroom began at a very young age, when he worked after school and during school holidays at the photography business owned by his father, photographer to the Emperor Hailé Silassé of Ethiopia. Yervant owns a prestigious photography studio and services clients nationally and internationally. He has been named Australia's Wedding Photographer of the Year three of the past four years.

Monte Zucker—Monte Zucker has been bestowed every major honor the photographic profession can offer, including WPPI's Lifetime Achievement Award. In 2002, Monte received the International Portrait Photographer of the Year Award from the International Photography Council, a non-profit organization of the United Nations. In his endeavor to educate photographers at the highest level, Monte, along with partner Gary Bernstein, has created an information-based web site for photographers, www.Zuga.net.

The rewards of being a successful professional wedding photographer are great—not only financially, but also in terms of community status. The wedding photographer of the new millennium is not regarded merely as a craftsman, but as an artist.

■ DEMANDS OF WEDDING PHOTOGRAPHY

Working Under Pressure. To be successful, wedding photographers must master a variety of types of photography and perform under pressure in a very limited time frame. No other photographic subject is more demanding.

The wedding photographer is under a great deal of stress, as the couple and their families have made months of detailed preparations, and a considerable financial investment for this (hopefully) once-in-a-lifetime event. It is the day of dreams and, as such, the expectations of clients are high.

Couples don't just want a photographic "record" of the day's events, they want inspired, imaginative images and an unforgettable presentation, and should anything go wrong photographically, the event cannot be re-shot. Aside from the obvious photographic skills, achieving success requires calm nerves and the ability to perform at the highest levels under stress. This pressure is why many gifted photographers do not pursue wedding photography as their main occupation.

A Sense of Style. Many wedding photographers religiously scour the bridal magazines, studying the various examples of editorial and advertising photography. Editorial style has become a major influence on wedding photography. These magazines are what prospective brides look at and tend to want in their own images. As a result, wedding photographers need to stay on top of the latest pictorial styles and be able to produce them for their clients.

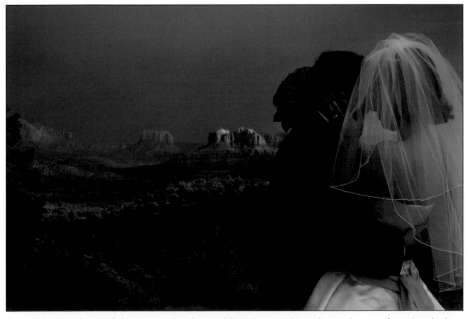

Incorporating beautiful scenes into the wedding images has always been a favorite device. Here, the drastically changing light of sunset in the Grand Canyon region of Arizona provides an amazing backdrop for this timeless wedding image by David Beckstead.

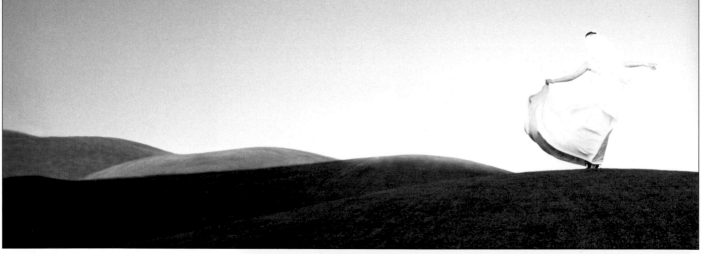

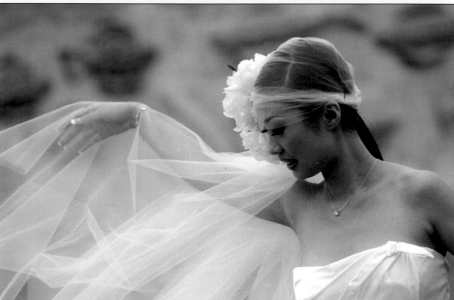

ABOVE—A lyrical pose and flawless design helped create a signature wedding photograph for David De Dios. **RIGHT**—Joe Photo noticed the bride's fascination with the wind blowing her veil and although the moment lasted only a second, Joe made it timeless.

Skilled Observation. The truly gifted wedding photographer is a great observer. He or she sees and captures the myriad of fleeting moments that often go unrecorded. The experienced professional knows that the wedding day is overflowing with these special moments and that memorializing them is the essence of great wedding photography.

The Ability to Idealize. One of the traits that separates the competent photographer from the great one is the ability to idealize. The exceptional photographer produces images in which the people look great. The photographer must be skilled at hiding pounds and recognizing a person's "best side." This recognition must be instantaneous and the photographer must have the skills to make any needed adjustments in the pictures. Through careful choice of camera angles, poses and lighting, many of these "imperfections" can be made unnoticeable.

It is especially important that the bride be made to look as beautiful as possible. Most women spend more time and money on their appearance for their wedding day than for any other day in their lives. The photographs should chronicle just how beautiful the bride really looked.

The truly talented wedding photographer will also idealize the *events* of the day, looking for opportunities to infuse emotion and love into the wedding pictures. In short, wedding photographers need to be magicians.

■ **GREATNESS**

In preparing the text for this book, I searched for the right words to define what makes "great" wedding photography and, consequently, "great" wedding photographers.

Consistency is surely one ingredient of greatness. Those photographers who produce splendid albums each time out are well on their way to greatness. Great wedding photographers also seem to have top-notch people skills. Through my association with WPPI and *Rangefinder* magazine, I talk to hundreds of wedding photographers each year. A common thread among the really good ones is affability and likability. They are fully at ease with other people and more than that they have a sense of personal confidence that inspires trust.

Seeing. David Anthony Williams, an inspired Australian wedding and portrait photographer,

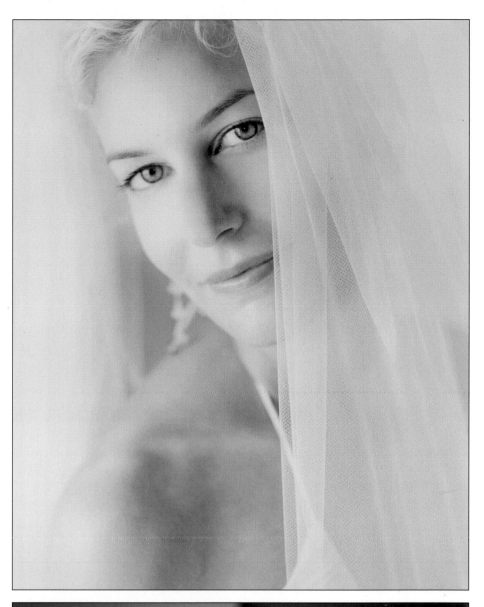

TOP—Formal portraits, often made on location, are a huge part of the standard wedding coverage. Here, Charles Maring created an elegant high-key portrait using available light and a reflector. By incorporating the veil into the composition, he has designed a delicate, romantic image. **BOTTOM**—Today's wedding photographer must have an acute sense of timing to be able to isolate moments like this—the quick turn of the bride and a glance in the compact mirror—from the flow of events. Timing is one of photographer Joe Photo's specialties.

believes that the key ingredient to great wedding photos is something he once read that was attributed to the great Magnum photographer Elliot Erwitt: "Good photography is not about zone printing or any other Ansel-Adams nonsense. It's about seeing. You either see or you don't see. The rest is academic. Photography is simply a function of noticing things. Nothing more."

Williams, who is quite articulate on the subject, goes on to say, "Good wedding photography is not about complicated posing, painted backdrops, sumptuous backgrounds, or five lights used brilliantly. It is about expression, interaction, and life! The rest is important, but secondary."

Immersion. In talking to Williams, and a great many other very successful wedding photographers, what seems to make them good (and an experience they all talk about) is total immersion. They involve themselves in the event and with the people. As Williams says, "I just love it when people think I'm a friend of the couple they just haven't met yet, who happens to do photography."

With the best wedding photographers, technical skills are practiced and second nature. Photographer

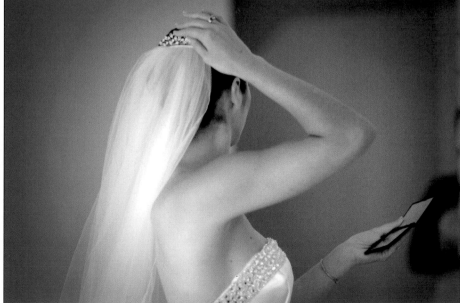

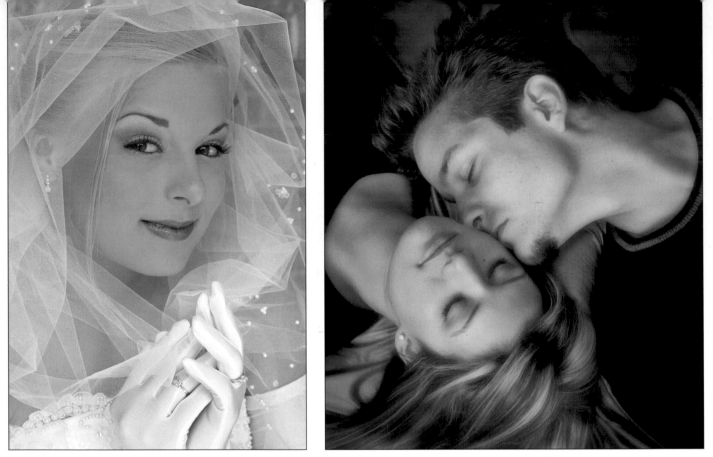

LEFT—Ray Prevost has created this flawless bridal formal portrait with expert hair and makeup, perfect posing, and a timeless expression. Believe it or not, Ray made this photo by available light on location. If you look closely, you can see Ray's murky silhouette in the bride's eyes. **RIGHT**—The engagement portrait is a vital part of the contemporary wedding package. This beautiful example, made by Ray Prevost, uses Photoshop effects to blend the highlights and shadows into a sweet, soft, romantic image.

Ken Sklute cut his teeth doing 150 to 200 weddings per year for over a decade. To say he has his technique down is an understatement, yet his images are always fresh and beautiful. He is also a devotee of the concept of immersion. Ken believes that the emotion within the moment is the heart of every great picture. And it's no surprise that he is phenomenal with people—getting them to both relax and be themselves and yet be more beautiful or handsome than they've ever been before.

Interaction. Both Williams and Sklute can make anyone look good, but their real gift is that ability to create the animated, filled-with-life portrait. It is the best of both worlds—the real and the idealized. Certainly part of the success is good

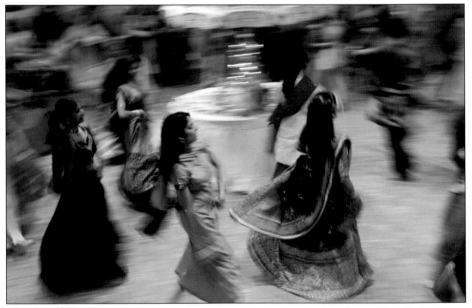

Claude Jodoin was struck by the color and frenetic motion of this dance at an Indian wedding so, he increased the film speed on his Canon 10D to ISO 1600 and exposed for $^{1}/_{10}$ second at f/5.6, knowing the dancers would blur; but so did the color, for an impressive result.

direction, but the less tangible ingredient is the interaction—the bringing out of the person who's alive and well in there. It's interaction and communication, but also a little magic.

There's no doubt about it, wedding photography has changed dramatically. So what is it about photojournalism that now makes images in this style so much more popular than traditional ones? And what do adherents of traditional styles have to say about this? More importantly, what does it take to create this unstructured type of imagery?

■ WHY IS PHOTOJOURNALISM SO POPULAR?

Bridal Magazines. One of the reasons wedding photojournalism has taken off in popularity is that it emulates the style of editorial photography that is seen in the contemporary brides' magazines like *Grace Ormonde Wedding Style, Modern Bride,* and *Town & Country.* Before brides even interview photographers, they have become familiar with this type of storytelling editorial imagery.

Traditional Images Can Lack Variety. Another big reason for the backlash against traditional wedding photography is the "sameness" of it. When scripted coverage is employed, similar shots will show up in albums done by different traditional photographers.

Another reason for the similarity is the types and numbers of formal groups. Even with elegant posing and lighting, shots can look similar if they are arranged similarly—bride and groom in the middle, bridesmaids and groomsmen staggered boy–girl on either side, etc. In contrast, when a wedding photojournalist makes groups, he or she might make them from the top of a stairwell or put them all in profile marching down a beach, or do something otherwise unpredictable and different.

Photojournalism vs. Traditional Wedding Photography

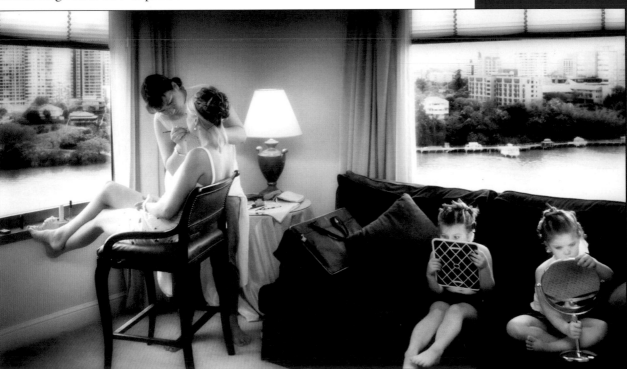

Look at the stories going on in this Marcus Bell photograph. The relaxed bride gets her face on while her toenails dry on the window ledge; the young flower girls have become engrossed in other things; and all the while the world outside the windows goes on in perfect harmony.

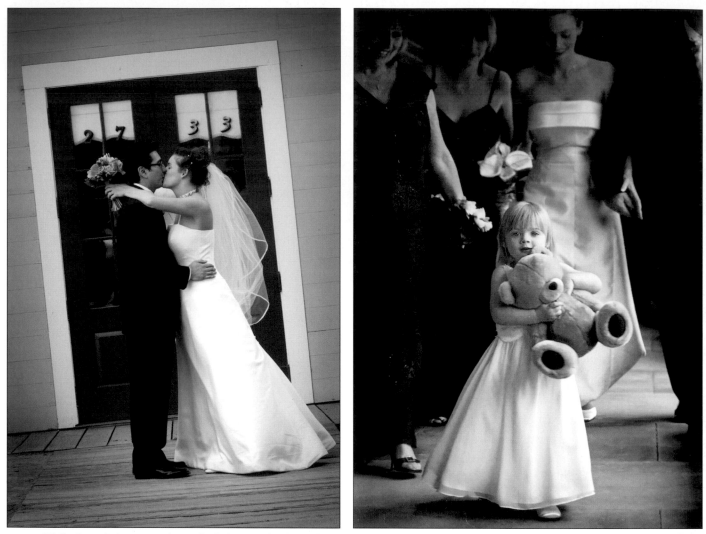

LEFT—While formals have not changed all that much, the style involved in producing them has. Here is a fairly ordinary shot of the bride and groom kissing made interesting by tilting the frame and vignetting the corners in Photoshop. Photograph by Joe Photo. **RIGHT**—Often the unique shot gets away when the photographer's mindset is to produce dozens of formal groups. Here, Stuart Bebb captured a delightful moment with the bridal party.

Today's bride and groom don't want the "cookie-cutter" approach to wedding photographs. They want unique, heartfelt images that tell the story of their important day.

Traditional Images Are More Time-Consuming. Another potential drawback of the traditional type of wedding coverage is that all those carefully posed pictures take lots of time. In fact, the bigger the wedding, the bigger the bridal party, and the bigger the list of "required" shots to make. As a result, the bride and groom can be missing for a

good part of the wedding day while they are working with the photographer. The less formal approach leaves couples free to enjoy more of their wedding day.

In this aspect, the photojournalistic system has mutual benefits. While the bride has more time to enjoy her day, the photographer also has more time to observe the subtleties of the wedding day and do his or her best work. I have heard many photographers say that brides and family have told them, "We don't even want to know you're there,"

which is just fine for most wedding photojournalists.

■ **TRADITIONALISTS FIGHT BACK**
Those photographers who still provide traditional coverage argue that the wedding photojournalist's coverage produces below-average photographs. In truth, the photojournalists (who do not disrupt the flow of the day to make pictures and don't isolate the bride and groom) can't possibly be as in tune with posing and lighting principles as the masters of the traditional style. They don't

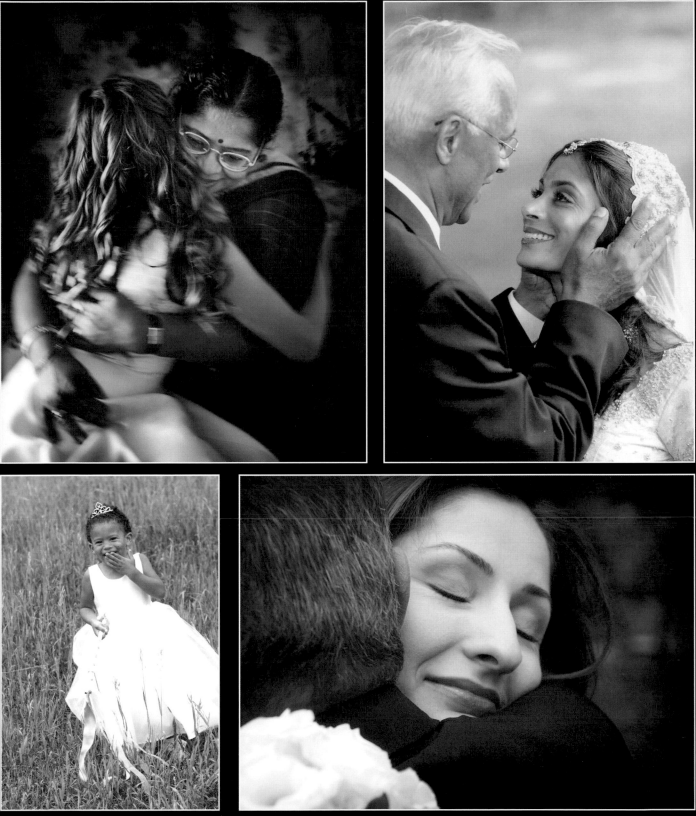

TOP LEFT—Images like this can't be staged, they must be captured with only one or two frames available in a brief window of time. Marcus Bell's sense of timing and composition are flawless in this wonderful wedding image. **TOP RIGHT**—Who would not want a portrait like this of the bride and her father? It's filled with emotion, the bride is gorgeous, and the moment is genuine. Photograph by Joe Photo. **BOTTOM LEFT**—Timing is always essential to the wedding photographer, but when kids are involved, emotions and precious moments seem even more fleeting. Photograph by Melanie Nashan. **BOTTOM RIGHT**—Expert wedding photographers work invisibly so that they do not intrude on moments of deep emotion. Photograph by Anthony Cava.

claim to be—nor do they stop the natural action to dictate posing, which, in their view, ruins the flow of things.

However, in the traditionalists' defense, one must acknowledge that the most elegant features of traditional portraiture are being thrown out in this "creative new" approach. It's very true—you can look at a masterful bridal portrait taken by a photojournalist and the trained eye will observe hands posed poorly or not at all, the head and shoulder axis confused, unflattering overhead lighting, and so on. Is the portrait spontaneous and the expression full of life? Perhaps, but there are traditions that also need preserving. These are the fundamentals of posing, composition, and lighting that date back thousands of years.

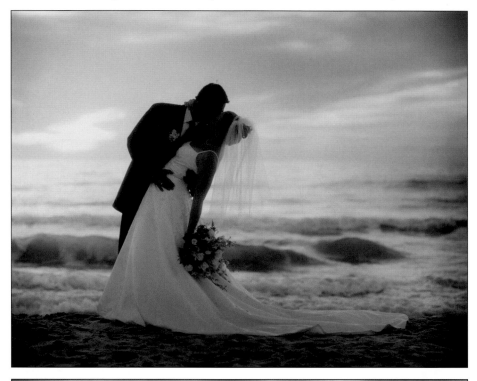

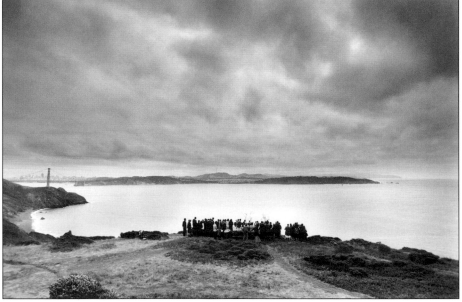

■ SUCCESS IN PHOTOJOURNALISM

Capturing Emotion. Photojournalism is all about capturing the emotion of a moment, which is extremely difficult. There is very little margin for error. The shutter has to be released at the peak of the moment, much like a sports photographer photographing athletes at the peak of action.

Anticipating Events. The most obvious skill a wedding photographer must possess is the ability to observe the flow of action and anticipate events. Anticipation is a function of how adept the photographer is at observation. A photographer skilled at wedding photojournalism techniques is always watching and monitoring the events—and usually more than one event at a time. The camera, usually a 35mm autofocus SLR (either film or digital), is always at the ready, set in an autoexposure mode so there is no guesswork or exposure settings to be made. Simply raise the camera, compose, and shoot.

Each phase of the wedding—the arrival at the ceremony, the ceremony itself, the receiving line, the cake cutting, etc.—presents its own set of unique opportunities. The reception is where most of these animated pic-

TOP—This is a good example of a traditional portrait made with contemporary style and vision. This beach formal by Tibor Imely captures the emotion between the couple, yet relies on excellent posing and pinpoint exposure control. The composition is dynamic and dramatic. **BOTTOM**—Wedding photojournalists often use overall shots as scene setters. This is the ultimate in scene setters as two converging roads meet on a cliff. A dramatic sky overhead makes the image even more unique. Photograph by Scott Streble.

tures will be made. After they've had a drink, people begin to relax and be themselves. With quiet observation, many wonderful moments and situations develop and can be captured by the photographer.

The experienced wedding photojournalist not only observes the scene, of course, but is also receptive to feeling the emotion surrounding the event. It is a heightened state of excitement and the photographer attuned to it will have superb insights into the unfolding of the wedding story.

Working Unobserved. The best photojournalists are nearly invisible. They work unobserved, blending into the background as much as possible. When people are not aware they are being photo-

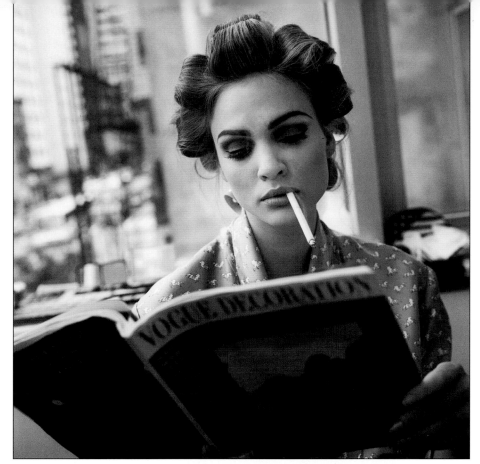

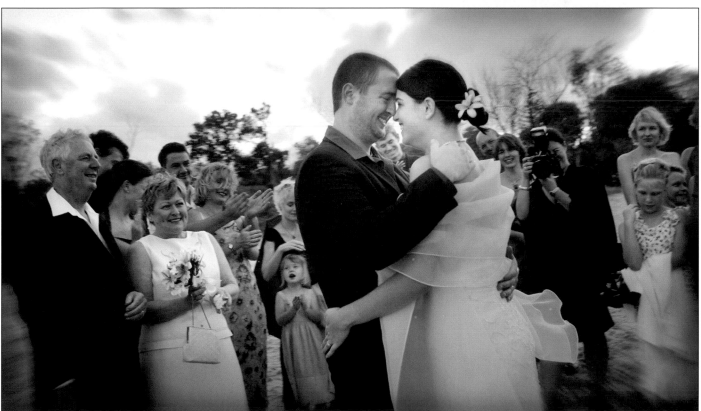

TOP—Traditional, this image is not. Ron Capobianco caught this priceless moment of the bride taking a break from getting ready for her Manhattan wedding. Despite its lack of political correctness, this image is realistic, strangely romantic, and tells the story of the day. **ABOVE**—Here, Marcus Bell captured a wonderful moment but also the emotion of the assembled group. A little motion blur on the frame edges makes it seem as if the viewer is being thrust into the moment.

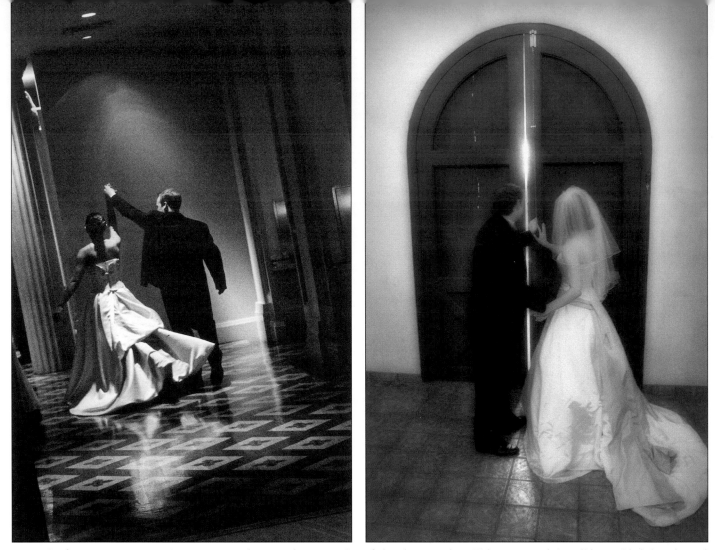

LEFT—Perfect moments may arise spontaneously or at the suggestion of the photographer. Either approach is valid, provided that the end result is natural, as in the case of this wonderful image made by overhead hotel lighting. Photograph by Becky Burgin. **RIGHT**—The photographer must be alert to nuances in the scene. David Beckstead caught the church doors about to be opened by the new bride and groom. The bright sunlight outside seems ready to burst onto this couple's lives, a symbolic moment captured from the tapestry of the day's events.

graphed they are most likely to act themselves. Moving quietly through the event, the photographer is alert and ready, but always listening and watching, sensitive to what is happening and always ready to react to the unexpected.

Split-Second Timing. One of the reasons for the photojournalist's perceived detachment is the concentration it takes to anticipate and observe the key action and the key elements of the story while engulfed in the mayhem that is the wedding and reception. Like a good sports photographer, who may work quiet-

ly on the sideline for hours without speaking, wedding photojournalists must concentrate to see multiple picture opportunities emerging simultaneously, a task that is rigorous and demanding.

As in sports photography, split-second timing is an absolute prerequisite, allowing the photojournalist to reveal the many subtleties and nuances of the story. Photojournalists talk about preparedness and technique being second nature—but there also has to be a basic instinct and an ability to sense the emotion around you. Another reason photo-

journalists seem detached is that it is human nature to fall prey to the emotion and literally join in the festivities. It's fun, why not? The photographer who indulges this impulse will most certainly lose his or her edge. There is a reason for the cordial aloofness of the wedding photojournalist—it is functional.

A Sense of Style. As in traditional photography, the most appreciated aspect of today's wedding photojournalism is a unique sense of style. Brides want distinctive images and they can only come from a photographer exercising his or her indi-

viduality in the making and presentation of the photographs. The style may be natural or chic, high energy or laid-back, but uniqueness is the real product people are buying and it is the single defining standard for the photographs found in this book.

■ EMERGING STYLES

Although the contrasts between traditional and photojournalistic photography are clear, and the benefits and drawbacks often fiercely debated, you should not get the impression that roving groups of wedding photographers are warring with one another.

At this writing, things seem to be settling down and hostilities fading somewhat, in favor of a more evolved approach. The near elimination of formal group portraiture in

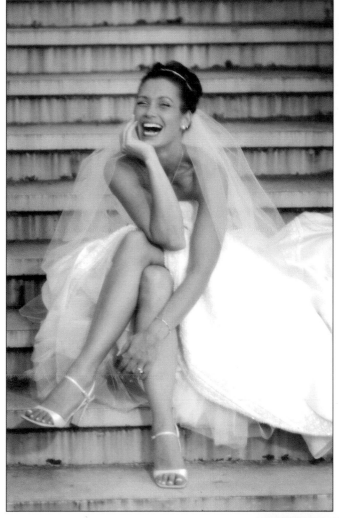

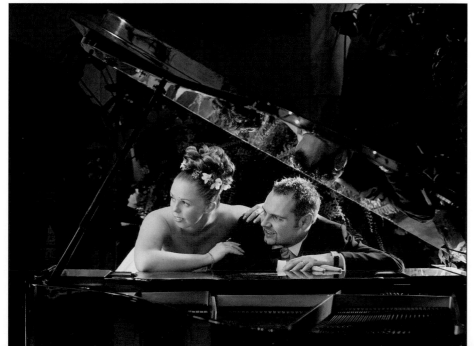

ABOVE—Parker Pfister used fading light and a slow shutter speed to capture this image. Even the slight subject movement doesn't detract from its charm. **TOP RIGHT**—Editorial styles have greatly influenced wedding photography. Here, only a glimpse of the bride is visible through a crack in the limo door. Photograph by Frank Cava. **RIGHT**—David Worthington created this portrait of the bride and groom using strobes carefully positioned to backlight the couple and another to fill the frontal planes of their faces. Perhaps the most interesting element of this portrait is the reflected image in the mirror finish of the piano lid.

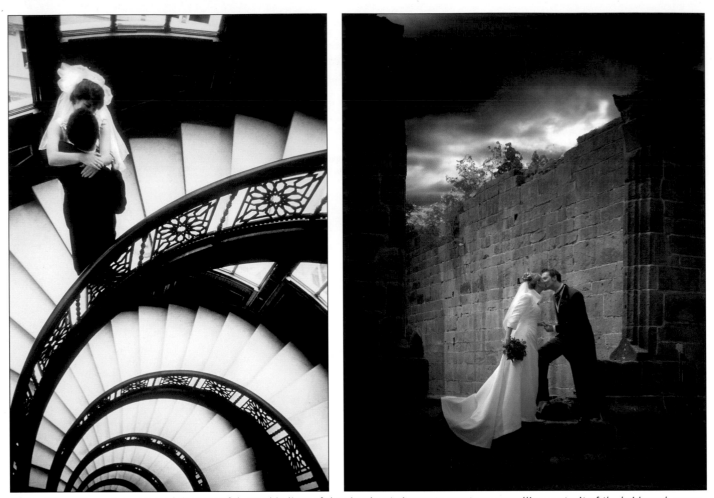

LEFT—Steven Gross incorporated the powerful, graphic lines of the circular staircase to create a compelling portrait of the bride and groom. **RIGHT**—David Worthington created a bridal formal that's almost cinematic in effect. Careful manipulation of the tones of the ancient stones and the introduction of a dramatic sky make this a priceless formal image.

photojournalistic wedding coverage is swinging back the other way. All types of wedding photographers are making more group portraits. The main reason for this is that groups sell, and sales mean increased profits. Also, failing to offer such coverage limits the photographer in his or her professional approach. As a result, photographers are offering brides more options, including posed formals. Because the choice is theirs, brides seem to be ordering them.

The nature of formal photos is changing, as well, adapting less formal posing and lighting techniques in an effort to preserve the carefree, relaxed attitude found in the rest of the album. You will also see group portraits made with more style and elegance than the on-camera flash-lit style you saw in wedding groups only twenty years ago. Again, brides are demanding ever more sophistication in their photographs.

Yes, the classic poses are fading in consideration of a more natural style. However, greater attention to posing fundamentals seems to be evident, as well. After all, these techniques represent time-honored ways of gracefully rendering the human form and revealing character.

In the words of Monte Zucker, known around the world for his traditional wedding portraits, "Photog- raphers are well aware of this [divergence in styles] . . . so they've combined a little of both. My particular style of wedding photography still comes from the fact that I'm more interested in faces and feelings than I am in backgrounds and trends." This combined approach opens up the best of both worlds. The quality and character of wedding coverage is better today than ever before.

With finely tuned skills, photojournalistic photographers unearth more of the wedding day's wonderful moments and preserve them for all time. With an added adherence to formal principles comes a type of classic elegance that is timeless.

W hether the images to be be created are traditional or photojournalistic, the equipment list for wedding coverage is extensive, including backup equipment and emergency supplies. Since so many different types of photography are required at a wedding, it's almost like outfitting oneself for safari.

■ THE 35MM DSLR

The 35mm DSLR (digital single-lens reflex) camera is the camera of choice for today's digital wedding photographer. The days when only medium-format cameras were used for wedding photography seem to be at an end. Fast, versatile zoom lenses, cameras that operate at burst rates of up to eight frames per second, amazingly accurate autofocus lens performance, and incredible developments in imaging technology have led to the 35mm DSLR becoming the camera system of choice for today's wedding photographer.

Professional digital-camera systems include a full array of fast lenses, dedicated flash units, and systems accessories. Currently there are seven manufacturers of full-fledged systems: Canon, Nikon, Olympus, Kodak (which uses Canon or Nikon autofocus lenses), Fuji (which uses Nikon autofocus lenses), Pentax, and Sigma (which uses the radically different Foveon X3 image sensor). Each manufacturer has several models within their product line to meet varying price points. Many of the pre-digital lenses available

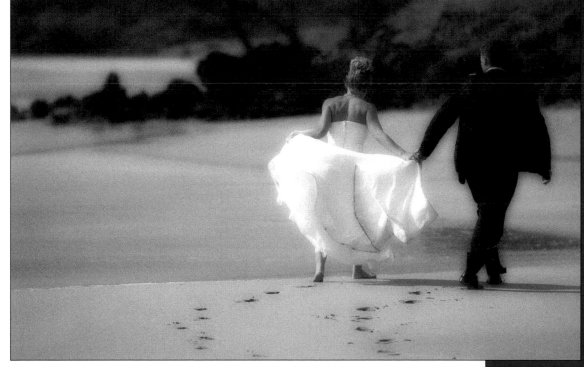

The DSLR is the tool of choice for the contemporary wedding photographer. Great flexibility is afforded by this format, as is seen in this image captured by David Beckstead. Using a Nikon D1X and 80–200mm f/2.8 zoom, the photographer zoomed until he got just the right relationship of subject to shoreline and fired away at $^1/_{6400}$ second at f/2.8 with the lens set to the 160mm setting. Grain and diffusion were added in Photoshop. The wide-open aperture "knocks" everything but the subjects out of focus.

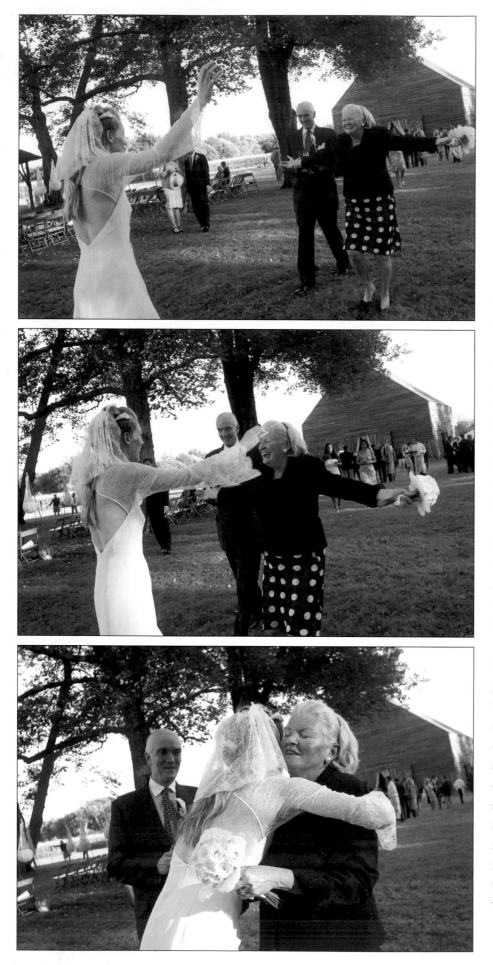

from these manufacturers for their film cameras also fit the new digital cameras, although sometimes with a corresponding change in focal length. In addition, a number of lens manufacturers also make AF lenses to fit various brands of DSLRs. These include Tokina, Tamron, and Sigma.

AF Technology. Autofocus (AF), once unreliable and unpredictable, is now extremely advanced. Some cameras feature multiple-area autofocus so that you can, with a touch of a thumbwheel, change the AF sensing area to one of four or five areas of the viewfinder (the center and four outer quadrants). This allows you to "decenter" your images and create more dynamic compositions. Once accustomed to quickly changing the AF area, this feature becomes an extension of the photographer's technique.

Autofocus and moving subjects used to be an almost insurmountable problem. While *you* could predict the rate of movement and focus accordingly, the earliest AF systems could not. Now, however, most AF systems use a form of predictive autofocus, meaning that the system senses the speed and direction of the movement of the main subject and reacts by tracking the focus of the moving subject. This is an ideal feature for wedding photojournalism, which is anything but predictable.

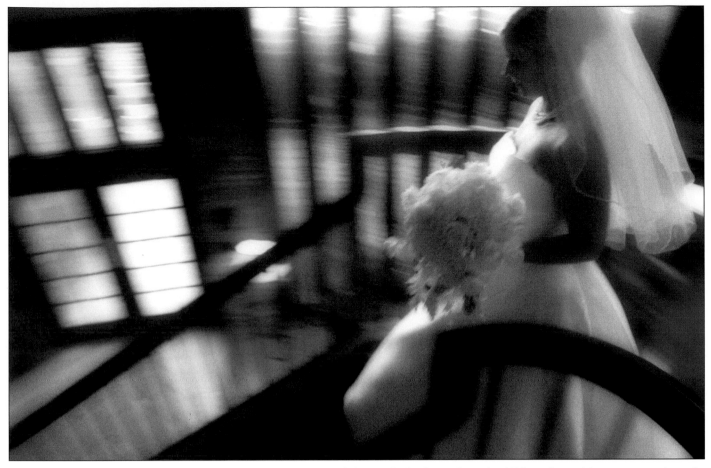

Predictive autofocus allows the photographer to choose the zone of the viewfinder from where the AF is active and focus on a moving subject. The camera's software takes over and predicts the rate of movement and focuses accordingly. In this image by David Beckstead, a slow shutter speed was used to blur the areas around the bride, enhancing the sense of motion.

A new addition to autofocus technology is dense multi-sensor area AF, in which an array of AF sensor zones (up to 45 at this writing) are densely packed within the frame, making precision focusing much faster and more accurate. These AF zones are user selectable or can all be activated at the same time for the fastest AF operation.

Images in Hand. Perhaps the greatest advantage of shooting digitally is that when the photographer leaves the wedding, the images are already in hand. Instead of scanning the images when they are returned from the lab, the originals are already digital and ready to be imported into Photoshop for retouching or special effects and subsequent proofing and printing. The instantaneous nature of digital even allows photographers to put together a digital slide show of the wedding ceremony that can be shown at the reception.

ISO Settings. Another reason digital has become so popular with wedding photographers is that you can change your ISO on the fly. For example, if you are shooting a portrait of the bride and groom before the ceremony and you are working outdoors in shade, you might select a 400 ISO speed. Then you might move to the church, where the light level would typically drop off by two or more f-stops. In this case, you would simply adjust the film speed to a higher setting, like 1600 ISO or faster, to compensate for the lower light levels. Unlike film, where you would have to change rolls or cameras to accomplish this, the selected digital ISO setting only affects the individual frame being recorded.

White Balance. Digital also allows you to change white balance on the fly. If you are shooting in deep afternoon shade, you can set white balance appropriately. If you move indoors soon thereafter and are shooting by tungsten room light, you can quickly adjust the white balance to a tungsten or incandescent setting, or rely on the camera's auto white balance function to correct the color of the light source.

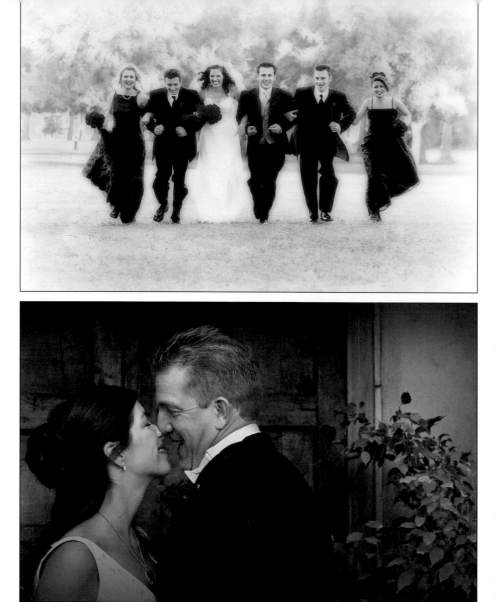

TOP—Sometimes you have to blanket a moving group like this with exposures to get the great expressions. Focus can be a problem, but when a group is moving toward you, the movement is fairly predictable and constant. Also, most predictive AF systems will handle this kind of movement easily. Note the priceless expression on the bride's face. Photograph by Tibor Imely. **ABOVE**—Digital files are sometimes like a blank canvas on which the photographer can work magic. In this image by David Beckstead, the image was tinged bronze in Photoshop to bring out the wood and stucco tones of the background. The corners were then slightly vignetted. The lower portion of the image, including the bride's shoulders, were burned in slightly to bring all of the viewer's attention to the bride and groom.

Color and Black & White. With some DSLR models you can instantly shift back and forth between color and black & white capture, creating even more variety in your images. With film, this would require changing rolls or cameras.

Quality Reproductions. With film, the negative or transparency is the original image. When prints or copies are made from that original, these second-generation images suffer a falloff in sharpness and image quality. Digital copies, on the other hand, maintain the integrity of their data indefinitely and do not suffer any kind of degradation in subsequent generations.

Reducing Costs. Bambi Cantrell, a noted wedding photojournalist from the San Francisco area, routinely shoots over a thousand exposures at weddings. Having switched to digital makes this easier, since she can download memory cards to a laptop and then reuse them or make sure to bring extra memory cards. Every wedding photographer who shoots film is wary of the number of rolls shot and the number remaining. It is human nature to, at some point during the day, calculate the cost of all that film and processing; with digital it's not an issue.

Creative Freedom. Noted wedding and portrait photographer Kevin Kubota hasn't shot a wedding on film since he purchased his Nikon D1X digital camera, saying that the quality is at least as good as 35mm film and that the creative freedom digital affords him is mind boggling. He can take more chances and see the results instantly, immediately knowing whether or not he got the shot. In addition, the digital tools he has come to master in Photoshop make him a better, more creative photographer.

■ **LENSES**

Whether film or digital, another reason the 35mm format is preferred by today's wedding photographers is the range and quality of ultrafast zoom lenses available. The lens of choice seems to be the 80–200mm f/2.8 (Nikon) or the 70–200mm f/2.8 (Canon). These are very fast, lightweight lenses that offer a wide variety of useful focal lengths for both the ceremony and reception. They are internal focusing, meaning

that autofocus is lightning fast and the lens does not change length as it is zoomed or focused. At the shortest range, 80mm, this lens is perfect for creating full- and ¾-length portraits. At the long end, the 200mm setting is ideal for tightly cropped, candid shots or head-and-shoulders portraits.

Other popular lenses include the range of wide angles, both fixed focal length lenses and wide-angle zooms. Focal lengths from 17mm to 35mm are ideal for capturing the atmosphere as well as for photographing larger groups. These lenses are fast enough for use by available light with fast ISOs.

Fast lenses (f/2.8, f/2, f/1.8, f/1.4 etc.) will get lots of work on the wedding day, as they afford many more "available light" opportunities than slower speed lenses. Marcus Bell, an award-winning wedding photographer from Australia, calls his Canon 35mm f/1.4L USM lens his favorite. Shooting at dusk, with a high ISO setting, he can shoot wide

open and mix lighting sources for unparalleled results.

Another favorite lens is the high speed telephoto—the 300mm f/2.8 or f/3.5. These lenses are ideal for

working unobserved and can isolate some wonderful moments. Even more than the 80–200mm lens, the 300mm throws backgrounds beautifully out of focus and, when used

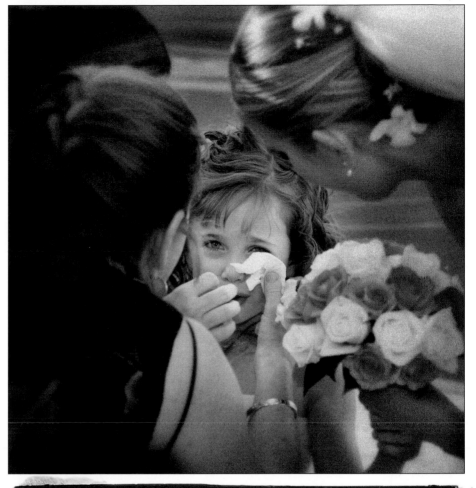

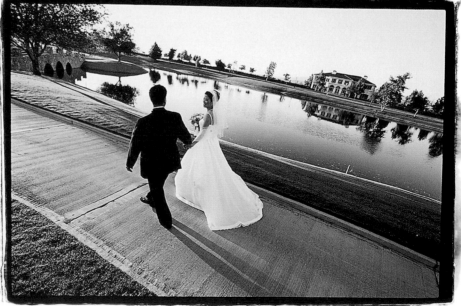

TOP—Images like this are fleeting. The photographer must be able to quickly react to the situation. Marcus Bell quickly bounced a flash to light the little girl. The focus was strictly on her. The image was made with a Canon 1DS at ISO 400 at a 52mm focal length at ¹/₂₅₀ at f/5.6. Straight flash would have lit the foreground, distracting from the little one. The bounce flash exposure was matched to the ambient light exposure so the scene appears natural. **BOTTOM**—The wide-angle lens thrusts the viewer into the scene and spreads out the background as if it were farther away than it is. Here Alisha Todd used a very wide-angle lens to stretch the foreground, creating an unusual but appealing image. It should be noted that you must keep your subjects close to the center of the frame in extreme wide-angle images to prevent subject distortion.

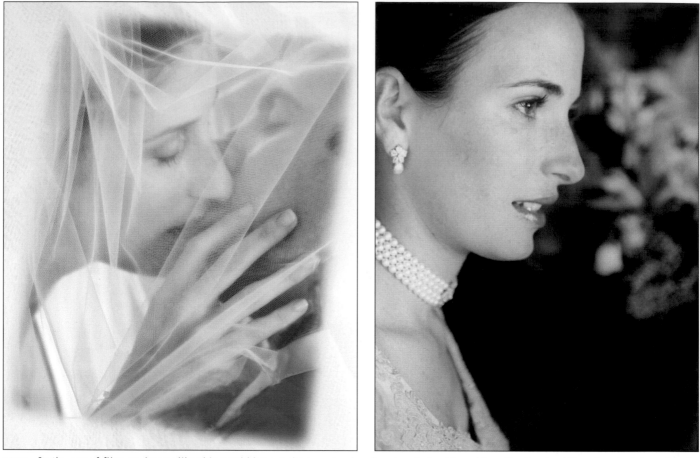

LEFT—In the era of film, an image like this would have to be imagined and a plan devised to achieve it using traditional materials and techniques. With Photoshop, the photographer can create images like this in the comfort of the studio without any special materials. Photograph by Al Gordon. RIGHT—Long telephotos have very shallow bands of focus when used at or near the lens's widest aperture and at close lens-to-subject distances. Here Brook Todd used a 50–300mm zoom at the 300mm setting and moved into position so that a colorful bouquet of flowers was positioned behind the bride. Because of the large distance between Brook and the bride, she was unaware of his presence.

wide open, provides a sumptuously thin band of focus, which is ideal for isolating image details.

Another popular choice is the 85mm (f/1.2 for Canon; f/1.4 or f/1.8 for Nikon), which is a short telephoto with exceptional sharpness. This lens gets used frequently at receptions because of its speed and ability to throw backgrounds out of focus, depending on the subject-to-camera distance.

One should not forget about the 50mm f/1.2 or f/1.4 "normal" lens for digital photography. With a 1.4x focal length factor, for example, that lens becomes a 70mm f/1.2 or f/1.4 lens that is ideal for portraits or groups, especially in low light. And the close-focusing distance of this lens makes it an extremely versatile wedding lens.

■ FILMS

Because a significant number of wedding photographers still shoot with film, this section remains intact from the first edition. However, it is followed by a section on digital film speeds.

Film Speed. Ultrafast films in the 1000–3200 ISO range offer an ability to shoot in very low light and produce a larger-than-normal grain pattern and lower-than-normal contrast—ideal characteristics for photojournalistic wedding coverage. Many photographers use these films in color and black & white for the bulk of their photojournalistic coverage. Usually, a slower, finer grain film will be used for the formals and the groups. These ultrafast films used to be shunned for wedding coverage because of excessive grain. But the newer films have vastly improved grain structure—and many brides and photographers have come to equate grain with mood, a positive aesthetic aspect.

Color negative films in the ISO 100–400 range have amazing grain structure compared to films of only a few years ago. They also possess

mind-boggling exposure latitude, from –2 to +3 stops under or over normal exposure. Of course, optimum exposure is still (and will always be) recommended, but to say that these films are forgiving is an understatement.

Film Families. Kodak and Fujifilm offer "families" of color negative films. Within these families are different speeds and varying contrast or varying color saturation—but with the same color palette. Kodak's Portra films include ISOs from 160 to 800 and are available in NC (natural color) or VC (vivid color) versions. Kodak even offers an ISO 100 tungsten-balanced Portra film. Fujicolor Portrait films, available in a similar range of speeds, offer similar skin-tone rendition among the different films as well as good performance under mixed lighting conditions because of a fourth color layer in the emulsion. These films are ideal for weddings, since different speeds and format sizes can be used with minimal differences in the prints.

Black & White Films. Many wedding photojournalists like to shoot color film and convert it later to black & white. That way there is

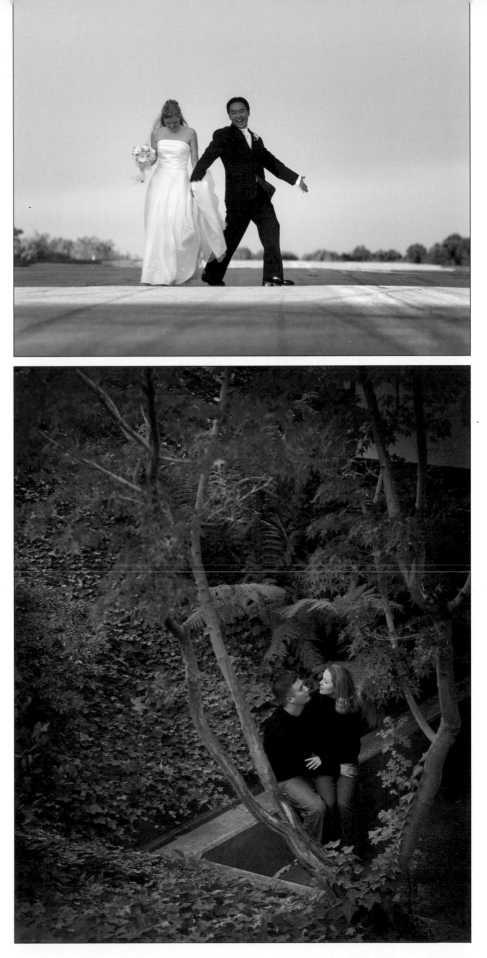

TOP—Telephoto lenses compress the perspective of the scene. Here, the bands of light and shadow look right on top of one another and the subjects stand out boldly from the background. This image by Cal Landau was made with a Canon EOS 10D and 70–200mm lens at the 200mm setting. **BOTTOM**—The moderate wide-angle allows you to incorporate foreground elements to frame a subject or provide lead-in lines. Here Ray Prevost has created a beautiful engagement portrait, framing the subject in the branches of a tree. Wide-angles are also characterized by long zones of sharpness, as seen here.

always a color original. With digital, this is a simple matter of changing the image mode in Photoshop or in the camera at capture. However, many photographers prefer the emulsions offered in black & white films. Kodak T-Max, a notable example, is available in a variety of speeds (ISO 100, 400, and 3200), is extremely sharp, and offers fine grain even in its fastest version. Black & white coverage is almost a necessity for today's wedding photographers. It provides a welcome relief from all-color coverage and offers a myriad of creative opportunities.

■ **ISO SETTINGS**

Most digital camera systems feature a sensitivity range from 100 to 800 ISO (or, in some cases, 1600 ISO). Some cameras also offer a 3200 ISO setting as a special custom function. Obviously, the wider the range of sensitivity, the more useful the camera system will be under a wider range of shooting conditions.

Whether it's film or a digital camera setting, the ISO affects the image quality in much the same way; the higher the ISO, the more noise (with digital) or grain (with film) will be recorded. The lower the ISO, the finer the image quality will be.

The difference is that with digital, much of the noise can be removed in image processing (if using RAW file capture) or with noise reduction filters or actions. Fred Miranda, a noted designer of Photoshop actions, has created an incredible Noise Reduction action that takes advantage of Photoshop's powerful image-processing functions. The action, called ISOxPro (available at www.fredmiranda.com), lets you reduce noise and other artifacts in any of ten different grades and calls on Photoshop's Smart Blur function to fuse together "scrubbed" layers. It's amazing to see what can be done with this action.

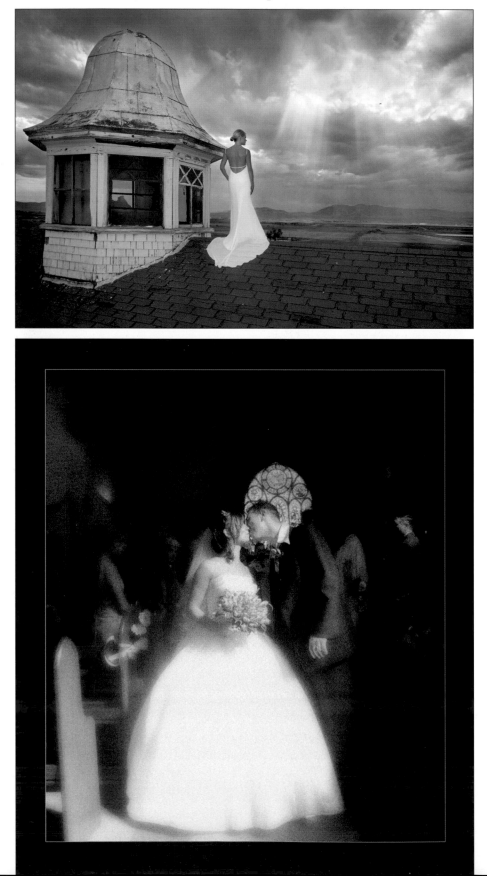

TOP—John Poppleton often puts beautiful brides in industrial settings to produce visually incongruous images. **BOTTOM**—As with film, the higher the ISO, the higher the noise levels (equivalent to grain). This is often a sought-after effect, as in this beautiful image made by Martin Schembri.

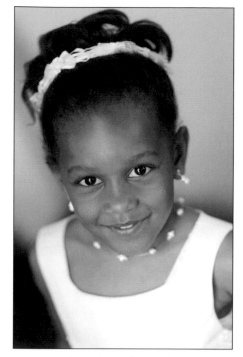

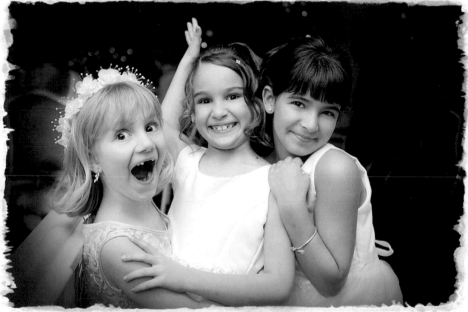

TOP LEFT—One of Joe Photo's favorite wedding lenses is the 85mm f/1.8 Nikkor used wide open. It is exceptionally sharp wide open and creates a shallow band of focus, which is ideal for isolating the eyes and keeping the mask of the face in sharp focus.
TOP RIGHT—Mercury Megaloudis is a master at capturing the dynamic between the sexes. Here, timing is the key ingredient.
RIGHT—Tibor Imely says of this shot, "It all happened really quickly. Everyone was waiting for the bride and groom to enter the reception for the introduction. I looked behind me and three feet away were these three little girls with their arms around each other. When I aimed the camera at them they came up with these incredible expressions. I made only one shot."

■ REMOVABLE STORAGE MEDIA

Instead of film, digital cameras store digital image files on portable digital media, such as CompactFlash (CF) cards, Memory Sticks, microdrives, and xD cards. The camera writes the image data to the removable storage media as photographs are captured. When the media becomes full, you simply eject it and insert a new card or microdrive just like you would change film at the end of the roll.

Removable media are rated and priced according to storage capacity—the more storage, the higher the price. There are two types: microdrives and flash memory. Microdrives are miniature, portable hard drives. Flash memory, which uses no moveable parts, tends to perform better than mechanical hard drives under adverse shooting conditions.

The latest memory card format at this writing is the xD card, developed jointly by Fuji and Olympus. By the time you read this, the maximum xD card capacity will be up to 8 gigabytes.

■ SENSOR SIZE AND FOCAL LENGTH

Most digital imaging sensors are smaller than the full-size 1x1.5-inch (24x36mm) 35mm frame. While the chip size does not necessarily affect image quality or file size, it does

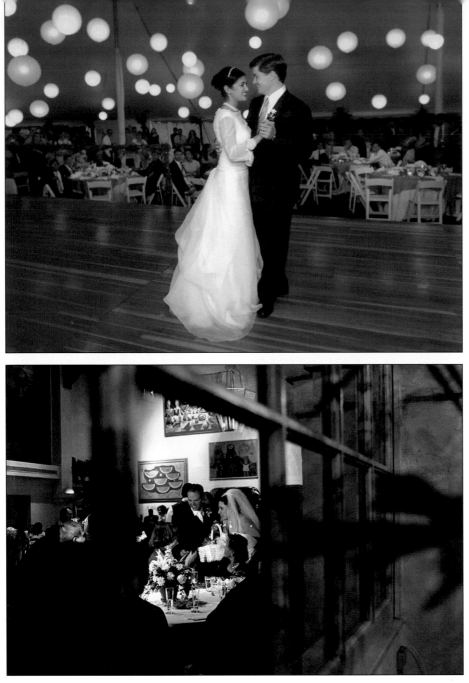

tal SLRs are now available with full-size 24x36mm imaging chips, meaning that there is no change to your lenses' effective focal lengths. Second, camera manufacturers who have committed to chip sizes that are smaller than full-frame 35mm have started to introduce lens lines specifically designed for digital imaging. The circle of coverage (the area of focused light falling on the film plane or digital-imaging chip) is smaller and more collimated to compensate for the smaller chip size. Thus, the lenses can be made more economically and smaller in size, yet still offer as wide a range of focal lengths as traditional lenses.

■ WHITE BALANCE

White balance is the color balance of the recorded digital image. It can be set individually for each series of shots you make (like applying a color-correction filter). Some manufacturers offer a wide range of white-balance options that correspond to a range of color temperatures (measured in degrees Kelvin). Others use more photographer-friendly terms like "afternoon shade." In addition, virtually all of the cameras feature an automatic white-balance setting that allows the camera to sense and determine the optimal white-balance setting. Most also include settings for fluorescent and incandescent lighting. Custom functions allow you to create your own unique white-balance settings to correspond to certain known shooting conditions or mixed light conditions. Obviously, the more flexibility you have in accurate white-balance recording, the less color correction you will have to

TOP—For the first dance, Charles Maring balanced flash with the interior tent lighting to create a magical image. The white balance was set for the strobe exposure, allowing the tungsten-lit interior to go red/orange. **ABOVE**—From outside the reception, Jerry D photographed through the glass to record the bride and company. A remote triggering device was used to fire a strobe inside the restaurant/reception. Jerry "dragged the shutter" to record the low-light exterior on the same frame as the strobe-lit interior.

affect lens focal length. With sensors smaller than 24x36mm, all lenses get effectively longer in focal length.

This is not usually a problem where telephotos and telephoto zooms are concerned, but when your expensive wide-angles or wide-angle zooms become significantly less wide on the digital camera body, it can be somewhat frustrating. For example, with a 1.4x focal-length factor, a 17mm lens becomes a 24mm lens.

Two different developments are occurring at this writing. First, chip sizes are getting larger. Several digi-

perform later in Photoshop. Some camera systems even offer a white-balance bracketing feature.

■ FLASHMETER

A handheld incident flashmeter is essential for work indoors and out, but it is particularly crucial when mixing flash and daylight. It is also useful for determining lighting ratios. Flashmeters will prove invaluable when using multiple strobes and when trying to determine the overall evenness of lighting in a large room. Flashmeters are also ambient light meters of the incident type, meaning that they measure the light falling on them and not the light reflected from a source or object.

■ REMOTE TRIGGERING DEVICES

If using multiple flash units (to light the dance floor, for instance), some type of remote triggering device will be needed to sync all the flashes at the instant of exposure. There are a variety of these devices available. Light-actuated slaves are sensitive to the light of a flash unit being fired and fire the flash they are attached to at the same instant they sense a flash going off. Unfortunately, this can be *your* flash or *someone else's*—a real drawback to this type of remote flash trigger. Infrared remote flash triggers are more reliable. Since many monolight-type flash units come equipped with an infrared sensor built in, it is a simple matter of syncing the flashes with the appropriate transmitter. A third type, the radio remote triggering device, uses a radio signal that is transmitted when you press the shutter release and then picked up by individual re-

ceivers mounted to each flash. These are reliable, but often require a plethora of cords. They are also not foolproof—a cordless microphone may trigger them accidentally. Radio remotes transmit signals in either digital or analog form. Digital systems, like the Pocket Wizard, are much more reliable and are not affected by local radio signals. Some photographers will use, as part of the standard equipment, a separate transmitter for as many cameras as are being used (for instance, an assistant's camera), as well as a separate transmitter for the handheld flashmeter, allowing the photographer to take remote flash readings from anywhere in the room.

■ FLASH

On-Camera Flash. On-camera flash is used sparingly because of the flat, harsh light it produces. As an alternative, many photographers use on-

camera flash brackets, which position the flash over and away from the lens, thus minimizing flash red-eye and dropping the harsh shadows behind the subjects—a slightly more flattering light. On-camera flash is often used outdoors, especially with TTL-balanced flash-exposure systems. With such systems, you can adjust the flash output for various fill-in ratios, thus producing consistent exposures. In these situations, the on-camera flash is most frequently used to fill in the shadows caused by the daylight, or to match the ambient light output in order to provide direction to the light.

Bounce-Flash Devices. Many photographers use their on-camera flash in bounce-flash mode. A problem, however, with bounce flash is that it produces an overhead soft light. With high ceilings, the problem is even worse—the light is almost directly overhead. A number

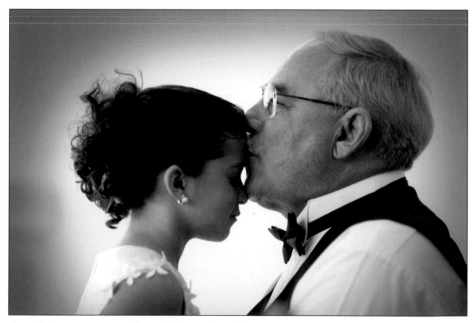

Joe Photo covers a wedding with speed and thoroughness and almost never lets a photo opportunity like this one get away. He uses a Nikon D1X and Nikon SB-80 Speedlites in bounce mode with the strobe's internal white fill card extended so that some of the bounce flash is directed forward onto the subjects. His flash technique is flawless—you never see flash in the final results. He vignetted the frame in Photoshop.

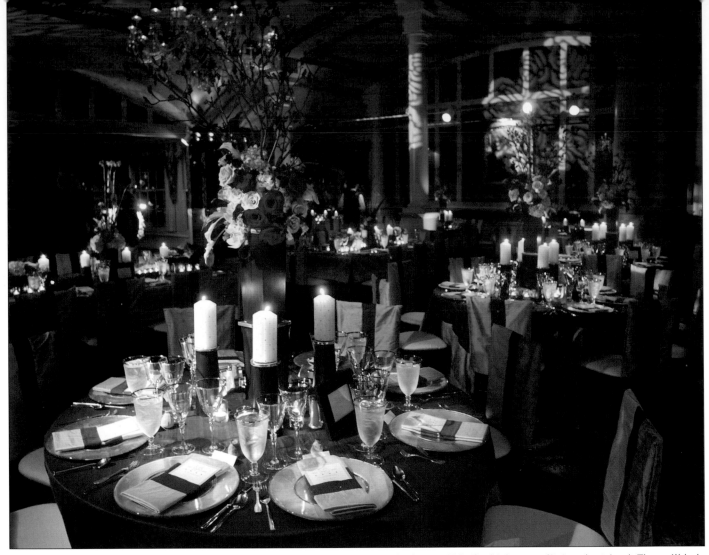

Charles and Jennifer Maring are sticklers for interiors at weddings. They use the lowest ISO (for highest quality) and a tripod. They will balance exposure throughout and, where needed, pop a bounce flash to augment the available light. Often shutter speeds will be in the $^1/_8$- to $^1/_{15}$-second range in aperture-priority mode. In Photoshop the Marings fine-tune the perspective to straighten walls, etc. Then they use the History brush to paint with light or burn and dodge as if they were lighting each individual table. Many times each napkin, place setting, and floral arrangement gets dodged or burned in. Any distracting hot-spots also get burned in.

of devices on the market, like the Lumiquest ProMax system, offer a way to direct some of that bounce light directly toward the subject. They offer accessories that mount to the flash housing and transmit 10 to 20 percent of the light forward onto the subject, with the remainder of the light being aimed at the ceiling. This same company also offers devices like the Pocket Bouncer, which redirects light at a 90-degree angle from the flash to soften the quality of light and distribute it over a wider area. No exposure compen-

sation is necessary with automatic and TTL flash exposure systems, although operating distances will be somewhat reduced.

Barebulb Flash. Perhaps the most frequently used handheld flash at weddings is the barebulb flash. These units are powerful and use, instead of a reflector, an upright mounted flash tube that is sealed in a plastic housing for protection. Since there is no reflector, barebulb flash generates light that goes in all directions. It acts more like a large point-source light than a small portable

flash. Light falloff with bare-bulb is less than with other handheld units, and these units are ideal for flash-fill situations.

These units are predominantly manual, meaning that you must adjust their intensity by changing the flash-to-subject distance or by adjusting the flash output. Many of the outdoor pictures in this book were created using barebulb flash. Many photographers even mount a sequence of barebulb flash units on light stands at the reception for doing candids on the dance floor.

Studio Flash System. You may find it useful to have a number of studio flash heads with power packs and umbrellas. You can set these up for formals or tape the light stands to the floor and use them to light the reception. Either way, you will need enough power (at least 50 watt-seconds per head) to light large areas or allow you to work at small apertures at close distances.

The most popular of these lights is the monolight type, which has a self-contained power pack and usually has an on-board photo cell that triggers the unit to fire when it senses a flash burst. All you need is an electrical outlet and the flash can be positioned anywhere. Be sure to take along plenty of gaffers' tape and extension cords. Tape everything in position securely in order to prevent accidents.

Studio flash units can also be used with umbrellas for lighting large areas of a room. Be sure, however, to "focus" the umbrella—adjusting the cone of light that bounces into and out of the umbrella surface by moving the umbrella closer and farther away from the light source. The ideal position is when the light fills the umbrella, but does not exceed its perimeter. Focusing the umbrella also helps eliminate hot spots and maximize light output.

■ REFLECTORS

When photographing by window light or outdoors, it is a good idea to have a selection of white, silver, gold, and black reflectors. Most photographers opt for the circular disks that unfold to produce a large reflector.

These are particularly valuable when making portraits by available light. It is wise to have an assistant along to precisely position reflectors, since it is nearly impossible to position a reflector correctly without looking through the viewfinder.

■ BACKUP AND EMERGENCY EQUIPMENT

Wedding photographers live by the expression, "If it *can* go wrong, it *will* go wrong." That is why most seasoned pros carry backups—extra camera bodies, flash heads, transmitters, batteries, cords, twice the required amount of film or storage cards, etc. For AC-powered flash, extra extension cords, several rolls of duct tape (for taping cords to the floor), power strips, flash tubes, and modeling lights also need to be on hand. Other items of note include the obligatory stepladder for making groups shots (renowned photographer Monte Zucker even has a black "formal" stepladder for use at weddings), flashlights, a mini tool kit (for mini emergencies), and quick-release plates for your tripods (these always seem to get left behind on a table or left attached to a camera).

■ SPARE BATTERIES

DSLRs go through batteries rather quickly. While you may bring along extra memory cards, the really essential backup items are spare battery packs. Even with quick-chargers, you will miss precious photo opportunities if waiting for the battery pack to charge. Spare packs should be fully charged and ready to go and you should have enough to handle your cameras as well as your assistant's cameras and the backup gear. If downloading images to a laptop, do not forget spare laptop batteries or the computer's AC adapter.

When Steven Gross shoots weddings, he takes his two Leica M6s, one M2, two Wideluxes, a Mamiya 7, and a Dianna camera (sort of a toy camera that produces interesting results), as well as "enough Tri-X and Plus-X film to fill a Volkswagen." Here, in documentary style, he captures "the punch line" with barebulb flash. His film is scanned into the digital environment after processing.

Posing Basics

There are some formals that must be made at each wedding. These are posed portraits in which the subjects are aware of the camera, and the principles of good posing and composition are essential. Even in so-called photojournalistic wedding coverage, there is an absolute necessity for posed images and not just formals. For those times—and because any good wedding photographer who is not aware of the traditional rules of posing and composition is deficient in his or her education—the basics are included here.

The rules of posing are not formulas; like all good rules, they should be understood before they can be effectively broken. Posing standards offer ways to show people at their best—a flattering likeness.

No matter what style of photography is being used, there are certain posing essentials that need to be at work—otherwise your technique (or lack of

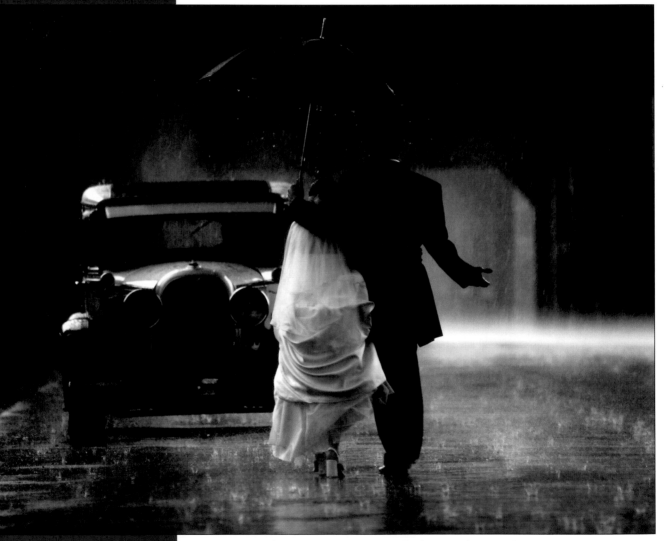

This image by Cal Landau was the one and only image he entered in WPPI 2004's print competition and it received a grand prize. It's called *Another Sunny Day in Pittsburgh.* Cal had his good-natured couple walk to the waiting car numerous times in the pouring rain until he got the shot. It helped that they were laughing hysterically at the sheer lunacy of what they were doing, but the photographer finally got the shot when the groom stuck his large hand out from under the umbrella to "see if it was raining."

LEFT—In this delicate portrait by Joe Photo, the head and shoulders are at clearly different angles in order to provide numerous dynamic lines within the composition. Notice the very thin band of focus, caused by shooting at an f/1.4 aperture, and the delicate highlight brilliance on the bridge of her nose—a function of bounce flash and perfect exposure. RIGHT—Marcus Bell created this handsome portrait of the groom using available light from both directions. The backlight creates delicate highlights on the forehead and cheekbone. Notice that the pose is between the 7/8 and 3/4 view, where the far ear is just out of view of the camera lens. The lighting, for available light, is quite elegant.

it) will be obvious. The more you know about the rules of posing, and particularly the subtleties, the more you can apply to your wedding images. And the more you practice these principles, the more they will become second nature and a part of your overall technique.

■ GIVING DIRECTIONS

There are a number of ways to give posing instructions. You can tell your subjects what you want them to do, you can gently move them into

position, or you can demonstrate the pose. The latter is perhaps the most effective, as it breaks down barriers of self-consciousness on both sides of the camera.

■ SUBJECT COMFORT

Your subjects should be made to feel comfortable. A subject who feels uncomfortable will most likely look uncomfortable in the photos. After all, these are normal people, not models who make their living posing. Use a pose that feels good to the

subject. If the person is to look natural and relaxed, then the pose must be not only natural to them, but also typical—something they do all the time. Refinements are your job—the turn of a wrist, weight on the back foot, the angling of the body away from the camera—but the pose itself must be representative of the person posing.

■ THE HEAD-AND-SHOULDERS AXIS

One of the basics of flattering portraiture is that the subject's shoul-

This is an incredible portrait by Erika Burgin. The pose uses a ³/₄ view of the bride's face and frontal lighting from camera right to produce beautiful roundness and sculpting. The bride's eyes, which are turned away from the light (the far eye shrouded in shadow), are mysterious. This is a beautiful example of split toning, where the highlights have a rich warm tint and the shadows have a cool blue-gray tint. This is an award-winning image.

line of the body, creates a sense of tension and balance. With men, the head is often turned the same general direction as the shoulders (but not at exactly the same angle); with women, the head is usually at an angle that opposes the line of the body.

■ THE ARMS

Subjects' arms should generally not be allowed to fall to their sides, but should project outward to provide gently sloping lines and a "base" to the composition. This is achieved in a number of ways. For men, ask them to put their hands in their pockets; for women, ask them to bring their hands to their waist (whether they are seated or standing). Remind them that there should be a slight space between their upper arms and their torsos. This triangular base in the composition visually attracts the viewer's eye upward, toward the face, and also protects subjects from appearing to have flat and flabby arms.

■ WEIGHT ON THE BACK FOOT

The basic rule of thumb is that no one should be standing at attention with both feet together. Instead, the shoulders should be at a slight angle to the camera, as previously described, and the front foot should be brought forward slightly. The subject's weight should always be on the back foot. This has the effect of creating a bend in the front knee and dropping the rear shoulder to a position lower than the forward one. When used in full-length bridal portraits, a bent forward knee will lend an elegant shape to the dress. With

ders should be turned at an angle to the camera. With the shoulders facing the camera straight on to the lens, the person looks wider than he or she really is. Additionally, the

head should be turned in a different direction than the shoulders. This provides an opposing or complementary line within the photograph that, when seen together with the

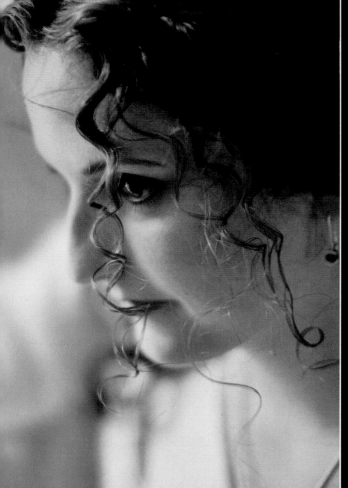

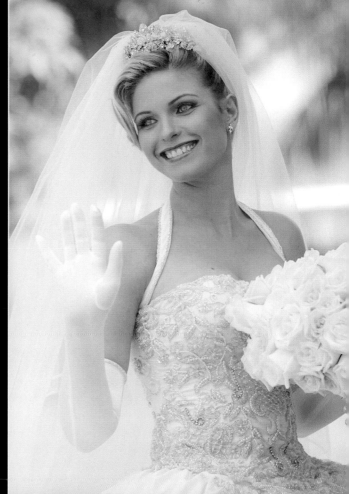

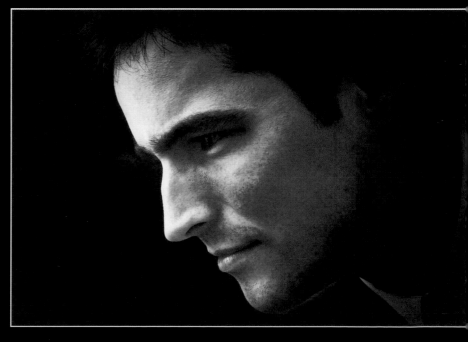

TOP LEFT—The profile is one of the most fascinating and dramatic posing positions. Here, Becky Burgin front-focused so that the near eye and ringlets of the bride's hair are in focus but everything past the bridge of the nose is pleasantly soft. The result is a telling and insightful portrait of the bride. Notice that the camera angle is above eye height, accentuating the bride's beautiful hair. **TOP RIGHT**—Charles Maring created this delightful bridal portrait with excellent posing. The line of the shoulders is about 30 degrees to the camera and the tilt of the head is toward the near shoulder in a decidedly "feminine" pose. Her weight is on her back foot, creating perfect posture and an elegant line through the composition. **RIGHT**—This is a dramatic and stylized profile of the groom that highlights his rugged good looks. The photographer, Frank Cava, burned in the non-highlighted areas of the portrait for a more dramatic effect. As in all good portraiture, the primary focus is on the eyes. Note the strong diagonal line produced by

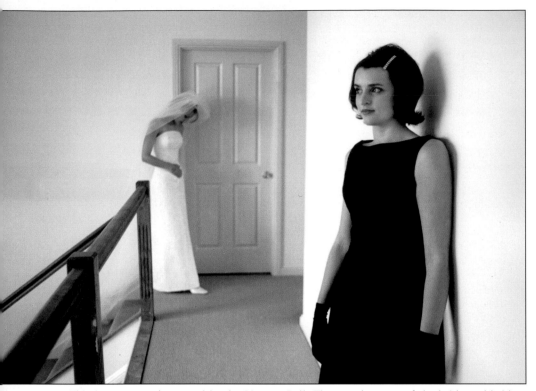

This is an unusual composition by Marcus Bell. The angular pose of the bride and bridesmaid force the viewer back and forth between the two figures. The staircase seems to point at the bride, yet the foreground girl is clearly dominant. Note the delicate pose of the bride's hand and the stark hands-at-her-sides pose of the bridesmaid, who is wearing black gloves.

one statement, "Weight on your back foot, please," you can introduce a series of dynamic lines into an otherwise average composition.

■ JOINTS

Never frame the portrait so that a joint—an elbow, knee, or ankle, for example—is cut off at the edge of the frame. This sometimes happens when a portrait is cropped. Instead, crop between joints, at mid-thigh or mid-calf, for example. When you break the composition at a joint, it produces a disquieting feeling.

■ FACE POSITIONS

As mentioned previously, the head should be at a different angle than the shoulders. There are three basic head positions (relative to the camera) found in portraiture.

The ⅞ View. If you consider the full face as a head-on "mug shot," then the ⅞ view is when the subject's face is turned just slightly away from the camera. In other words, you will see a little more of one side of the subject's face. You will still see the subject's far ear in a ⅞ view.

The ¾ View. This is when the far ear is hidden from camera and more of one side of the face is visible. With this pose, the far eye will appear smaller because it is farther away from the camera than the near eye. Because of this, it is important when posing subjects in a ¾ view to position them so that the subject's smallest eye (people usually have one eye that is slightly smaller than the other) is closest to the camera. This way, the perspective makes both eyes appear to be the same size in the

photograph. This may not be something you have time to do when posing groups of people at a wedding, but when photographing the bride and groom, care should be taken to notice these subtleties.

Profile. In the profile, the head is turned almost 90 degrees to the camera. Only one eye is visible. In posing your subjects in profile, have them turn their heads gradually away from the camera position until the far eye and eyelashes just disappear.

Knowing the different head positions will help you provide variety and flow to your images, and you can incorporate the different head positions within group portraits. You may, at times, end up using all three head positions in a single group pose. The more people in the group, the more likely that becomes.

■ THE EYES

The best way to keep your subjects' eyes active and alive is to engage the person in conversation. Look at the person while you are setting up and try to find a common frame of interest. Inquire about the other person—almost everyone loves to talk about themselves! If the person does not look at you when you are talking, he or she is either uncomfortable or shy. In either case, you have to work to relax the person. Try a variety of conversational topics until you find one he or she warms to and then pursue it. As you gain their interest, you will take the subject's mind off of the photograph.

The direction the person is looking is important. Start the formal session by having the person look at you. Using a cable release with the

camera tripod-mounted forces you to become the host and allows you to physically hold the subject's gaze. It is a good idea to shoot a few frames of the person looking directly into the camera, but most people will appreciate some variety.

One of the best ways to enliven your subject's eyes is to tell an amusing story. If they enjoy it, their eyes will smile—one of the most endearing expressions a human being can make.

■ THE SMILE

One of the easiest ways to produce a natural smile is to praise your subject. Tell her how good she looks and how much you like a certain feature of hers—her eyes, her hair style, etc. To simply say "Smile!" will produce that familiar lifeless expression. By sincere confidence building and flattery, you will get the person to smile naturally and sincerely and their eyes will be engaged by what you are saying.

Remind the subject to moisten her lips periodically. This makes the lips sparkle in the finished portrait, as the moisture produces tiny specular highlights on the lips.

Pay close attention to your subject's mouth, making sure there is no tension in the muscles around it, since this will give the portrait an unnatural, posed look. Again, an air of relaxation best relieves tension, so talk to the person to take his or her mind off the photo.

One of the best photographers I've ever seen at "enlivening" total strangers is Ken Sklute. I've looked at literally hundreds of his wedding images and in almost every photograph, the people are happy and relaxed in a natural, typical way. Nothing ever looks posed in his photography—it's almost as if he happened by this beautiful picture and snapped the shutter. One of the ways he gets people "under his spell" is

This is an uncharacteristic pose in that the hands are extended toward the camera and with a relatively short lens (50mm) they attain prominence by proximity to the lens. However, because the overall pose and attitude of the bride is relaxed and fun, it is a highly effective portrait. Also notice that the hands are indeed carefully posed to reveal the engagement ring and "French tips." The hands are also posed at an angle so that the edges of both hands are visible. Photograph by Becker.

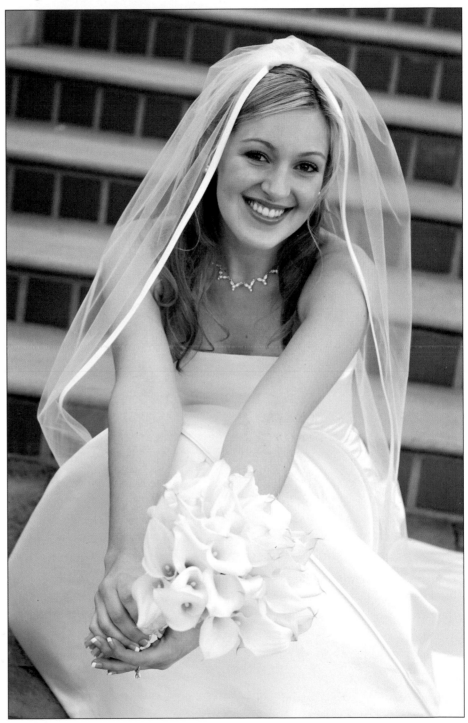

■ HANDS

Posing hands properly can be very difficult because, in most portraits, they are closer to the camera than the subject's head and thus appear larger. One thing that will give hands a more natural perspective is to use a longer-than-normal lens. Although holding the focus on both the hands and face is more difficult with a longer lens, the size relationship between them will appear more natural. If the hands are slightly out of focus, this is not as crucial as when the eyes or face are soft.

One basic rule is never to photograph a subject's hands pointing straight into the camera lens. This distorts the size and shape of the hands. Always have the hands at an angle to the lens.

Another basic is to photograph the outer edge of the hand whenever possible. This gives a natural, flowing line to the hand and wrist and eliminates distortion that occurs when the hand is photographed from the top or head-on. Try to raise the wrist slightly so there is a gently curving line where the wrist and hand join. Additionally, you should always try to photograph the fingers

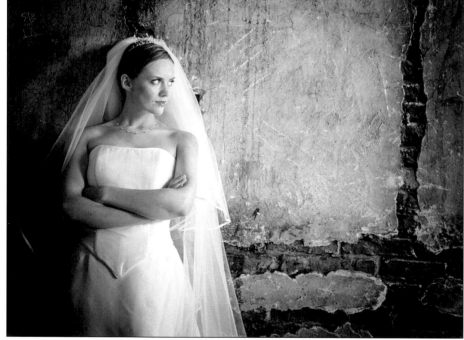

his enthusiasm for the people and for the excitement of the day. His enthusiasm is contagious and his affability translates into attentive subjects.

Another gifted wedding photographer is a Southern Californian who goes by his last name only: Becker. He is a truly funny man and he always seems to find a way to crack up his subjects.

While it helps any wedding photographer to be able to relate well to people, those with special gifts— good storytellers or people, like Becker, with a good senses of humor—should use those skills to get the most from their clients.

with a slight separation in between them. This gives the fingers form and definition. When the fingers are closed, there is no definition.

As generalizations go, it is important that the hands of a woman have grace, and the hands of a man have strength.

Hands in Groups. Hands can be a problem in group portraits. Despite their small size, they attract attention—especially against dark clothes. They can be especially troublesome in seated groups, where at first glance you might think there are more hands than there should be.

A general rule of thumb is to either show all of the hand or show none of it. Don't allow a thumb or half a hand or only a few fingers to show. Hide as many hands as you can behind flowers, hats, or other people. Be aware of these potentially distracting elements and look for

RIGHT—This is a beautiful portrait by Joe Photo. The camera was lowered to the ground to mimic the traditional "proposal" pose and make the ground a tripod, allowing a $\frac{1}{6}$ second shutter speed in the fading light. The lines in the concrete provide directional markers within the composition, reinforcing its symmetry. **BELOW**—A somewhat more formal pose is usually required when the bridesmaids are involved. The dresses must be shown off well, and the posing should be expert, as it is here. Marcus Bell had the girls all turn at slightly different angles to the camera with heads all tilting at different angles. The exception is the bridesmaid who is second from the left, who is straight-on and more or less anchors the composition.

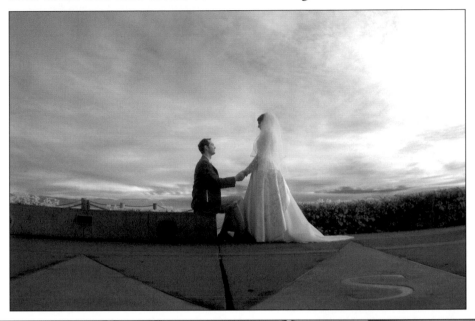

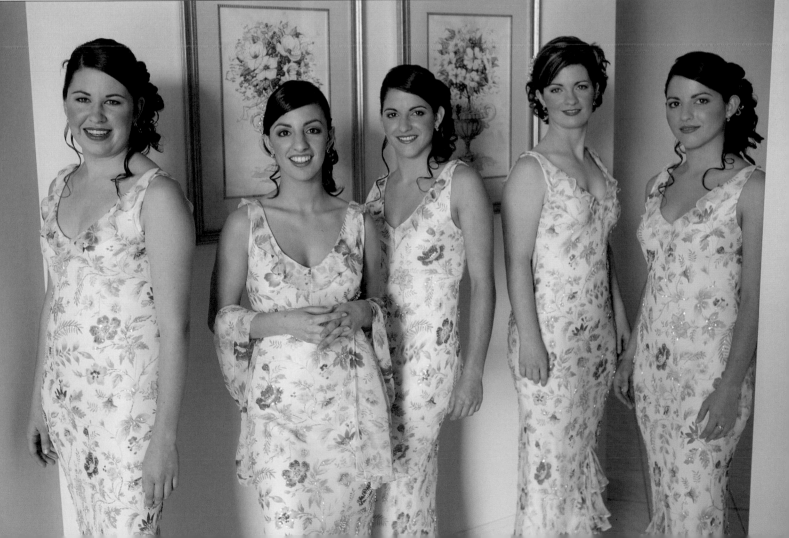

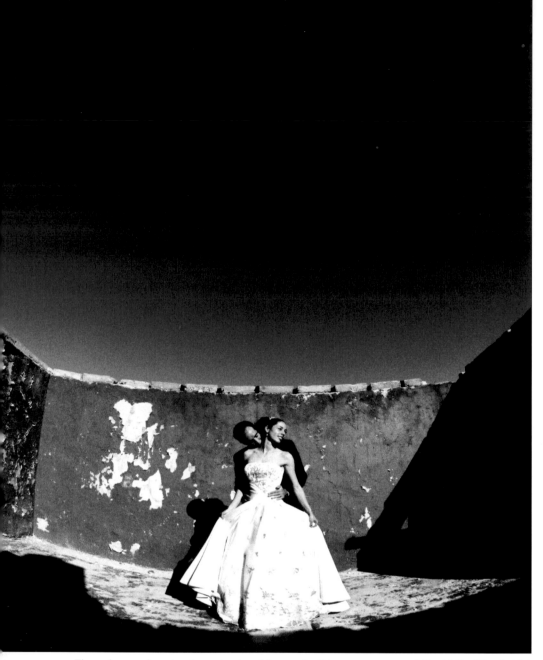

The colors and contrast are loud and brassy in this cross-processed David De Dios bridal "formal" made in a deserted swimming pool. All of the loud color contrasts with the sweet simplicity of the pose. Notice that with all good full-length posing, a triangle base is formed by the basic arrangement of the forms.

them as part of your visual inspection of the frame before you make the exposure.

Hands with Standing Subjects. When some of your subjects are standing, hands are an important issue. If you are photographing a man, folding his arms across his chest produces a good, strong pose. Remember, however, to have the man turn his hands slightly, so the edge of the hand is more prominent than the top of the hand. In such a pose, have him lightly grasp his biceps, but not too hard or it will look like he's cold. Also, remember to instruct the man to bring his folded arms out from his body a little bit. This slims down the arms, which would otherwise be flattened against his body, making them (and him) appear larger. Separate the fingers slightly.

With a standing woman, one hand on a hip and the other at her side is a good standard pose. Don't let the free hand dangle, but rather have her twist the hand so that the outer edge shows to the camera. Always create a break in the wrist for a more dynamic line.

■ **CAMERA HEIGHT**
When photographing people with average features, there are a few general rules that govern camera height in relation to the subject. These rules will produce normal (not exaggerated) perspective.

For head-and-shoulders portraits, the rule of thumb is that camera height should be the same height as the tip of the subject's nose. For ¾-length portraits, the camera should be at a height midway between the subject's waist and neck. In full-length portraits, the camera should be the same height as the subject's waist. In each case, the camera is at a height that divides the subject into two equal halves in the viewfinder. This is so that the features above and below the lens–subject axis will be the same distance from the lens, and thus recede equally for "normal" perspective.

When the camera is raised or lowered, the perspective (the size relationship between parts of the photo) changes. This is particularly exaggerated with wide-angle lenses. By controlling perspective, you can alter the subject's physical traits.

By raising the camera height in a ¾- or full-length portrait, you en-

large the head-and-shoulders region of the subject, but slim the hips and legs. Conversely, if you lower the camera, you reduce the size of the head, but enlarge the size of the legs and thighs. Tilting the camera down when raising the camera (and up when lowering it) increases these effects. The closer the camera is to the subject, the more pronounced the changes are. If you find that, after you adjust camera height for a desired effect, there is no change, move the camera in closer to the subject and observe the effect again.

When you raise or lower the camera in a head-and-shoulders portrait, the effects are even more dramatic. Raising or lowering the camera above or below nose height is a prime means of correcting facial irregularities. Raising the camera height lengthens the nose, narrows the chin and jaw line and broadens the forehead. Lowering camera height shortens the nose, de-emphasizes the forehead and widens the jaw line, while accentuating the chin.

While there is little time for many such corrections on the wedding day, knowing these rules and introducing them into the way you photograph people will help make many of these techniques second nature.

■ EYEGLASSES

Eyeglasses can present major problems on the wedding day, especially

in group pictures. When working with bounce flash or when using flash-fill outdoors, you can pick up specular reflections on eyeglasses and not even notice the problem until later. The best bet is to ask the person to remove their glasses—but don't be surprised if they decline. Many people wear glasses all the

time and they may feel extremely self-conscious without them.

One rule of light to remember when you encounter eyeglasses is this: the angle of incidence equals the angle of reflection. Light directed head-on toward a group will more than likely produce an unwanted eyeglass reflection. Instead, move

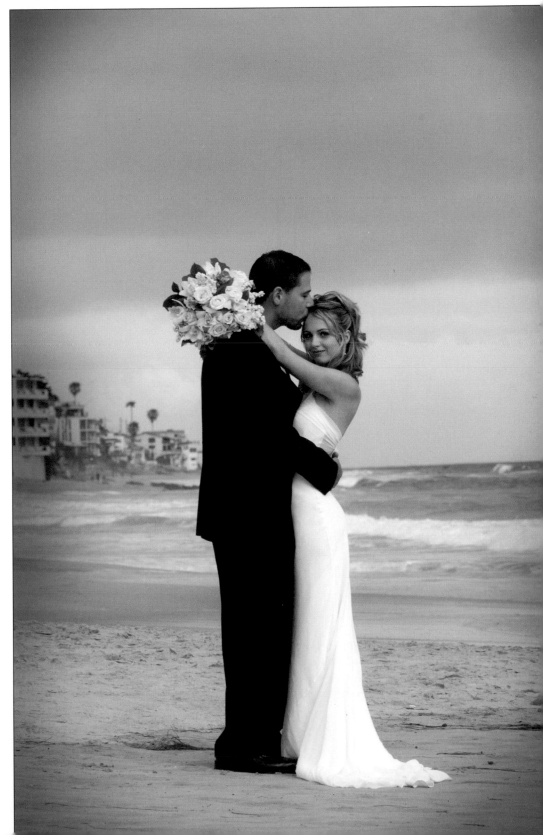

the main light to the side and raise it so that the angle of reflection is directed away from the camera lens. Any fill light should be adjusted laterally away from the camera until its reflection disappears. If you cannot eliminate the fill light's reflection, try bouncing the fill light off the ceiling.

Another trick is to ask the person to tilt his or her glasses down slightly. This should solve most problems with reflections.

When your subject is wearing thick glasses, it is not unusual for the eyes to record darker than the rest of the face. If this happens, there is nothing you can do about it during the photography, but the eyeglasses can be dodged during printing or in Photoshop to restore the same print density as the rest of the face.

Any type of "photo-gray" or self-adjusting lenses should be avoided. Outdoors, they will photograph like sunglasses. Indoors, under normal room light, they won't present much of a problem. A trick is to have the person keep their glasses in a pocket until you are ready to shoot. This will keep the lenses from getting dark prematurely from the ambient or shooting lights.

■ PORTRAIT LENGTHS

Three-Quarter and Full-Length Poses. When you employ a ¾-length pose (showing the subject from the head to below the waist) or a full-length pose (showing the subject from head to toe), you have more of the body to contend with.

As noted above, it is important to angle the person to the lens. Don't photograph the person head-on, as this adds mass to the body. Also, your subject's weight should be on the back foot rather than distributed evenly on both feet—or worse yet, on the front foot. There should be a slight bend in the front knee if the person is standing. This helps break up the static line of a straight leg. The feet should also be at an angle to the camera; feet look stumpy when shot straight-on.

When the subject is sitting, a cross-legged pose is effective. Have the top leg facing at an angle and not directly into the lens. When posing a woman who is seated, have her tuck the calf of the leg closest to the camera in behind the leg farthest from

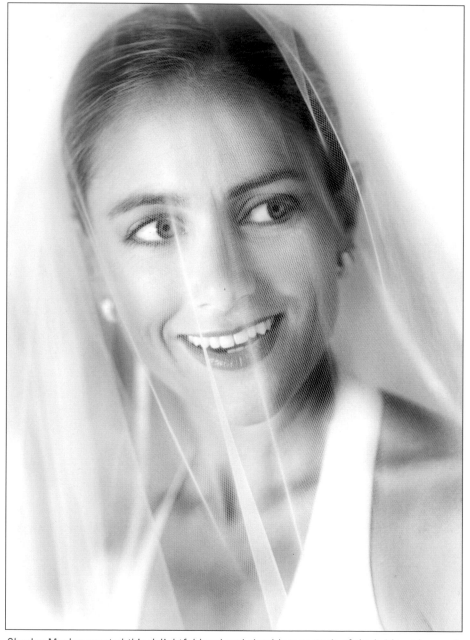

Charles Maring created this delightful head-and-shoulders portrait of the bride on her wedding day using a Nikon D1X and 85mm f/1.4 lens. The exposure was ¹/₂₅₀ second at f/1.4 and the focus was on her eyes, letting almost everything else fall out of focus. Notice how many diagonal lines are introduced into the portrait because of the angle of her shoulders and the tilt of her head and veil.

the camera. This reduces the size of the calves, since the leg that is farther from the camera becomes more prominent. Whenever possible, have a slight space between the subject's leg and the chair, as this will slim down thighs and calves.

Head-and-Shoulder Portraits. With close-up portraits of one or more people, it is important to tilt the head and retain good head-and-shoulder axis positioning. The shoulders should be at an angle to the camera lens and the angle of the person's head should be at a slightly different angle. Often, head-and-shoulders portraits are of the face alone—as in a beauty shot. In such an image, it is important to have a dynamic element, such as a diagonal line, which will create visual interest.

In a head-and-shoulders portrait, all of your camera technique will be evident, so focus is critical (start with the eyes) and lighting must be flawless. Use changes in camera height to correct any irregularities (see pages 46–47). Don't be afraid to fill the frame with the bride or bride and groom's faces. They will never look as good again as they do on their wedding day!

■ **GROUP PORTRAITS**
Noted group portrait specialist Robert Love has a simple concept for photographing groups—each person must look great—as if the portrait were being made solely of that individual. Achieving this ideal means calling on both compositional and posing skills.

Form, Line and Direction. Designing groups of people successfully depends on your ability to man-

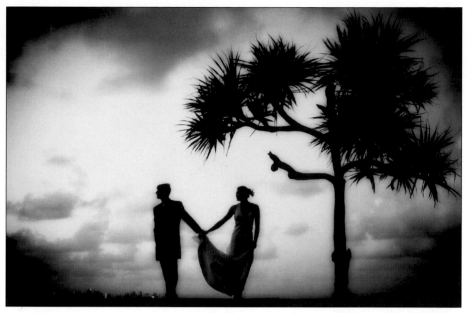

Jerry Ghionis captured his couple in silhouette during an evening stroll. Normally, couples are captured with a degree of intimacy, but here the connection is friendly and casual. A long lens was used to isolate the couple on the skyline. Vignetting was done in Photoshop to add to the drama of the scene. The result is a strong graphic image that could stand alone as a single album page or run across two pages as a bleed.

age the intangible—implied and inferred lines and shapes within a composition. Line is an artistic element used to create visual motion within the image. It may be implied by the arrangement of the group, or inferred, by grouping various elements within the scene. It might also be literal, as well, like a fallen tree used as a posing bench that runs diagonally through the composition.

Shapes are groupings of like elements: diamond shapes, circles, pyramids, etc. These shapes are usually a collection of faces that form the pattern. They are used to produce pleasing shapes that guide the eye through the composition. The more you learn to recognize these elements, the more they will become an integral part of your compositions.

These are the keys to making a dynamic group portrait. The goal is to move the viewer's eye playfully and rhythmically through the photo-

graph. The opposite of a dynamic image is a static one, where no motion or direction is found, and the viewer simply "recognizes" rather than enjoys all of the elements in the photograph.

Enter the Armchair. An armchair is the perfect posing device for photographing from three to eight people. The chair is best positioned at about 30 to 45 degrees to the camera. Regardless of who will occupy the seat, he and/or she should be seated laterally across the seat cushion. They should be seated on the edge of the chair, so that all of their weight does not rest on the chair back. This promotes good sitting posture and narrows the lines of the waist and hips for both men and women.

Using an armchair allows you to seat one person, usually the man, and position the other person close to or on the arm of the chair, leaning

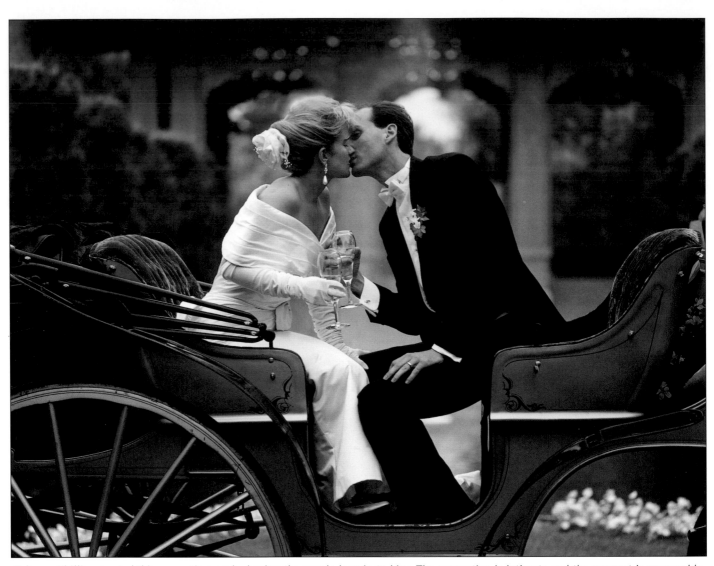

Norman Phillips created this romantic pose by having the couple lean in to kiss. The connection is intimate and the moment is memorable. Note that each person's shoulders are angled in toward each other and their weight is forward on the seat.

on the far armrest. This puts their faces in close proximity but at different heights. A variation of this is to have the woman seated and the man standing. If their heads are far apart, you should pull back and make the portrait full-length.

Couples. The simplest of groups is two people. Whether it's a bride and groom, mom and dad, or the best man and maid of honor, the basic building blocks call for one person slightly higher than the other. A good starting point is to position the mouth of the lower person even

with the forehead of the higher person. Many photographers recommend this "mouth to eyes" strategy as the ideal starting point.

Although they can be posed in parallel position, a more interesting dynamic with two people can be achieved by having them pose at 45-degree angles to each other, so their shoulders face in toward one another. With this pose you can create a number of variations by moving them closer or farther apart.

Another intimate pose for two is to have two profiles facing each

other. One should still be higher than the other, as this allows you to create an implied diagonal between their eyes, which also gives the portrait direction.

Since this type of image is fairly close up, make sure that the frontal planes of the subjects' faces are roughly parallel so that you can hold focus on both faces.

Adding and Third Person. A group portrait of three is still small and intimate. It lends itself well to a pyramid- or diamond-shaped composition, or an inverted triangle, all

of which are pleasing to the eye. Don't simply adjust the height of the faces so that each is at a different level; turn the shoulders of those at either end of the group in toward the central person as a means of looping the group together.

Once you add a third person, you will begin to notice the interplay of lines and shapes inherent in good group design. As an exercise, plot the implied line that goes through the shoulders or faces of the three people in the group. If the line is sharp or jagged, try adjusting the composition so that the line is more flowing, with gentler edges.

Try different configurations. For example, create a diagonal line with the faces at different heights and all the people in the group touching. It's a simple yet pleasing design. The graphic power of a well defined diagonal line in a composition will compel the viewer to keep looking at the image. Adjust the group by having those at the ends of the diagonal tilt their heads slightly in toward the center of the composition.

Try a bird's-eye view. Cluster the group together, grab a stepladder or other high vantagepoint, and you've got a lovely variation on the three-person group. It's what photographer Norman Phillips calls "a bouquet." For a simple variation, have the people turn their backs to each other, so they are all facing out of the triangle.

Adding a Fourth and Fifth Person. This is when things really get interesting. As you photograph more group portraits, you will find that even numbers of people are harder to pose than odd. Three, five, seven, or nine people seem much easier to photograph than similarly sized groups of an even number. The reason is that the eye and brain tend to accept the disorder of odd-numbered objects more readily than even-numbered objects.

As you add more people to a group, remember to do everything you can to keep the film plane parallel to the plane of the group's faces in order to ensure that everyone in the photograph is sharply focused.

With four people, you can simply add a person to the existing poses of three described above—with the following advice in mind. First, be sure to keep the eye height of the fourth person different from any of the others in the group. Second, be aware that you are now forming shapes within your composition. Think in terms of pyramids, extended triangles, diamonds, and curved lines. Finally, be aware of lines, shapes, and direction as you build your groups.

An excellent pose for four people is the sweeping curve of three people with the fourth person added below and between the first and second person in the group.

The fourth person can also be positioned slightly outside the group for accent, without necessarily disrupting the harmony of the rest of the group.

When Monte Zucker has to pose four people, he sometimes prefers to play off of the symmetry of the even number of people. He'll break the rules and he'll seat two and stand

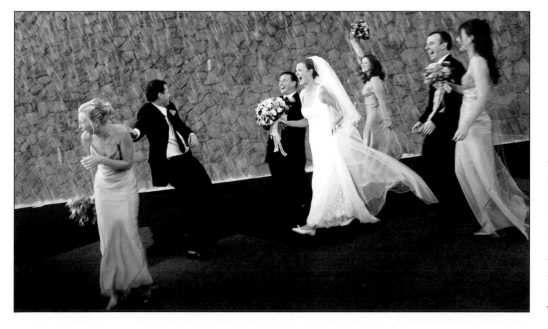

This is the type of group photo favored by today's brides. It's spontaneous, reflects a moment of fun and revelry, and is anything but formal. Marcus Bell used a 25mm focal-length setting and a $1/40$ second shutter speed at f/4.5 to capture the scene. The background is a waterfall wall.

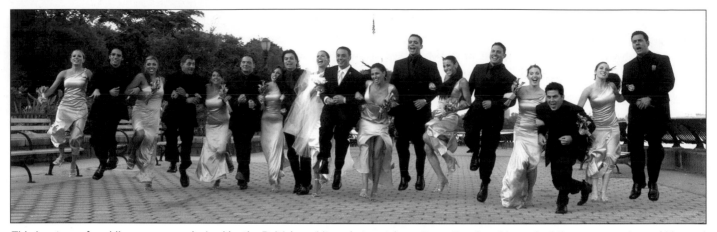

This is a type of wedding group popularized by the British wedding photographers. Here, Ron Capobianco had the group run toward him and jump on cue. Using a 21mm lens, Nikon D100 and a $1/400$ second shutter speed, he was able to freeze the action and capture nine of the eighteen people in midair. With the camera's LCD screen, Ron instantly knew when he got the shot.

two and, with heads close together, making the line of the eyes parallel with both the top two and bottom two. Strangely, this seems to work, without the monotony one would expect.

Bigger Groups. Compositions will always look better if the base is wider than the top, so the final person in a large group should elongate the bottom of the group.

Each implied line and shape in the photograph should be designed by you and should be intentional. If the arrangement isn't logical (i.e., the line or shape doesn't make sense visually), then move people around and start again.

Try to coax "S" shapes and "Z" shapes out of your compositions. They form the most pleasing shapes to the eye and will hold a viewer's eye within the borders of the print. Remember that the diagonal line also has a great deal of visual power in an image and is one of the most potent design tools at your disposal.

The use of different levels creates a sense of visual interest and lets the viewer's eye bounce from one face to another (as long as there is a

logical and pleasing flow to the arrangement). The placement of faces, not bodies, dictates how pleasing and effective a composition will be.

When adding a sixth or an eighth person to the group, the group should still retain an asymmetrical look for best effect. This is best accomplished by creating elongated sweeping lines and using the increased space to slot in extra people. Keep in mind that, while a triangle shape normally calls for three people, you can add a fourth and still keep the shape intact.

As your groups get bigger, keep your depth of field under control. The stepladder is an invaluable tool for larger groups, because it lets you elevate the camera position and keep the camera back (or film plane) parallel to the group for most efficient focus. Another trick is to have the last row in a group lean in while having the first row lean back, thus creating a shallower subject plane, making it easier to hold the focus across the entire group.

As your grouping exceeds six people, you should start to base the

composition on linked shapes—like linked circles or triangles. What makes combined shapes work well is to turn them toward the center. Such subtleties unify a composition and make combining visually appealing design shapes more orderly.

Camera Technique

Whether you've grouped your subjects and posed them beautifully or are shooting candids from across the dance floor, using good camera technique can make or break your images. From lens selection, to depth of field, to exposure, there's a lot to keep in mind as you capture each important frame.

■ FOCAL LENGTH AND ITS EFFECT ON PERSPECTIVE

Short- to medium-length telephotos provide normal perspective without subject distortion. If you used a "normal" focal-length lens (50mm in 35mm format, 75–90mm in the medium formats), you would need to move in too close to the subject to attain an adequate image size. Because it alters the perspective, close proximity to the subject exaggerates subject features—noses appear elongated, chins jut out and the backs of heads may appear smaller than normal. This phenomenon is known as foreshortening. The short telephoto provides a greater working distance between camera and subject, while increasing the image size to ensure normal perspective.

When photographing groups, some photographers prefer long lenses; for example, a 180mm lens on a 35mm camera. The longer lens keeps people in the back of the group the same relative size as those in the front of the group.

When space doesn't permit the use of a longer lens, short lenses must be used, but you should be aware that the subjects in the front row of a large group will appear larger than those in the back of the group, especially if you get too close. Extreme wide-angle lenses will distort the subjects' appearance,

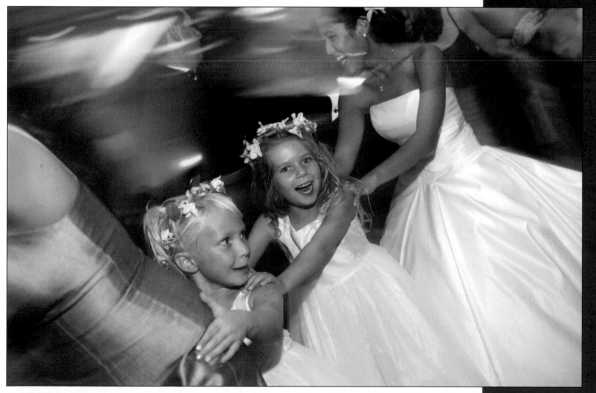

Joe Photo captured the action and the color of the conga line using a wide-angle lens, low camera angle, and flash at ⅛ second at f/2.8 (dragging the shutter to record the background light and color).

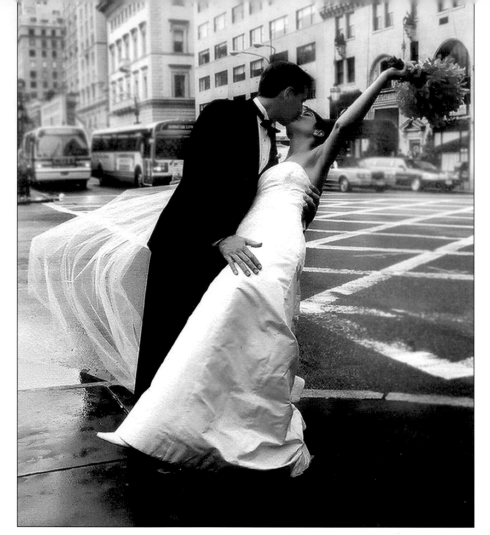

Ron Capobianco posed this memorable kiss in New York City, trying to mimic the focal length and angle of a famous VJ-day photo by Alfred Eisenstaedt. Using a short focal length, he was able to incorporate the background into the scene, as well as widen the foreground portion of the image.

particularly those closest to the frame edges. Raising the camera height, thus placing all subjects at the same relative distance from the lens, can minimize some of this effect. Also, the closer to the center of the frame the people are, the less distorted they will appear.

Conversely, you can use a much longer lens if you have the working room. A 200mm lens, for instance, is a beautiful portrait lens for the 35mm format because it provides very shallow depth of field and throws the background completely out of focus, providing a backdrop that won't distract viewers from the subjects. When used at wider apertures, this focal length provides a very shallow band of focus that can be used to accentuate just the eyes, for instance, or just the frontal planes of the faces.

Very long lenses (300mm and longer for 35mm) can sometimes distort perspective. With them, the subject's features appear compressed. Depending on the working distance, the nose may appear pasted onto the subject's face, and the ears may appear parallel to the eyes. While lenses this long normally prohibit communication in a posed portrait, they are ideal for working unobserved as a wedding photojournalist often does. You can make head-and-shoulders images from a long distance away.

When making ¾- or full-length group portraits, it is best to use the normal focal length lens for your camera. This lens will provide normal perspective because you will be at a greater working distance from your subjects than you would be when making a close-up portrait. It is tricky sometimes to blur the background with a normal focal length lens, since the background is in close proximity to the subjects. If forced to use a normal or short lens, you can always blur the background elements later in Photoshop using selective blurring. With longer lenses you can isolate your subjects from the background because of the working distance and image size.

When making group portraits, you are often forced to use a wide-angle lens. In this case, the background problems noted above can be even more pronounced. Still, a wide angle is often the only way you can fit the group into the shot and maintain a decent working distance. For this reason, many group photographers carry a stepladder or scope out the location in advance to find a high vantagepoint, if called for.

■ DEPTH OF FIELD

The closer you are to your subjects with *any* lens, the less depth of field you will have at any given aperture. When you are shooting a tight image of faces, be sure that you have enough depth of field at your working lens aperture to hold the focus on all the faces.

Learn to use your the depth-of-field scale on your lenses. The viewfinder screen is often too dim when the lens is stopped down with the depth-of-field preview to gauge overall image sharpness accurately. Learn to read the scale quickly and practice gauging distances. With the camera away from your eye, guess how far away your subject is. Focus and then check the lens focus ring to confirm the distance. With practice, you can become amazingly accurate.

Learn the characteristics of your lenses. You should know what to expect in the way of depth of field, at your most frequently used lens apertures, which for most group shots will be f/5.6, f/8, and f/11. Some photographers tend to use only one or two favorite apertures when they shoot. Norman Phillips, for instance, prefers f/8 over f/11 (for shooting group portraits), even though f/11 affords substantially more depth of field than f/8. He prefers the relationship between the sharply focused subject and the background at f/8, saying that the subjects at f/11 look "chiseled out of stone."

■ DEPTH OF FOCUS

When working up close at wide lens apertures, where depth of field is reduced, you must focus carefully to hold the eyes, lips, and tip of the nose in focus. This is where a good working knowledge of your lenses is essential. Some lenses will have the majority (two thirds) of their depth of field *behind* the point of focus; others will have the majority (two thirds) of their depth of field *in front of* the point of focus. In most cases, depth of field is split 50–50, half in front of and half behind the point of focus. It is important that you know how your different lenses operate and that you check the depth of field with the lens stopped down to the taking aperture, using your camera's depth-of-field preview control.

One of the benefits of shooting with digital SLRs is the large LCD panel. Most cameras allow you to inspect the sharpness of the image by zooming in or scrolling across the image—a dramatic improvement over the depth-of-field preview.

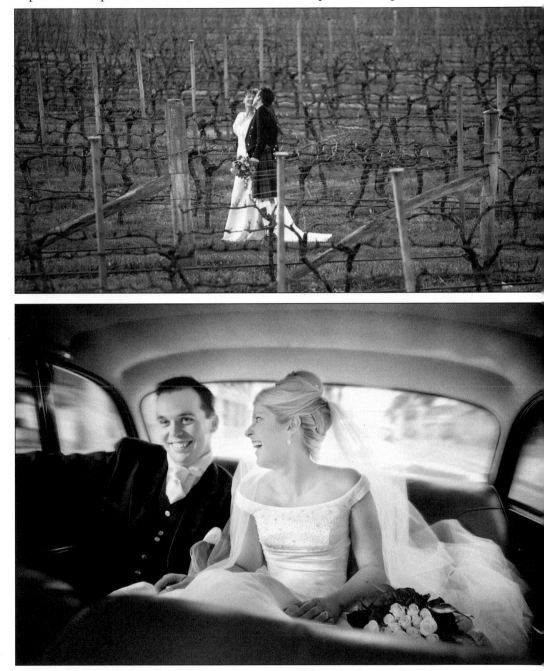

TOP—Long lenses stack the perspective, making near and far objects seem closer together because of the narrower angle of view. Here Mercury Megaloudis photographed bride and groom strolling through a dreary scene that is made joyful by the couple's presence. **ABOVE**—When using a wide-angle lens you must center the subjects or they will distort. A shutter speed like 1/30 second is short enough to sharply capture the couple inside the car but blur the scene outside the windows. It's a realistic, cinematic effect. Photograph by Marcus Bell.

With most lenses, if you focus one third of the way into the group or scene, you will ensure optimum depth of focus at all but the widest apertures. Assuming that your depth of field lies half in front and half behind the point of focus, it is best to focus on the eyes. The eyes are the region of greatest contrast in the face, and thus make focusing easier. This is particularly true for autofocus cameras that often seek areas of highest contrast on which to focus.

Focusing a ¾- or full-length portrait is a little easier because you are farther from your subjects, where depth of field is greater. With small groups, it is essential that the faces fall in the same focusing plane. This is accomplished with posing and careful maneuvering of your subjects or camera position.

■ MAKING THE CAMERA BACK PARALLEL TO THE SUBJECT

Suppose that your wedding group is large and you have no more room in which to make the portrait. One easy solution is to raise the camera height, angling the camera downward so that the film plane is more parallel to the plane of the group. You have not changed the amount of depth of field that exists at that distance and lens aperture, but you have optimized the plane of focus to accommodate the depth of the group. By raising the camera height, you are effectively shrinking the depth of the group, making it possible to get the front and back rows in focus at the same time.

■ SHIFTING THE FOCUS FIELD

Lenses characteristically focus objects in a more or less straight line— but not completely straight. If you line your subjects up in a straight line and back up so that you are far away from the group, all subjects will be rendered sharply at almost any aperture. At a distance, however, the subjects are small in the frame. For a better image, you must move closer to the group, making those at the ends of the group proportionately farther away from the lens than those in the middle of the lineup. Those farthest from the lens will be difficult to keep in focus. The solution is to bend the group, making the middle

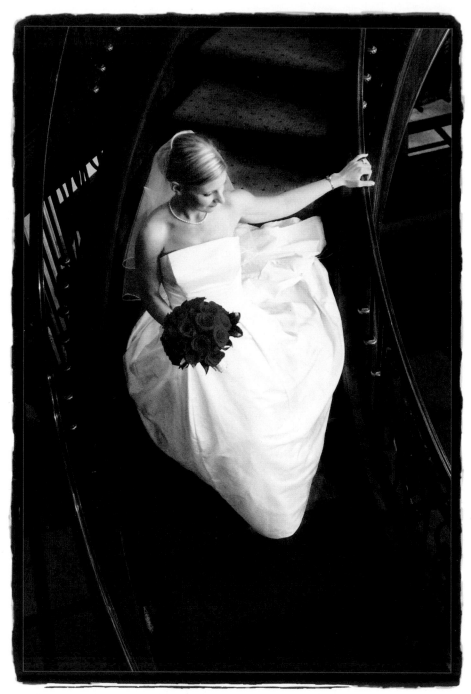

The normal lens produces excellent perspective for ¾- and full-length portraits at a moderate taking distance. If a wide-angle had been used here, the bride's head and shoulders would have appeared distorted. Photograph by Erika Burgin.

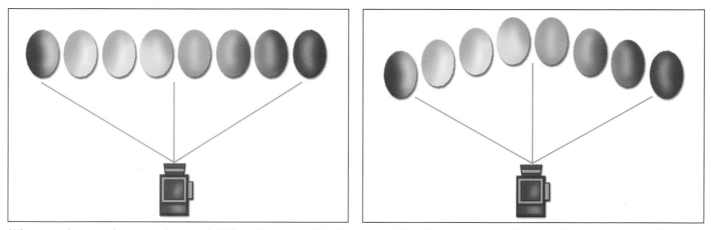

When you photograph a group in a straight line, those closest to the center of the line are closest to the lens. Those on the ends of the line are farther away from the lens. When you bend the group, you can make each person the same distance from the lens, thus requiring the same amount of depth of field to render them sharply. Diagram concept by Norman Phillips; diagram by Shell Dominica Nigro.

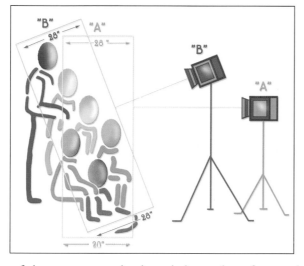

In this example, the depth of field at the given taking distance and f-stop is 28 inches—not enough to cover the group from front to back. By raising the camera and tilting it down, the depth of field now covers the same 28 inches but a different plane in the subject, thus reapportioning the available depth of field to cover the subject. Diagram concept by Norman Phillips; diagram by Shell Dominica Nigro.

of the group step back and the ends of the group step forward so that all of the people in the group are the same relative distance from the camera. To the camera, the group looks like a straight line, but you have actually distorted the plane of sharpness to accommodate the group.

■ THE RIGHT SHUTTER SPEED

You must choose a shutter speed that stills both camera and subject movement. If using a tripod, a shutter speed of $\frac{1}{15}$ to $\frac{1}{60}$ second should be adequate to stop average subject movement. If you are using electronic flash, you are locked into the flash-sync speed your camera calls

for—unless you are "dragging" the shutter. Dragging the shutter means working at a slower-than-flash-sync speed to bring up the level of the ambient light. This effectively creates a balanced flash exposure with the ambient-light exposure.

It should be noted that 35mm SLRs have a different shutter type than medium and large format cameras. 35mm SLRs use a focal-plane shutter, which produces an X-sync speed for electronic flash use of anywhere from $\frac{1}{60}$ to $\frac{1}{500}$ of a second. The X sync speed is always marked in a different color on the shutter speed dial. Many medium format cameras use lens-shutters, which allow you to

synchronize with electronic flash at any shutter speed. Using the technique of "dragging the shutter" you can shoot at any shutter speed slower than the X-sync speed with a SLR camera and still maintain flash synchronization. If you shoot at a shutter speed faster than the X-sync speed using an SLR, the flash will only partially expose the film frame.

Outdoors, you should normally choose a shutter speed faster than $\frac{1}{60}$ second, because even a slight breeze will cause the subjects' hair to flutter, producing motion during the moment of exposure.

When handholding the camera, you should use the reciprocal of the focal length of the lens you are using for a shutter speed. For example, if using a 100mm lens, use $\frac{1}{100}$ second (or the next highest equivalent shutter speed, like $\frac{1}{125}$) under average conditions. If you are very close to the subjects, as you might be when making a portrait of a couple, you will need to use an even faster shutter speed because of the increased image magnification. When working farther away from the subject, you can revert to the shutter speed that is

the reciprocal of your lens's focal length.

A great technical improvement is the development of image stabilization lenses, which correct for camera movement and allow you to shoot handheld with long lenses and slower shutter speeds. Canon and Nikon, two companies that currently offer this feature in some of their lenses, offer a wide variety of zooms and long focal length lenses with image stabilization. If using a zoom, for instance, which has a maximum aperture of f/4, you can still shoot handheld wide open in subdued light at $\frac{1}{10}$ or $\frac{1}{15}$ second and get dramatically sharp results. The benefit is that you can use the light longer in the day and still shoot at low ISO settings for fine grain. It is important to note, however, that subject movement will not be quelled with these lenses, only camera movement.

When shooting groups in motion, use a faster shutter speed and a wider lens aperture. It's more important to freeze subject movement than it is to have great depth of field for this kind of shot. If you have any question as to which speed to use, always use the next fastest speed to ensure sharpness.

Some photographers are able to handhold their cameras for impossibly long exposures, like $\frac{1}{4}$ or $\frac{1}{2}$ second. They practice good breathing and shooting techniques to accomplish this. With the handheld camera laid flat in the palm of your hand and your elbows in against your body, take a deep breath and hold it. Do not exhale until you've "squeezed off" the exposure. Use your spread feet like a tripod and if you are near a doorway, lean against it for additional support. Wait until the action is at its peak (all subjects except still lifes are in some state of motion) to make your exposure. I have seen the work of photographers who shoot in extremely low-light conditions come back with available-light wonders by practicing these techniques.

■ EXPOSURE

When it comes to exposure, the wedding day presents the ultimate in extremes: a black tuxedo and a white wedding dress. Both extremes require the photographer to hold the image detail in them, but neither is as important as proper exposure of skin tones. Although this will be discussed later in the section on lighting, most pros opt for an average lighting ratio of about 3:1 so that there is detail in both facial shadows and highlights. They will fill the available light with flash or reflectors in order to attain that medium lighting ratio and this frees them to concentrate on exposures that are adequate for the skin tones.

Metering. The preferred type of meter for portraiture is the handheld incident light meter. This does not measure the reflectance of the sub-

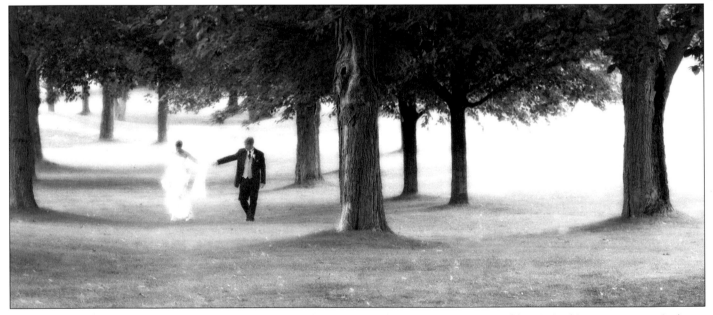

Knowing that he needed a large image for the album, Parker Pfister chose camera settings that would optimize his camera system's sharpness. One of the sharper lenses around, the Nikkor 85mm f/1.8, was focused at close to infinity and the taking aperture set to f/4—the lens's optimum aperture for image sharpness. A $\frac{1}{125}$ second shutter speed was sufficient to quiet camera and subject motion. Parker later added grain and noise to the image in Photoshop, creating a painterly feel.

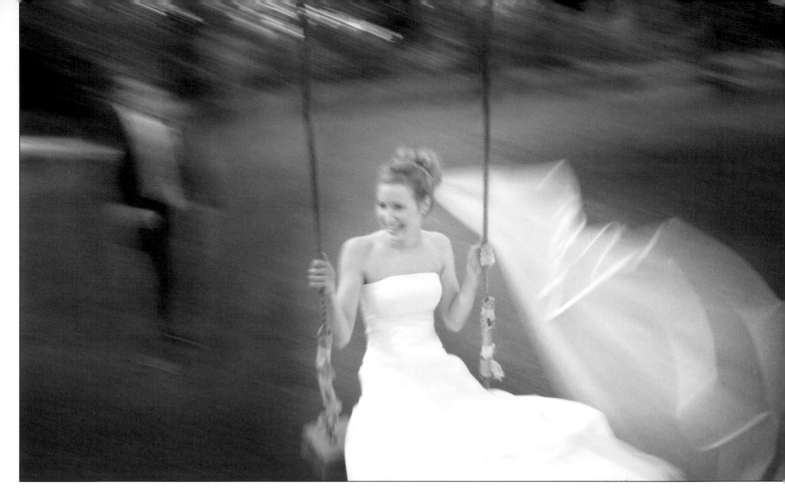

Parker Pfister waited until the swinging bride reached the apex of her swing (where she stopped moving forward and started moving backward) to snap the shutter. This is why she is sharper than anything else in the frame. He also panned the camera into position so as to really blur the background. The exposure was $^1/_{20}$ second at f/13 with a 20mm lens.

jects, but measures the amount of light falling on the scene. Simply stand where you want your subjects to be, point the hemisphere (dome) of the meter directly at the camera lens and take a reading. This type of meter yields extremely consistent results, because it is less likely to be influenced by highly reflective or light-absorbing surfaces.

When you are using an incident meter but can't physically get to your subject's position to take a reading, you can meter the light at your location if it is the same as the lighting at the subject position.

It is advisable to run periodic checks on your meter if you base the majority of your exposures on its data. You should do the same with any in-camera meters you use frequently. If your incident meter is also a flashmeter, you should check it against a second meter to verify its accuracy. Like all mechanical instruments, meters can get out of whack and need periodic adjustment.

Exposure Latitude. Working with digital files is much different than working with film. For one thing, the exposure latitude, particularly in regard to overexposure, is virtually nonexistent. Some photographers liken shooting digital to shooting transparency film—it is unforgiving in terms of exposure. The upside of this is that greater care taken in creating a proper exposure only makes you a better photographer. But for those used to –2/+3

stops of exposure latitude, this is a different game altogether.

Proper exposure is essential because it determines the range of tones and the overall quality of the image. Underexposed digital files tend to have an excessive amount of noise; overexposed files lack image detail in the highlights. You must either be right on with your exposures or, if you make an error, let it be only slightly underexposed, which is survivable. Overexposure of any kind is a deal breaker. With digital capture, you must also guarantee that the dynamic range of the processed image fits that of the materials you will use to exhibit the image (i.e., the printing paper and ink or photographic paper).

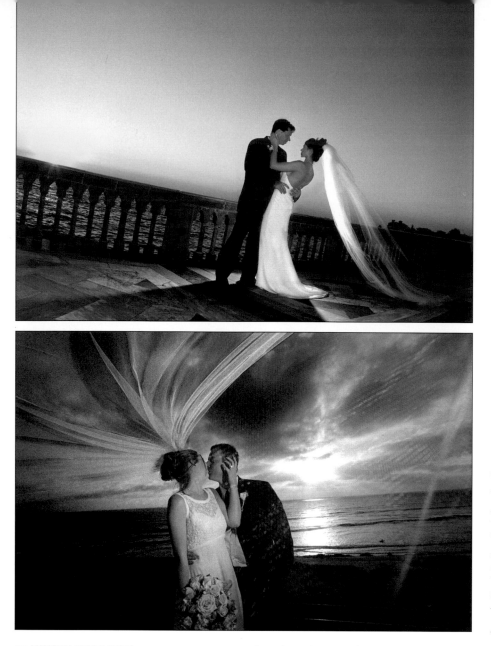

TOP—Three light sources are at work here: ambient light from the setting sun, a strobe behind the couple, and a strobe at the camera position. The key is to match the exposure of all three. An exposure reading of the sky provides the base exposure. From there, you can determine your frontal flash exposure. If the exposure of the sky is $^1/_{250}$ second at f/8, then the frontal flash should be set to f/8 or f/5.6. For the backlight flash, depending on whether you want the exposure to be more or less than the front-flash, you would set its output to f/8 or f/11. In this case, the backlight flash is about one stop hotter than the frontal flash. The same $^1/_{250}$ second shutter speed would be used, providing it is equal to or longer than the X-sync speed. Photograph by Al Gordon. **BOTTOM**—One of the benefits of the newer DSLRs is the higher flash-sync speeds—up to $^1/_{500}$ second. Scott Eklund created this wonderful wide-angle shot of the bride and groom with the bride's veil blowing in the breeze and in front of the lens. Scott simply matched his flash output to his daylight exposure.

■ WHITE BALANCE

White balance is the digital camera's ability to correct color when shooting under a variety of different lighting conditions, including daylight, strobe, tungsten, and fluorescent lighting.

White balance is particularly important if you are shooting highest-quality JPEG files; it is less important when shooting in RAW file mode, since these files contain more data than the compressed JPEG files and are easily remedied later. While this would seem to argue for shooting exclusively RAW files, it's important to note that these files take up more room on media storage cards and they take longer to write to the cards. As a result, many wedding photographers find it more practical to shoot JPEGs and perfect the color balance when creating the exposure, much like shooting conventional transparency film with its unforgiving latitude.

A system that many pros follow is to take a custom white balance of a scene where they are unsure of the lighting mix. By selecting a white area in the scene and neutralizing it with a custom white-balance setting, you can be assured of an accurate color rendition. Others swear by a device known as the Wallace Expo-Disc (www.expodisc.com), which attaches to the the lens like a filter. You take a white-balance reading with the disc in place and the lens pointed at your scene. It is highly accurate in most situations and can also be used for exposure readings.

■ OTHER CAMERA SETTINGS

Image sharpening should be set to off or minimal. Sharpening is usually the last step before output and should be done in Photoshop where there is optimum control. Contrast should be adjusted to the lowest setting. According to California wedding photographer Becker, "It's always easy to add contrast later, but more difficult to take away."

■ RAW VS. JPEG MODE

Should wedding photographers shoot in RAW mode or JPEG mode? Shooting in the RAW mode requires the use of RAW file processing software that translates the file information and converts it to a useable format. If you shoot in RAW mode, backup the RAW files as RAW files; these are the original images and contain the most data. While not as forgiving as color negative film, RAW files can be "fixed" to a much greater degree than JPEGs.

Although RAW files offer the benefit of retaining the highest amount of image data from the original capture, if you are like most wedding photographers and need fast burst rates, RAW files will definitely slow you down. They will also fill up your storage cards or microdrives much quicker because of their larger file size.

Your other file option is shooting in the JPEG Fine mode (sometimes called JPEG Highest Quality mode). Shooting in JPEG mode creates smaller files, so you can save more images per media card or microdrive. It also does not take as long to write the JPEG files to memory and allows you to work much more quickly. The biggest drawback to JPEG files is that they are a "lossy" format, meaning that since the JPEG format compresses file information, these files are subject to degradation by repeated saving. Most photographers who shoot in JPEG mode either save the file as a JPEG copy each time they work on it, or save it to the TIFF format, which is "lossless," meaning it can be saved again and again without degradation.

Since most wedding photographers opt for speed and flexibility,

LEFT—When shooting digitally, correct exposure is critical. Photographer Becker spot-metered this low-light scene and came up with a perfect exposure: $^1/_{45}$ second at f/5.0 with a 28mm lens on his Fuji FinePix S2 Pro. This is another beautiful example of split toning. **RIGHT**—Here, Joe Photo glimpsed the apprehensive bride as she waited inside the white limo. There was a huge difference in exposure values between the white roof in sunlight and the bride inside the car in shadow. He based his exposure on the inside exposure, effectively "blowing out" the highlights in the roof and chrome. He made the shot in aperture-priority mode at $^1/_{1000}$ at f/2.8.

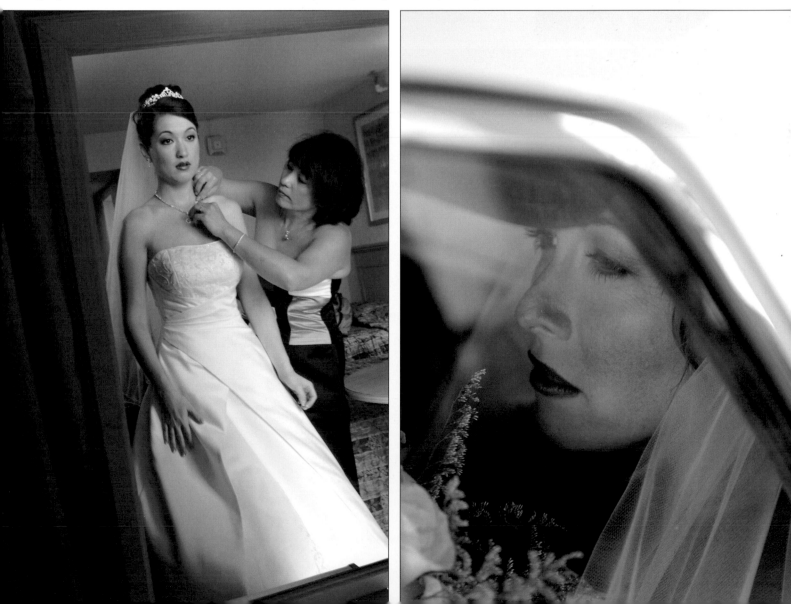

most shoot in the JPEG Fine mode. Because there is less data preserved in this format, your exposure and white balance must be flawless. In short, the JPEG format will reveal any weakness in your technique.

■ FILE MAINTENANCE

It is extremely important to back up your original (source) files before you reuse your CF cards. A good friend of mine, who shall remain nameless, asked his assistant to download and reformat the cards at the wedding only to find out later that the cards had been reformatted but the image files had not been saved. There were no wedding pictures except for the cards still in the cameras.

A good rule of thumb is to back-up the files to CDs or DVDs as soon as possible. Avoid reformatting the CF cards until that has been done and verified. After you backup your source files, it's a good idea to erase all of the images from your CF cards and then reformat them. It simply isn't enough to delete the images, because extraneous data may remain on the card causing data interference. After reformatting, you're ready to use the CF card again.

Some photographers shoot an entire job on a series of cards and take them back to the studio prior to performing any backup. Others refuse to fill an entire card at any time; instead opting to download, back up and reformat cards directly during a shoot. This is a question of preference and security. Many photographers who shoot with a team of shooters train their assistants to perform these operations to guarantee the images are safe and in hand before anyone leaves the wedding.

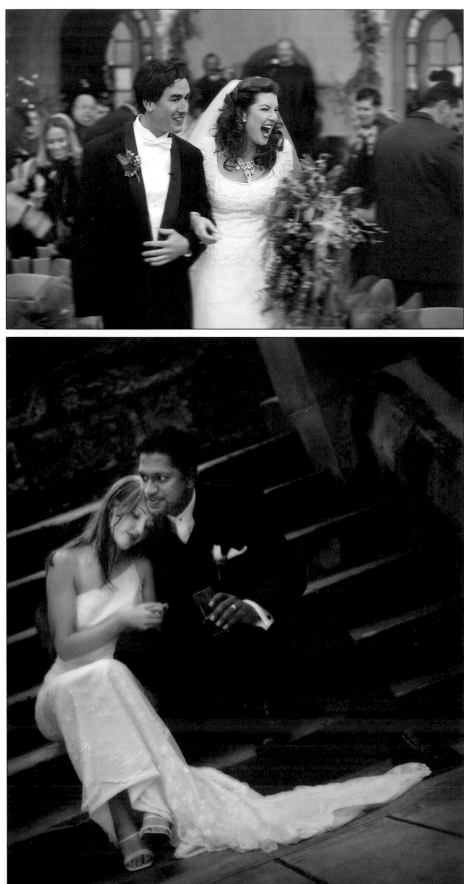

TOP—White balance is crucial, particularly when shooting JPEG files. A situation like this, with mixed lighting in varying degrees, calls for a custom white balance. Photograph by Tibor Imely. **BOTTOM**—One of Marcus Bell's favorite lenses is his Canon EF 35mm f/1.4L, which he uses in near-dark situations. Here he photographed a bride and groom in twilight under mixed lighting. The exposure is $1/15$ second at f/1.4 using an 800 ISO film speed. Even wide open, this lens is extremely sharp because of its floating aspheric element.

Studio Lighting

ecause the contemporary wedding encompasses so many different types of photography, it is essential for the wedding photographer to be well versed in all of these disciplines. However, no pictures are more important to the bride and groom than the engagement photo and formal portraits. The engagement portrait is often used in newspapers and local magazines to announce the couple's wedding day, and it is a portrait that can enrich the wedding photographer's profits significantly. These portraits may be (and usually are) made in advance of the wedding day, providing the much needed time to get something really spectacular. An additional benefit of a pre-wedding session is that, by the wedding day, the couple and the photographer are familiar with each other, making the photography much easier.

The formal portraits of the bride and groom together, and of each alone, are also significant images that demand special time allotted to them and an understanding of formal posing and lighting techniques. Often the photographer will arrange to make the formal portraits on the day of the wedding, but several hours before the day's schedule commences. Couples relish the alone time and it is another good opportunity for the photographer to break the ice with the couple.

Because of the importance of these images, it is essential that the wedding photographer be skilled in studio portraiture, which is quite different but related to the techniques normally employed on the wedding day. The key to understanding good lighting and creating it in your photographs is to understand the concept of "single-light" lighting. The sun is the primary light source in all of nature, and all lighting emanates from the sun. While

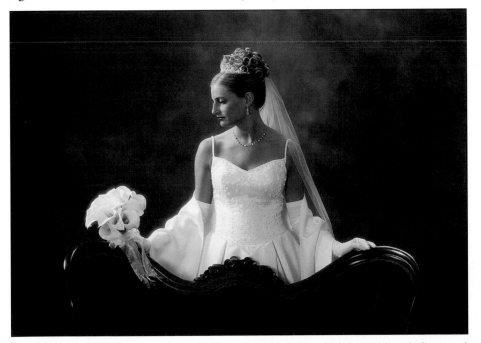

The effect of studio lights can be seen here. The key light, which is positioned above and behind the bride, lights the edge of her face, the edge of her nose, and her near cheekbone. The fill light opens up the shadows created by the key light. The background light creates a gradient on the background canvas. Hair lights illuminate the top of her hair and a little bit of her veil. The image was masterfully lit and photographed by Rita Loy.

there may be secondary light sources in nature, they are all subservient to the sun. So it is in the studio.

■ THE FIVE LIGHTS

Basic portrait lighting can be done with as few as two lights, but to get the full effect, a full set of five lights with stands and parabolic reflectors is often recommended. Most photographers opt for studio strobes—either self-contained monolight-type strobes, or those systems using a single power pack into which all lights are plugged. Some use a combination of the two types. A full system of reflectors and diffusers is required with any studio lighting system. The five lights are: the key light; the fill light; the hair light; the background light; and the optional kicker, a backlight used for shoulder or torso separation.

Key and Fill Lights. The key and fill lights should be high-intensity lights. These may be used in parabolic reflectors that are silver-coated on the inside to reflect the maximum amount of light. However, most photographers don't use parabolic reflectors anymore. Instead, they opt to use diffused key- and fill-light sources. If using diffusion, either umbrellas or softboxes, each light assembly should be supported on its own sturdy light stand.

The key light, if undiffused, should have barn doors affixed. These are black, metallic, adjustable flaps that can be opened or closed to control the width of the beam of the light. Barn doors ensure that you light only the parts of the portrait you want lighted. They also keep stray light off the camera lens, which can cause flare.

The fill light, if in a reflector, should have its own diffuser, which is nothing more than a piece of frosted plastic or acetate in a screen that mounts over the reflector. The fill light should also have barn doors attached. If using a diffused light source, such as an umbrella or softbox for a fill light, be sure that you do not "spill" light into unwanted areas of the scene, such as the background or onto the camera's lens. All lights, whether in reflectors of diffusers, should be "feathered" by aiming the core of light slightly away from the subject, employing the edge of the beam of light.

Hair Light. The hair light is a small light. Usually it takes a scaled-down reflector with barn doors for control. Barn doors are a necessity, since this light is placed behind the subject to illuminate the hair; without barn doors, the light will cause lens flare. The hair light is normally adjusted to a reduced power setting, because hair lights are almost always used undiffused.

Background Light. The background light is also a low output light. It is used to illuminate the background so that the subject and background will separate tonally. The background light is usually used on a small stand placed directly behind the subject, out of view of the camera lens. It can also be placed on a higher stand or boom and directed onto the background from either side of the set.

Kicker. Kickers are optional lights that are used in much the same way as hair lights. These add highlights to the sides of the face or body to increase the feeling of depth and

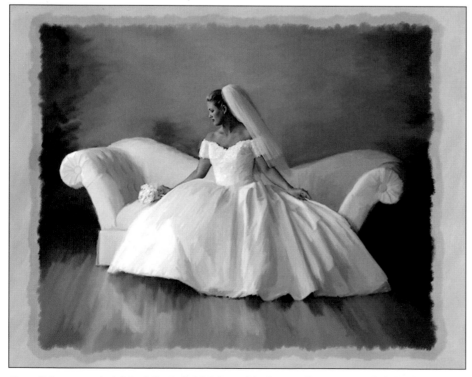

Fran Reisner created this delicate bridal formal in her studio using north light from a bay window. The light is soft and wraps around the bride requiring no fill except that light bouncing off the light colored interior walls of the studio. Fran worked the image in Painter to create the brush strokes and stippled background.

richness in a portrait. Because they are used behind the subject, they produce highlights with great brilliance, as the light just glances off the skin or clothing. Since kickers are set behind the subject, barn doors should be used to control the light.

■ BROAD AND SHORT LIGHTING

There are two basic types of portrait lighting. Broad lighting means that the key light is illuminating the side of the face turned toward the camera. Broad lighting is used less frequently than short lighting because it flattens and de-emphasizes facial contours. It is often used to widen a thin or long face.

Short lighting means that the key light is illuminating the side of the face turned away from the camera. Short lighting emphasizes facial contours, and can be used as a corrective lighting technique to narrow a round or wide face. When used with a weak fill light, short lighting produces a dramatic lighting with bold highlights and deep shadows.

■ BASIC LIGHTING SETUPS

Paramount Lighting. Paramount lighting, sometimes called butterfly lighting or glamour lighting, is a lighting pattern that produces a symmetrical, butterfly-shaped shadow directly beneath the subject's nose. It emphasizes cheekbones and good skin. It is generally not used on men because it tends to hollow out cheeks and eye sockets too much.

For this style, the key light is placed high and directly in front of the subject's face, parallel to the vertical line of the subject's nose. Since the light must be high and close to

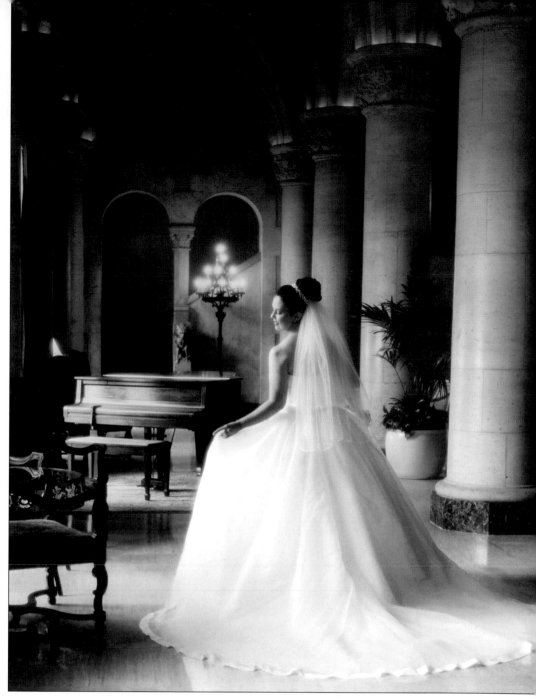

Instead of studio light, daylight is made to mimic the fine control of light achieved in the studio. Larry Capdeville made this exquisite portrait using the floor-to-ceiling windows, which emitted soft directional daylight. The fill light came from daylight bouncing off the columns in the room and from the ambient lights.

the subject to produce the wanted butterfly shadow, it should not be used on women with deep eye sockets, or very little light will illuminate the eyes. The fill light is placed at the subject's head height directly under the key light. Since both the key and fill lights are on the same side of the camera, a reflector must be used op-

posite these lights and in close to the subject to fill in the deep shadows on the neck and shaded cheek.

The hair light, which is always used opposite the key light, should light the hair only and not skim onto the face of the subject. The background light, used low and behind the subject, should form a semi-

circle of illumination on the seamless background (if using one) so that the tone of the background grows gradually darker toward the edges of the frame.

Loop Lighting. Loop lighting is a minor variation of Paramount lighting. The key light is lowered and moved more to the side of the subject so that the shadow under the nose becomes a small loop on the shadow side of the face. This is one of the more commonly used lighting setups and is ideal for people with average, oval-shaped faces.

The fill light is moved to the opposite side of the camera from the key light in loop lighting. It is used close to the camera lens. In order to maintain the one-light character of the portrait, it is important that the fill light not cast a shadow of its own. To determine if the fill light is doing its job, you need to evaluate it from the camera position. Check to see if the fill light is casting a shadow of its own by looking through the viewfinder.

In loop lighting, the hair light and background lights are used the same way they are in Paramount lighting.

Rembrandt Lighting. Rembrandt or 45-degree lighting is characterized by a small, triangular highlight on the shadowed cheek of the subject. It takes its name from the famous Dutch painter who used window light to illuminate his subjects. This lighting is dramatic and more often used with masculine subjects. Rembrandt lighting is often used with a weak fill light to accentuate the shadow-side highlight.

The key light is moved lower and farther to the side than in loop and Paramount lighting. In fact, the key light almost comes from the subject's side, depending on how far his or her head is turned away from the camera.

The fill light is used in the same manner as it is for loop lighting. The hair light, however, is often used a little closer to the subject for more brilliant highlights in the hair. The background light is in the standard position.

With Rembrandt lighting, kickers are often used to delineate the sides of the face. As with all front-facing lights, avoid shining them directly into the lens. The best way to check is to place your hand between the subject and the camera on

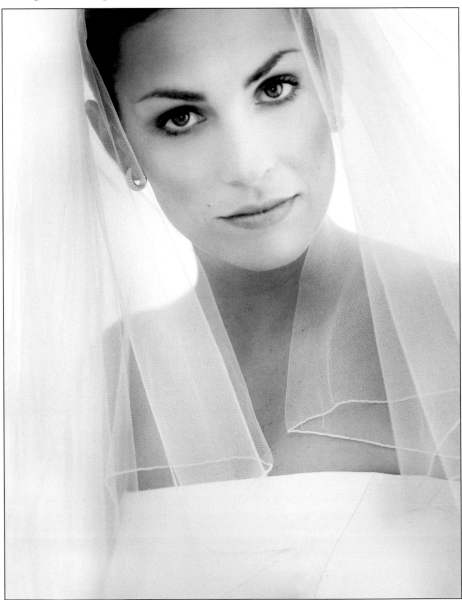

Charles Maring photographed this stunning bride using two very diffused light sources: a strobe on axis with the lens and a large softbox to camera right. A reflector beneath the light and lens was used to fill in the shadows. This is really a fashion type of lighting and, as you can see, makeup and subtle print manipulation are used to create contouring on the face. When the catchlights are at or near the pupil of the eye, an on-axis type of lighting is being used.

the axis of the kicker. If your hand casts a shadow on the lens, then the kicker is shining directly into the lens and should be adjusted.

Split Lighting. Split lighting is when the key light illuminates only half the face. It is an ideal slimming light. It can also be used with a weak fill to hide facial irregularities. Split lighting can also be used with no fill light for dramatic effect.

In split lighting, the key light is moved farther to the side of the subject and lower. In some cases, the key light may be slightly behind the subject, depending on how far the subject is turned from the camera. The fill light, hair light, and background light are used normally for split lighting.

Profile or Rim Lighting. Profile or rim lighting is used when the subject's head is turned 90 degrees away from the camera lens. It is a dramatic style of lighting used to accent elegant features. It is used less frequently now than in the past, but it is still a stylish type of portrait lighting.

In rim lighting, the key light is placed behind the subject so that it illuminates the profile of the subject and leaves a polished highlight along the edge of the face. The key light will also highlight the hair and neck of the subject. Care should be taken so that the accent of the light is centered on the face and not so much on the hair or neck.

The fill light is moved to the same side of the camera as the key light and a reflector is used to fill in the shadows. An optional hair light can be used on the opposite side of the key light for better tonal sep-

Martin Schembri created this beautiful high-key image, eliminating all of the detail of the bride and gown through soft lighting and overexposure. If you look carefully, there is a subtle line of her back still visible. The lighting is so diffused (very close to a 1:1 ratio) that you cannot see a lighting pattern or direction—it is almost completely shadowless lighting. The photographer used a subtle black rule to enclose the composition, which would otherwise be without borders.

aration of the hair from the background. The background light is used normally.

■ **AVOID OVERLIGHTING**
In setting the lights, it is important that you position the lights gradually, studying their effect as you use more and more light aimed at the subject. If you merely point the light directly at the subject, you will probably overlight the person, producing pasty highlights with no detail.

Adjust the lights carefully, and observe the effects from the camera position. Instead of aiming the light

so that the core of light strikes the subject, feather the light so that you employ the edge of the light to light the subject. The trick is to add brilliance to your highlights. This is achieved by the use of careful lighting. The highlights, when brilliant, have minute specular (pure white) highlights within the main highlight. This further enhances the illusion of great depth in a portrait.

Sometimes feathering won't make the skin "pop" (show highlight brilliance) and you'll have to make a lateral adjustment to the light or move it back from its current

position. A good starting position for your key light is 8–12 feet from the subject.

■ **DOUBLE SHADOWS AND CATCHLIGHTS**
The fill light can pose its own set of problems. If too close to the subject, the fill light will produce its own set of specular highlights that show up in the shadow area of the face, making the skin appear excessively oily. To solve the problem, move the camera and light back slightly or move the fill light laterally away from the camera slightly. You might also feather the light into the camera a bit. This method of limiting the fill light is preferable to closing down the barn doors to lower the intensity of the fill light.

The fill light often creates second set of catchlights (small specular highlights) in the subject's eyes. This gives the subject a directionless gaze, so it is usually removed later in retouching. When using a large diffused fill light, there is usually not a problem with dual catchlights.

Ray Prevost created this high-key portrait using soft, diffused light from the sky behind him. You can see that there are virtually no shadows anywhere in this portrait. Ray merged the portrait with flattened white linen to create an unusual effect. In portraits with flat frontal lighting like this, makeup must be used to contour cheekbones and other planes of the face to give the portrait dimension. When asked about the unusual shape of the catchlights in the bride's eyes, Ray responded, "What you see is the sky, and perhaps sunlit areas behind me. In the middle of all that, is a dark object—that is my reflection. It's sort of my Hitchcockian way of getting into my own images—as an obscure reflection in my subject's eyes."

Instead, the fill produces a large, milky highlight that is much less objectionable.

■ LIGHTING RATIOS

The term "lighting ratio" is used to describe the difference in intensity between the shadow and highlight side of the face. It is expressed numerically. A 3:1 ratio, for example, means that the highlight side of the face has three units of light falling on it, while the shadow side has only one unit of light falling on it. That's all the lighting ratio means.

Ratios are useful because they determine how much local contrast there will be in the portrait. They do not determine the overall contrast of the scene; rather, lighting ratios determine how much contrast you will give to the lighting of the subject(s). (*Note:* In the descriptions that follow, the key light refers to the main light source(s). The fill light refers to the source(s) of illumination that fills in the shadows created by the main or key light. In outdoor lighting situations, the key light can either be daylight or artificial light, such as that from an electronic flash or reflector. The fill light outdoors can also be either daylight or flash.)

Since lighting ratios reflect the difference in intensity between the key light and the fill light, the ratio is an indication of how much shadow detail you will have in the final portrait. Since the fill light controls the degree to which the shadows are illuminated, it is important to keep the lighting ratio fairly constant. A desirable ratio for outdoor group portraits in color is 3:1 because it is ideal for average shaped faces.

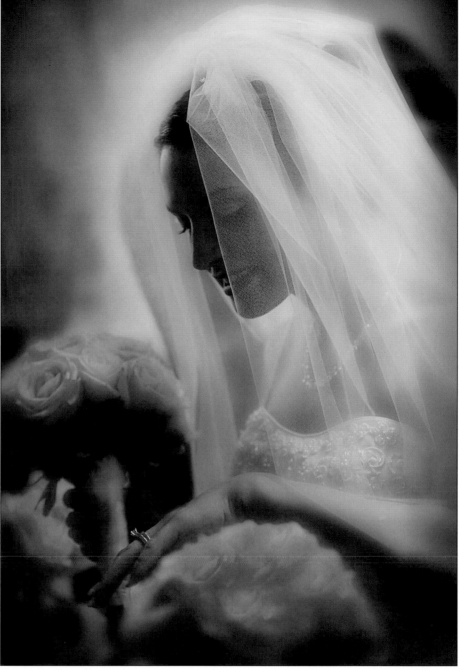

This is an interesting lighting scheme created by Tibor Imely. The bride is backlit, as if she were being posed in profile. There is very little fill light, which keeps the lighting ratio high, however there is good detail in the dress and in her neck area. This is caused by the soft nature of the overhead backlight. A background light can be seen illuminating the area behind the bride and a kicker is used from the opposite side and behind the bride to illuminate the veil.

Ratios are determined by measuring the intensity of the fill light on both sides of the face with a light meter, then measuring the intensity of the key-light side of the face only. If the fill light is next to the camera, it will cast one unit of light on each side (shadow and highlight sides) of the face. The key light, however, only illuminates the highlight side.

Determining Lighting Ratios. There is considerable debate and confusion over the calculation of lighting ratios. This is principally because you have two systems at work, one arithmetical and one log-

Al Gordon created this lighting masterpiece on location. The scene is lit with mixed lighting, with a predominance of window light and tungsten lighting from the candelabras. Al picked that spot for the bride because the window light was about a stop brighter—a result of that window being larger than the rest. His assistant held a Monte Illuminator (a silver reflector) to camera left to kick in a little fill light and open up the folds of the dress. Scenes like this require very careful metering and white balance settings. Ironically, he had a softbox on hand that he did not use because the existing light was perfect.

arithmic. F-stops are in themselves a ratio between the size of the lens aperture and the focal length of the lens, which is why they are expressed as f/2.8, for example. The difference between one f-stop and the next full f-stop is either half the light or double the light. F/8 lets in twice as much light through a lens as f/11 and half as much light as f/5.6.

However, when we talk about light ratios, each full stop is equal to two units of light. Therefore, each half stop is equal to one unit of light, and each quarter stop is equivalent to half a unit of light. This is, by necessity, arbitrary, but it makes the light ratio system explainable and repeatable. In other words, it is a practical system for determining the difference between the highlight and shadow sides of the face.

Further, most seasoned photographers have come to recognize the subtle differences between lighting ratios and will strive to reproduce such subtleties in their exposures. For instance, a photographer might recognize that with a given width of face, a 2:1 ratio does not provide enough dimension and a 4:1 ratio is too dramatic, thus he or she would strive for a 3:1 ratio. The differences between ratios are easy to observe with practice, as are the differences between fractional ratios like 3.5:1 or 4.5:1, which are reproduced by reducing or increasing the fill light amount in quarter-stop increments.

In lighting of all types, from portraits made in the sunlight to portraits made in the studio, the fill light is always calculated as one unit of light because it strikes both the high-light and shadow sides of the face. The amount of light from the key light, which strikes only the high-light side of the face, is added to that number. For example, imagine you are photographing a small group of three and the main light is one stop greater than the fill light. These two lights are metered independently and separately. The one unit of the fill (because it illuminates both the shadow and highlight sides of the faces) is added to the two units of the key light, thus producing a 3:1 ratio.

Lighting Ratios and Their Unique Personalities. A 2:1 ratio is the lowest lighting ratio you should employ. It shows only minimal roundness in the face and is most desirable for high key-effects. High-key portraits are those with low

lighting ratios, light tones, and usually a light background. In a 2:1 lighting ratio, the key and fill light sources are the same intensity. One unit of light falls on the shadow and highlight sides of the face from the fill light, while an additional unit of light falls on the highlight side of the face from the key light—1+1=2:1. A 2:1 ratio will widen a narrow face and provide a flat rendering that lacks dimension.

A 3:1 lighting ratio is produced when the key light is one stop greater in intensity than the fill light. One unit of light falls on both sides of the face from the fill light, and two additional units of light fall on the highlight side of the face from the key light—2+1=3:1. This ratio is the most preferred for color and black & white because it will yield an exposure with excellent shadow and highlight detail. It shows good roundness in the face and is ideal for rendering average-shaped faces.

A 4:1 ratio (the key light is 1½ stops greater in intensity than the fill light—3+1=4:1) is used when a slimming or dramatic effect is desired. In this ratio, the shadow side of the face loses its slight glow and the accent of the portrait becomes the highlights. Ratios of 4:1 and higher are appropriate for low-key portraits, which are characterized by dark tones and, usually, a dark background.

A 5:1 ratio (the key light is two stops greater than the fill light— 4+1=5:1) and higher is considered almost a high-contrast rendition. It is ideal for creating a dramatic effect and is often used in character studies. Shadow detail is minimal at the higher ratios and as a result, they are

not recommended unless your only concern is highlight detail.

■ METERING

If using an incident meter, hold it at the subject's nose and point it directly back toward the camera position. If any of the backlights (like the hair lights or the kickers) are shining on the meter's light-sensitive hemisphere, shield the meter from them, as they will adversely affect exposure. You are only interested in the intensity of the frontal lights when determining exposure.

■ CLASSICAL LIGHTING AT THE WEDDING

While the basic lighting patterns do not have to be used with absolute precision, it is essential to know what they are and how to achieve them. If, for instance, you are photographing your bride and groom outdoors, you can position a single key light to produce the desired lighting pattern and ratio, and use the ambient light (shade, or sun as backlighting) as the fill light. No other lights are needed to produce every one of the five basic portrait lighting setups. Use of reflectors, instead of an independent fill light or kickers, may accomplish much the same results in terms of controlling light.

You can also create an elegant profile of the bride with a single flash used as a backlight, outlining the edges of her face, neck, and the wedding veil. With the daylight as fill, only one light is required to produce an elegant, classically lit portrait.

Lighting ratios, as well, are just as effectively employed outdoors as they are in the studio.

■ STUDIO LIGHTING ON LOCATION

One of the great advantages of working in a studio, as opposed to working on location, is that you can adjust the ambient light level of the studio to a low level, thus making the studio lighting stand out. On location, you must deal with the location lighting, which occurs at much higher levels than you would prescribe for the studio.

For example, imagine a courtyard where the key light is diffused daylight coming in through an archway or doorway. Your ambient fill level would be very low, because there are no auxiliary light sources nearby. Unless your goal was to produce high-contrast lighting (not that great for brides), you would need to raise the level of the ambient or fill light. This might be accomplished locally (i.e., on the subject via a silver reflector), or it might be accomplished more universally by raising the overall interior light level by using ceiling-bounce strobes. This solution would allow you to shoot in a number of locations within the location, not just the one closest to the archway. The point of the illustration is that you must be able to react to the lighting situation with the tools at your disposal.

Outdoor and Mixed Lighting

Weddings are photographed in almost every kind of light you can imagine—open shade, bright sun, dusk, dim room light, and every combination in between. Savvy wedding photographers must feel at home in all these different situations and know how to get great pictures in them. Their ability to work with outdoor lighting is really what separates the good wedding photographers from the great ones. Learning to control, predict and alter these various types of light will allow the photographer to create great wedding pictures all day long.

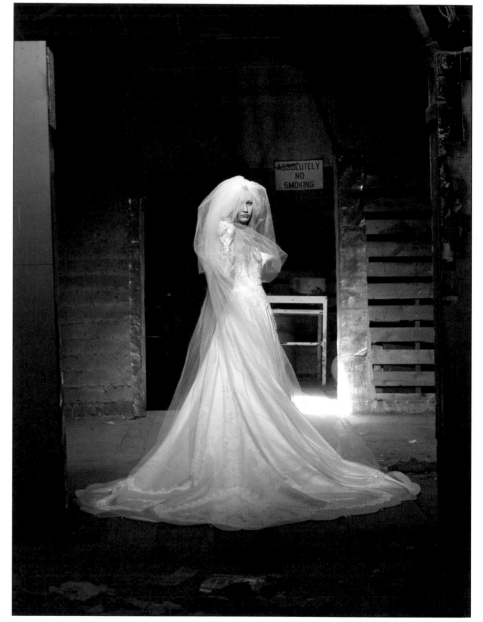

John Poppleton is a photographer who likes to photograph his brides in architecturally challenged areas. Here, a beautiful blond bride is lit with skewed rays of direct sunlight, which are coming through a hole in the roof of a dilapidated warehouse. Notice that where the full strength of the sun is imaged behind the bride, a hot spot is formed that is roughly three stops greater than the base exposure. The effect is not dissimilar to feathering a light source to take advantage of the more functional edge of the light, as opposed to its core. Image made entirely by direct sunlight.

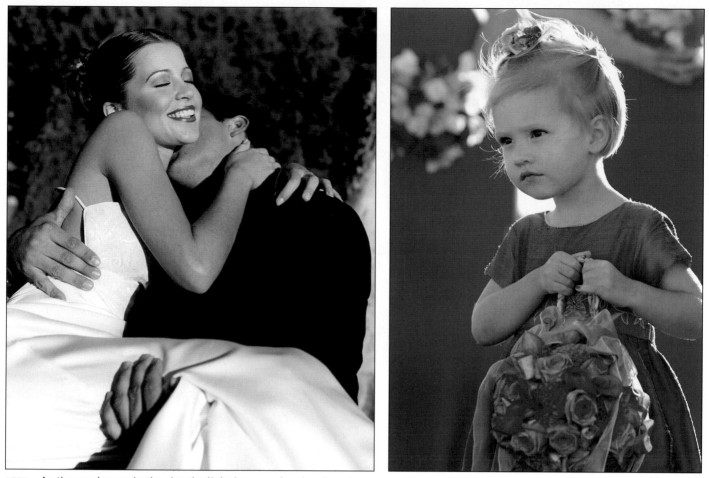

LEFT—As the sun lowers in the sky, the light becomes less harsh and more useable. It also takes on a golden yellow to red hue. Here, Ron Capobianco captured this couple in a perfect moment late in the day. No fill was used since the sun was low and lit the couple with a minimum of harsh shadows. **RIGHT**—Backlighting with direct sunlight can create a beautiful edge highlight. Becker photographed this beautiful and intense young flower girl readying herself for her job. The background of the bridesmaids' dresses makes this shot even more festive. Becker used a Fuji Finepix S2 Pro and 80–200mm f/2.8 lens set to 145mm. The ISO was 160 and the exposure was $1/350$ second at f/4.

■ DIRECT SUNLIGHT

Sometimes you are forced to photograph wedding groups in bright sunlight. While this is not the best scenario, it is still possible to get good results. Begin by turning your group so the direct sunlight is backlighting or rim lighting them. This negates the harshness of the light and prevents your subjects from squinting. Of course, you need to fill in the backlight with strobe or reflectors and be careful not to underexpose. It is best to give your exposure another $1/3$ to $1/2$ stop of exposure in backlit portraits in order to "open up" the skin tones.

Don't trust your in-camera meter in backlit situations. It will read the bright background and highlights instead of the exposure on the face. If you expose for the background light intensity, you will silhouette the subject. As usual, it is best to use the handheld incident meter in these situations. Shield the meter from any backlight, so you are only reading the light on the faces.

If the sun is low in the sky, you can use cross lighting to get good modeling on your subjects. You must be careful to position the subjects so that the sun's side lighting does not hollow out the eye sockets on the highlight sides of their faces. Subtle repositioning will usually correct this. You'll need to use fill light on the shadow side to preserve detail. Try to keep your fill-flash output about $1/2$ to one stop less than your daylight exposure.

■ CONTRAST CONTROL IN BRIGHT SUN

Images made in bright sunlight are unusually contrasty. To lessen that contrast, try using telephoto lenses or zooms, which have less inherent contrast than shorter lenses. You can noticeably soften the image contrast by using a telephoto lens. If shoot-

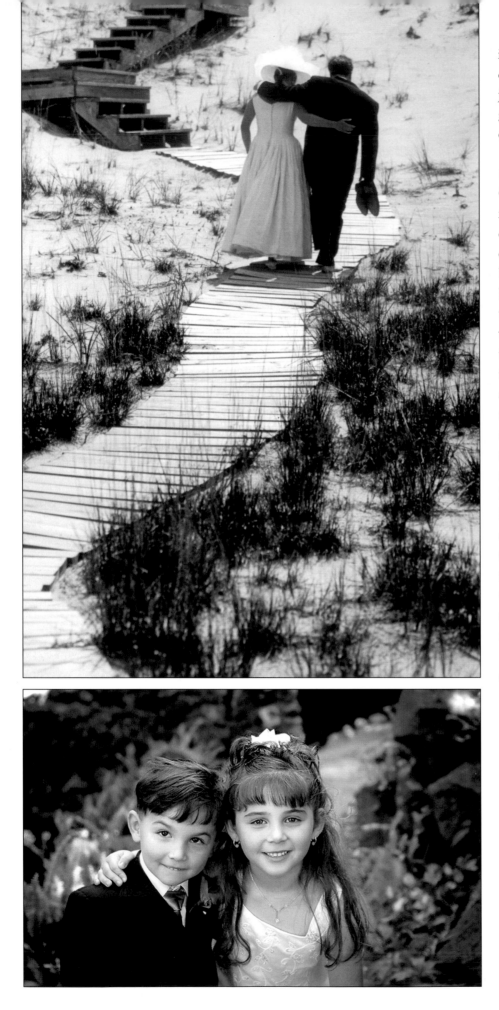

ing digitally, another thing you can do is have your contrast preset adjusted to a low setting. This is a good idea in general, but it will be especially useful in backlit situations.

■ OPEN SHADE

Open shade is soft light that is reflected from the sky on overcast days. It is different than shade created by direct sunlight being blocked by obstructions, such as trees or buildings. Open shade can be particularly harsh, especially at midday when the sun is directly overhead. In this situation, open shade takes on the same characteristics as overhead sunlight, creating deep shadows in the eye sockets and under the noses and chins of the subjects. Open shade can, however, be tamed and made useful by finding an overhang, like tree branches or a porch, which blocks the overhead light, but allows soft shade light to filter in from the sides, producing direction and contouring on the subject. This cancels out the overhead nature of the light and produces excellent modeling on the faces.

If forced by circumstance to shoot your subjects out in unob-

TOP—Steven Gross captured the bride and groom on a boardwalk with a beautiful S-curve shape. The overhead light highlighted the boardwalk and nearly silhouetted the couple. Instead of trying to capture fleeting detail, Steven settled for forms in a pleasing composition. BOTTOM—Open shade seems attractive, but it can be overhead in nature. Here, that problem was rectified by redirecting the overhead light. The photographer used two silver reflectors, one placed on either side of the camera and positioned below camera level, to bounce the light up into the children's faces. The soft, directional light makes this scene look like it was a studio shot that just happened to have a lovely garden setting. Photograph by David Anthony Williams.

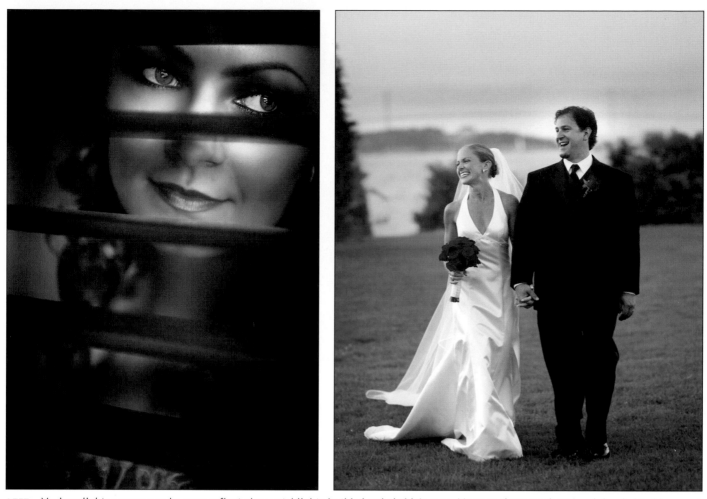

LEFT—Various light sources can be seen reflected as catchlights in this lovely bride's eyes. Yervant chose to photograph her behind louvered blinds, breaking up the composition with the wooden slats. However, he positioned the bride perfectly to receive the soft contouring light on the rounded portions of her face. He particularly wanted to isolate her eyes. He purposely kept the tonality in the dark end of the spectrum to preserve its moody look. **RIGHT**—The light at the first half-hour after sunset is known as "sweet light." As you can see, the sun's rays are still direct, but weak and diffused, creating a directional but soft lighting pattern across their faces. If the photographer, Charles Maring, captured the couple looking in the other direction, the image would have been unusable; their heads would have blocked the light.

structed open shade, you must fill in the shade with a frontal flash or reflector. If shooting the bride or the bride and groom, a reflector held close to and beneath your subjects should suffice for filling in the shadows created by open shade. If photographing more than two people, then fill-flash is called for. The intensity of the light should be about equal to the daylight exposure.

Even experienced photographers sometimes can't tell the direction of the light in open shade, particularly in mid-morning or mid-afternoon. A simple trick is to use a piece of gray or white folded card—an index card works well. Crease the card in the middle to form an open V shape. Hold the card vertically with the point of the V pointed toward the camera, then compare the two sides of the V. The card will tell you if the light is coming from the right or left and how intense the ratio between highlight and shadow is. Held with the fold horizontal and pointed toward the camera, the card will tell you if the light is vertical in nature, coming from above. Sometimes, using this handy tool, you can gauge when a slight adjustment in subject or camera position will salvage an otherwise unusable background.

■ **TWILIGHT, THE BEST LIGHT**

The best time of day for great pictures is just after sunset when the sky becomes a huge softbox and the lighting on your subjects is soft and even with no harsh shadows.

There are three problems with working with this great light. First, it's dim. You will need to use medium to fast films or ISO settings com-

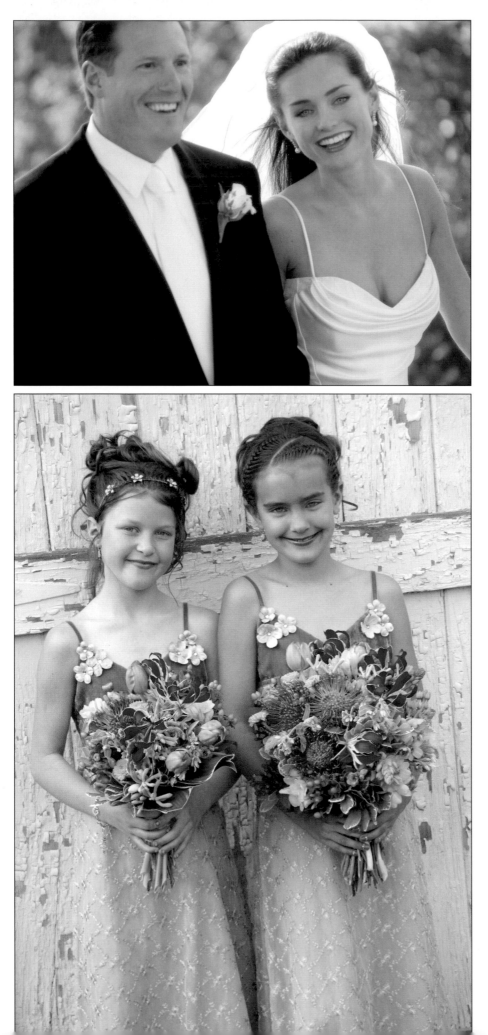

bined with slow shutter speeds, which can be problematic. Working in subdued light also restricts your depth of field, as you have to choose wide apertures. The second problem in working with this light is that twilight does not produce catchlights. For this reason, most photographers augment the twilight with some type of flash, either barebulb flash or softbox-mounted flash that provides a twinkle in the eyes. Third, twilight is difficult to work with because it changes so rapidly. The minutes after sunset (or before sunrise, when similarly beautiful lighting conditions also exist) produce rapidly changing light levels. Meter often and adjust your flash output, if using fill-flash, to compensate.

■ A SINGLE MAIN LIGHT, ALWAYS

It is important to have only one main light in your images. This is fundamental. Other lights can modify the main light, but there should always be a single defining light source. Most photographers who shoot a lot of outdoor portraits subscribe to the use of a single main light for groups, indoors or out, and fill the shadows of the main light with one or more flash units.

■ REFLECTORS

It is a good idea to take a selection of portable light reflectors to every

wedding. Reflectors should be fairly large for maximum versatility. Light discs, which are reflectors made of fabric mounted on flexible and collapsible circular frames, come in a variety of diameters and are a very effective means of providing fill-in illumination. They are available from a number of manufacturers and come in silver (for maximum fill output), white, gold foil (for a warming fill light), and black (for blocking light from hitting a portion of the subject). In most instances, an assistant is required to position and hold the reflector for maximum effect.

When the shadows produced by diffused light are harsh and deep—or even when you just want to add a little sparkle to the eyes of your subjects—use a large reflector or several reflectors. As mentioned, it really helps to have an assistant so that you can precisely set the reflectors and see their effect from the viewfinder. Be sure to position reflectors outside the frame. With foil-type reflectors used close to the subject, you can sometimes overpower the daylight, creating flattering fill-in.

TOP—David De Dios created this image with the light of a hotel ceiling "can." He had his bride tilt her head up to light the various planes of her face and later burned in the shadow pattern on the wall. This portrait is evidence that, with a little inventiveness, you can make a great picture almost anywhere. **BOTTOM**—A technique perfected by many Australian wedding photographers is working by the low levels of available light in pubs, the frequent haunts of Australian bridal parties in the time between the wedding and the reception. Here, Jerry Ghionis uses a small video light held by an assistant to light the couple. The intensity or distance of the light is varied to match the ambient light exposure of the room.

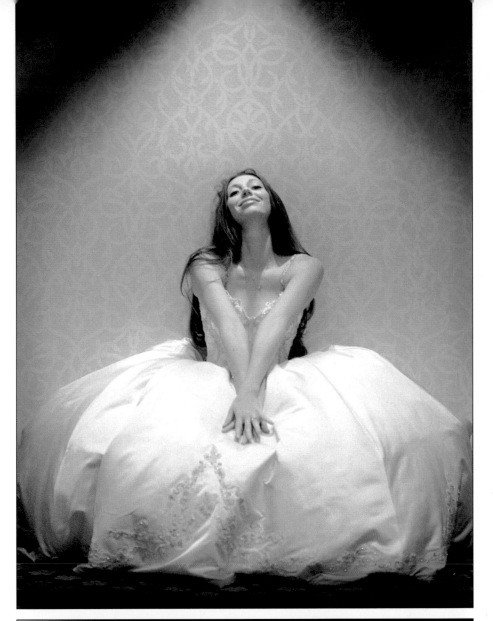

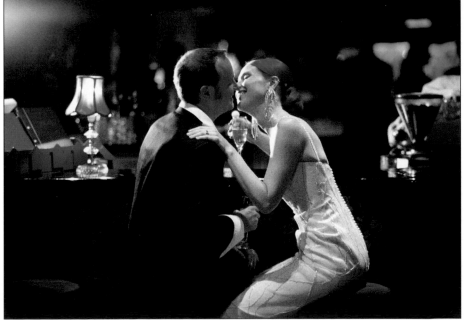

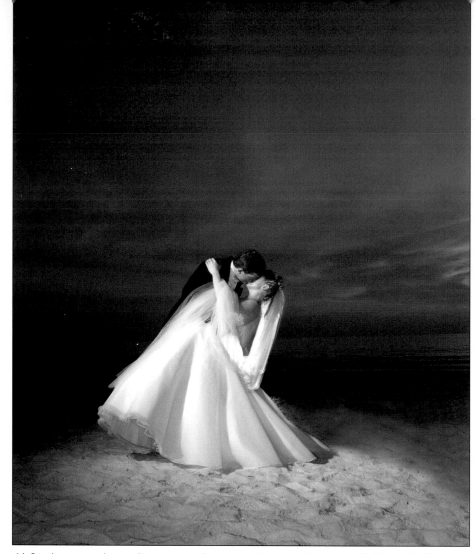

Al Gordon created a studio at sunset by using a barebulb flash on a light stand. The flash became the key light, overpowering the daylight, as the photographer underexposed the background by about 1½ stops to saturate the colors of sunset. Getting the light up and to the side gives modeling and dimension to the couple's form.

Be careful about bouncing light in from beneath your subjects. Lighting coming from under the eye/nose axis is generally unflattering. Try to "focus" your reflectors (this really does require an assistant), so that you are only filling the shadows that need filling in.

■ FLASH-FILL

A more predictable form of shadow fill-in is electronic flash. As mentioned, many photographers shooting weddings use barebulb flash, a portable flash unit with a vertical flash tube, like a beacon, that fires the flash a full 360 degrees. You can use as wide a lens as you own and you won't get flash falloff with barebulb flash. Barebulb flash produces a sharp, sparkly light, which is too harsh for almost every type of photography except outdoor fill. The trick is not to overpower the daylight. It is most desirable to let the daylight or twilight backlight your subjects, capitalizing on a colorful sky background if one exists, and use barebulb flash to fill the frontal planes of your subjects.

Some photographers like to soften their fill-flash, using a softbox instead of a barebulb flash. In this situation, it is best to trigger the strobe cordlessly with a radio remote trigger. This allows you to move the diffused flash out to a 30- to 45-degree angle to the subjects for a dynamic fill-in. For this application, it is wise to equal or overpower the daylight exposure slightly so that the off-angle flash acts more like a key light, establishing a lighting pattern. For larger groups, it may be necessary to use several softboxes or to use a single one close to the camera for more even coverage.

Metering and Exposure. Here is how you determine accurate fill-flash exposures every time. First, meter the daylight with an incident flashmeter in "ambi" mode. Say, for example, that the metered exposure is 1/30 second at f/8. Next, meter the flash only. It is desirable for the flash output to be one stop less than the ambient exposure. Adjust the flash output or flash distance until your flash reading is f/5.6. Set the camera to 1/30 second at f/8. That's it. You can set the flash output from f/8 to f/5.6 and you will not overpower the daylight, you will only fill in the shadows created by the daylight and add sparkle to the eyes.

If the light is fading or the sky is brilliant and you want to shoot for optimal color saturation in the background, overpower the daylight with the flash. Returning to the situation above, where the daylight exposure was 1/30 second at f/8, adjust your flash output so your flashmeter reading is f/11, a stop more powerful than the daylight. Set your camera to 1/30 second at f/11. The flash is now the key light and the soft twilight

is the fill light. The problem with this technique is that you will get shadows from the flash. This can be acceptable, however, since there aren't really any shadows coming from the twilight. As described previously, this technique works best when the flash is diffused and at an angle to the subjects so there is some discernable lighting pattern.

It is also important to remember that you are balancing two light sources in one scene. The ambient light exposure will dictate the exposure on the background and the subjects. The flash exposure only affects the subjects. When you hear of photographers "dragging the shutter" it refers to using a shutter speed slower than X-sync speed in order to expose the background properly.

Flash-Fill Variation. Backlit subjects allow you to work in bright light as long as you fill the shadows. One of the outdoor techniques master photographer Monte Zucker uses

is to position his single flash on a light stand as if it were a studio light, raised and to the right or left of the subjects, usually at a 30- to 45-degree angle. He uses his single flash at the same output as his daylight exposure, which may be as bright as f/16. The effect is to fill the shadows with dynamic light that rounds and sculpts each face. The effect is similar to the studio lighting involving a

strong backlight and single key light. Ambient daylight provides the fill-in.

Remember that electronic flash falls off in intensity rather quickly, so be sure to take your meter readings from the center of your group and then from either end to be sure the illumination is even. With a small group of three or four, you can get away with moving the strobe away from the camera to get better mod-

LEFT—Cal Landau used a Metz 45CL flash on camera and another Metz 45CL on a stand to the right. Both flash units were bounced into the ceiling. The halo effect on the bride happened because she passed between Cal and a spotlight in the ceiling. Asked about this shot he said, "I would like to say that I planned it that way, but the truth is, I was shooting from near the floor without looking through the viewfinder." Cal used a Canon EOS 10D and 15mm lens. ISO was set to 400 and the exposure was ¹/₂₅ second at f/5.6. **BELOW**—Al Gordon is a virtuoso of flash fill. He waited until the perfect moment at sunset to create this fun photo. Note that both the flash and ambient exposures are perfect and, increasing the difficulty, he had the group splash with their feet so he could freeze the water with his flash. Also note his higher-than-head-height vantage point and the perfect arrangement of the group. Yet for all of its control, there is spontaneity and fun in the image.

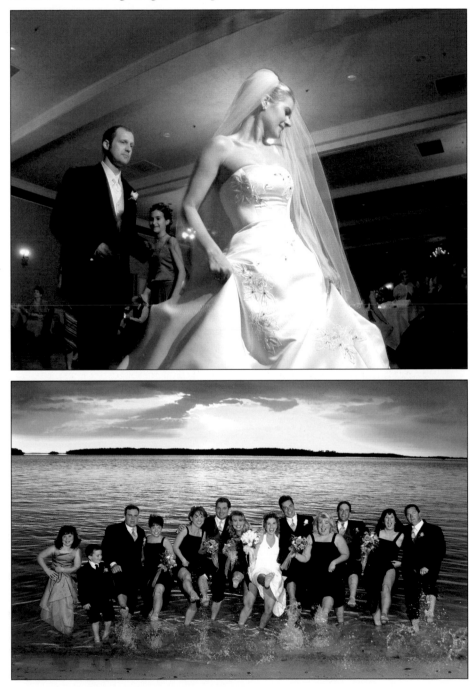

eling—but not with larger groups, where the light falloff is too great. You can, however, add a second flash of equal intensity and distance to help widen the light.

Monte uses a similar technique for formal groups where a single flash would fall off too rapidly, leaving one half of the group unlighted. He adds a second light at the same angle as the first, but spaced so that it will light the half of the group that is farthest away. He feathers both lights so they don't overlight the middle of the group. This technique allows you to create big wide groups—even use wide-angle lenses—and still attain elegant lighting.

■ FLASH-KEY ON OVERCAST DAYS

When the flash exposure and the daylight exposure are identical, the effect is like creating your own sunlight. This technique works particularly well on overcast days when using barebulb flash, which is a point light source like the sun. Position the flash to the right or left of the subject(s) and raise it up for better modeling. If you want to accentuate the lighting pattern and darken the background and shadows, increase the flash output to ½ to one stop greater than the daylight exposure and expose for the flash exposure. Do not underexpose your background by more than a stop, however, or you will produce an unnatural nighttime effect.

Many times this effect will allow you to shoot out in open shade without fear of hollow eye sockets. The overhead nature of the diffused daylight will be overridden by the directional flash, which creates a distinct lighting pattern.

■ FLASH-SYNC SPEEDS

If using a focal plane shutter as found in 35mm SLRs, you have an X-sync shutter speed setting. You cannot use flash and employ a shutter speed faster than the X-sync speed. Otherwise, your files or negatives will be only half exposed. You can, however, use any shutter speed slower than the X-sync speed. Your strobe will fire in synchronization with the shutter, and the longer shutter speed will build up the ambient light exposure. The latest generation of DSLRs, like the Nikon D1X and Canon EOS 1-Ds, use flash-sync shutter speeds of $\frac{1}{500}$ second, making daylight flash sync at almost any aperture possible.

With in-lens blade-type shutters, flash sync occurs at any shutter speed, because there is no focal-plane shutter curtain to cross the film plane.

■ "STRAIGHT" FLASH

On-camera flash should be avoided altogether for making wedding portraits—except as a fill-in source. Straight flash is too harsh and flat and it produces no roundness or contouring. Since light falloff is extreme, it produces cavernous black backgrounds—unless the shutter is left open for a longer time to expose the ambient room light.

When you diffuse on-camera flash, you get a reasonably soft frontal lighting. While diffused flash is still a flat lighting and frontal in nature, the softness of the light produces much better contouring than direct, undiffused flash. Lumiquest offers devices like the Pocket Bouncer, which redirects light at a 90-degree angle from the flash to soften the quality of light and distribute it over a wider area. There are also

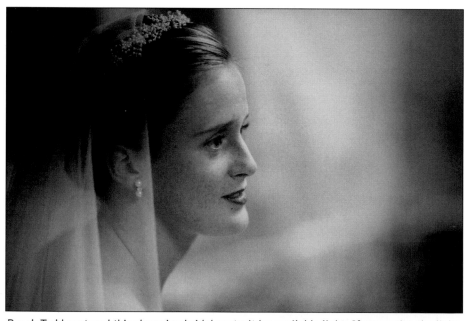

Brook Todd captured this charming bridal portrait by available light. If you notice the light, although minimal in terms of brightness, it is elegant. Detail within the highlights is evident and a beautiful Rembrandt lighting pattern is created. Some extraneous light is present but most likely there were multiple light sources, none of them bright. Not only is the shot elegant, but it was taken under difficult lighting conditions and executed flawlessly.

frosted acetate caps that fit over the flash reflector to soften the direct flash and these can be effective as well. Most of these accessories can be used with your flash in auto or TTL mode, making exposure calculation effortless.

Many photographers, especially those shooting 35mm systems, prefer on-camera TTL flash, which features a mode for TTL fill-in flash that will balance the flash output to the ambient-light exposure for balanced fill-flash. Most of these TTL flash systems are adjustable so that you can vary the flash output in fractional increments, thus providing the means to dial in the precise ratio of ambient-to-fill illumination. They are marvelous systems and, of more importance, they are reliable and predictable. The drawback to these systems is that they are camera-mounted—although many such systems also allow you to remove the flash from the camera via a TTL remote cord.

■ BOUNCE FLASH

Portable flash units do not have modeling lights, so it is impossible to see beforehand the lighting effect produced. However, there are certain ways to use a camera-mounted flash in a predictable way to get excellent lighting—especially at the reception.

Bounce flash is an ideal type of portrait light. It is soft and directional. By bouncing the flash off the ceiling, you can achieve an elegant, soft light that fully illuminates your subjects. You must learn to gauge angles and distances when using bounce flash. Aim the flash unit at a point on

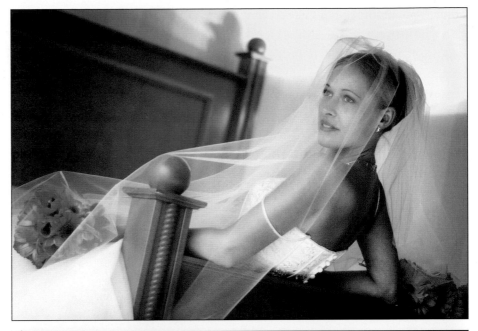

One of the best facets of shooting digitally is the ability to shoot virtually anywhere in almost any lighting situation. Anthony Cava made these images with a Nikon D100 at $^1\!/_{320}$ second at f/1.7. In the image of the bride, he set the white balance for shade so the mixture of daylight and tungsten would go yellow-red. In the shot of the groom, he set the white balance to tungsten, even though there was a mix of tungsten, fluorescent, and daylight. He could have color corrected each scene but opted for a more creative approach to the color balance.

the ceiling that will produce the widest beam of light reflecting back onto your subjects. You should never use color film when bouncing flash off colored ceilings or walls—the light reflected back onto your subjects will be the same color as the walls. Even if shooting digitally, you

may not be able to compensate with custom white balance for the green-colored bounce flash coming off of a green ceiling.

TTL flash metering systems and autoflash systems will read bounce-flash situations fairly accurately, but factors such as ceiling distance,

color, and absorption qualities can affect proper exposure. Although no exposure compensation is necessary with these systems, operating distances will be reduced.

You don't necessarily have to use your flash-sync speed when making bounce flash exposures. If the room-light exposure is within a stop or two of your bounce flash exposure ($\frac{1}{125}$ second at f/4, for example), simply use a slower shutter speed to record more of the ambient room light. If the room light exposure is $\frac{1}{30}$ second at f/4, for example, expose the bounce-flash photos at $\frac{1}{30}$ second at f/4 for a balanced flash and room-light exposure. Be wary of shutter speeds longer than $\frac{1}{15}$ second, as you might incur camera movement or subject movement in the background (the flash will freeze the nearer subject although the longish shutter speed might produce "ghosting" if your subject is moving). These effects are actually quite interesting visually and many photographers incorporate a slow shutter speed and flash to record a sharp image over a moving one for a painterly effect.

■ USING A DSLR'S LCD TO EVALUATE FLASH OUTPUT

One of the best means of evaluating flash output, lighting ratios, and the balance between flash illumination and daylight or room light is by using the digital SLRs LCD monitor. While the LCD may not be the perfect tool to evaluate subtle exposure effects, it is quite effective in evaluating how well your bounce flash is performing. You can see at a glance if you need to increase or decrease flash output.

■ UMBRELLAS

Often, you will need to light an area, such as the dance floor or dais at a reception. Stationary umbrellas that are "slaved" to your camera or on-camera flash are the ideal way to accomplish even lighting over a large area. It is important to securely tape all cords and stands to the floor in as inconspicuous a manner as possible to prevent anyone from tripping over them. Once positioned, you can adjust the umbrellas so that you get

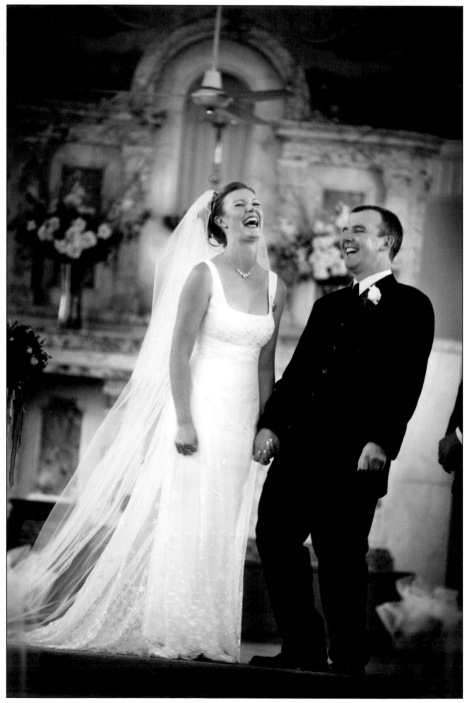

Daylight streams in from either side, but the light level is very low. Here is where image stabilization lenses come in handy, allowing you to shoot as slow as $\frac{1}{15}$ or $\frac{1}{8}$ second. Photograph by Marcus Bell.

TOP—John Poppleton captured this bride in an old glassless window. Shooting from outside the window, he was able to harness the full soft directional quality of the light. The light is so soft that it actually looks like a softbox was used. A careful inspection of the catchlights reveals a large area across from the window that is illuminated by a mixture of sunlight and shade. A little selective diffusion and a contrasting frame edges were later applied in Photoshop. **BOTTOM**—Parker Pfister created this lovely portrait of a bride using diffused tungsten illumination. He photographed the scene with a Nikon D1X and 24mm lens at $\frac{1}{30}$ second at f/2.8. The back-illuminated steps add a cool graphic element to the photograph.

even illumination across the area. To do that, focus the umbrellas.

Umbrellas fit inside a tubular housing inside most studio electronic flash units. The umbrella slides toward and away from the flash head, and is anchored with a set-screw or similar device. The reason the umbrella-to-light-source distance is variable is because there is a set distance at which the full amount of strobe light hits the full surface of the umbrella, depending on the diameter of the umbrella and type of reflector housing used on the flash head. This is the optimal setting. If the umbrella is too close to the strobe, much of the beam of light is focused in the center portion of the umbrella, producing light with a "hot-spot" center. If the strobe is too far away from the umbrella surface, the beam of light is focused past the umbrella surface, wasting a good amount of light. When setting up, use the modeling light of the strobe to focus the distance correctly so the outer edges of the light core strike the outer edges of the umbrella for maximum output.

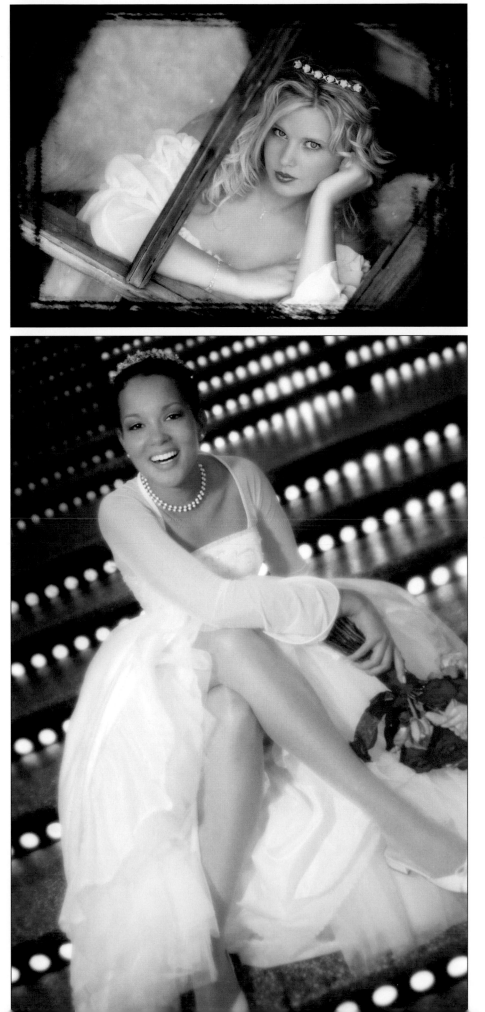

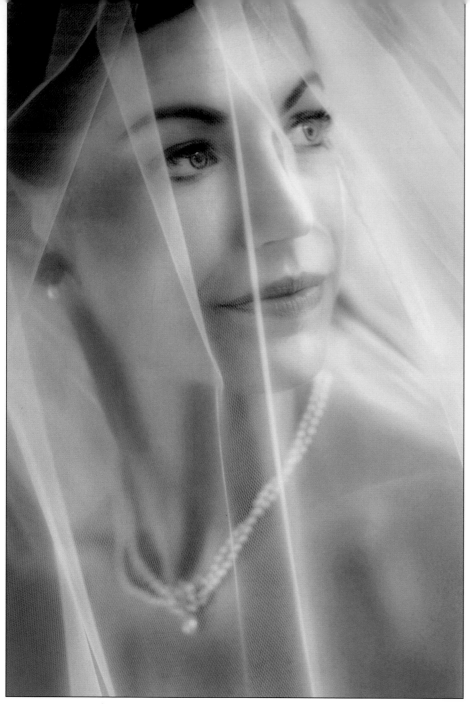

One might think this is a studio portrait, but it was created on location at the wedding by Charles Maring using a Nikon D1X and 85mm f/1.4 lens. His exposure, in the low window light, was ⅟₄₀ second at f/1.4. Using a wide-open aperture like this on very fast lenses produces a razor-thin band of focus—in this case, the bride's eyes, lips, and part of the veil. Even her nose is not fully in focus. The effect is soft and dreamy. The lighting is expertly handled to provide loop lighting. The veil provided a natural fill in on the bride's face.

Umbrellas also need to be "feathered" to maximize the coverage of the umbrella's beam of light. If you aim a light source directly at the area you want illuminated then meter the light, you'll find that it is falling off at the ends of the area—despite the fact that the strobe's modeling light might trick you into thinking that the lighting is even throughout. Feathering the light past the area you want illuminated will help more evenly light your scene because you are using the edge of the light. Another trick is to move the light source back so that is less intense overall but covers a wider area. The light will become harsher and less diffuse the farther back you move it. Triggering is best accomplished with a radio transmitter set to fire only those strobes.

■ AVAILABLE LIGHT

Throughout this chapter, various means of augmenting available and existing light have been discussed. There are many occasions when the available light cannot really be improved. Such situations might arise from window light or open shade or sometimes the incandescent light found in a room. It is a matter of seeing light that is important. Learn to evaluate light levels as well as lighting patterns, both inside and out. The better you can see light, the more advanced and refined your photographs will be.

■ HANDHELD VIDEO LIGHTS

David Williams uses small handheld video lights to augment existing light at a wedding. He glues a Cokin Filter holder to the front of the light and places a medium blue filter (a 025 Cokin filter) in it. The filter brings the white balance back from tungsten to about 4500°K, which is still slightly warmer than daylight. It is the perfect warm fill light. If you want a warmer effect, or if you are shooting indoors with tungsten lights, you can remove the filter.

These lights sometimes have variable power settings. Used close to the subject (within 10 feet) they are fairly bright, but can be bounced or feathered to cut the intensity.

David uses them when shooting wide open, so they are usually just used for fill or accent.

The video light can also be used to provide what David calls a "kiss of light." He holds the light above and to the side of the subject and feathers the light back and forth while looking through the viewfinder. The idea is to produce just a little warmth and light on something that is backlit or lit nondescriptly.

Sometimes he will use an assistant to hold two lights, which cancel out the shadows of one another. He often combines these in a flash-bracket arrangement with a handle. His video light has a palm grip attached to the bottom to make it more maneuverable when he has a camera in the other hand.

■ WINDOW LIGHT

One of the most flattering types of lighting you can use is window lighting. It is a soft light that minimizes facial imperfections, yet it is also highly directional light, for good facial modeling with low to moderate contrast. Window light is usually a fairly bright light and it is infinitely variable, changing almost by the minute. This allows a great variety of moods, depending on how far you position your subjects from the light.

Since daylight falls off rapidly once it enters a window, and is much

weaker several feet from the window than it is closer to the window, great care must be taken in determining exposure—particularly with groups of three or four people. You will undoubtedly need to use reflectors to balance the light overall when photographing that many people in a group. There are a couple of other problems, namely that you will sometimes have to work with distracting backgrounds and uncomfortably close shooting distances.

The best quality of window light is the soft light of mid-morning or mid-afternoon. Direct sunlight is difficult to work with because of its intensity and because it will often create shadows of the individual windowpanes on the subject.

Diffusing Window Light. If you find a nice location for a portrait but the light coming through the windows is direct sunlight, you can diffuse the window light with some acetate diffusing material taped to the window frame. It produces a warm golden window light. Light diffused in this manner has the warm feeling of sunlight but without the harsh shadows.

If the light is still too harsh, try doubling the thickness of the acetate for more diffusion. Since the light is so scattered by the diffusers, you may not need a fill source, unless working with a larger group. In that case, use reflectors to kick light back into the faces of those farthest from the window.

David Worthington created this elegant window-lit bridal formal by positioning the bride where the soft glow of the light illuminated her from head to toe. The white columns act like a fill-light source and bounce light back into the shadow side of the bride. The stately archways add formality to this beautiful portrait.

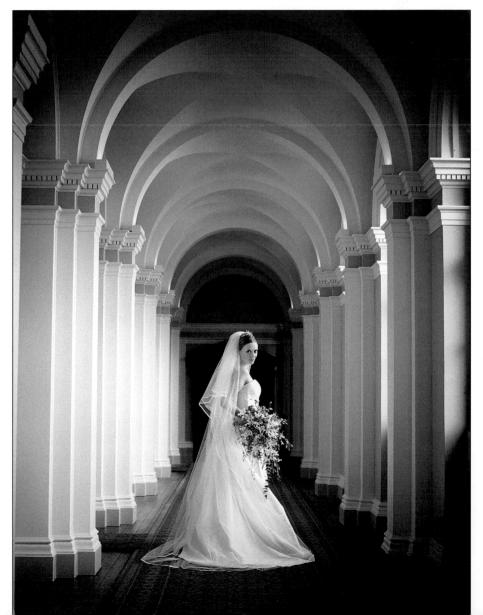

Preparation and Planning

Preparation is critical when photographing a once-in-a-lifetime event that is as complicated as a wedding. With lots of people, places, and events to document, getting all the details and formulating a plan before the wedding will help ensure you're ready to capture every moment.

■ PRE-WEDDING PREPARATIONS

Arrange a meeting with the couple at least one month before the wedding. Use this time to take notes, formulate detailed plans, and get to know the couple in a relaxed setting. This will be time well spent and allows you a month after the meeting to check out the locations, introduce yourself to the people at the various venues (including the minister, priest, or rabbi), and go back to the couple if there are any problems or if you have questions. This initial meeting also gives the bride and groom a chance to ask any questions of you that they may have.

Tell the couple what you plan to photograph and show them examples. Ask if they have any special requests or special guests who may be coming from far away. Avoid creating a list of required photographs, as it may not be possible to adhere to one. Make a note of the names of the parents and also of all the bridesmaids, groomsmen, the best man, and maid of honor so that you can address each by name. Also make notes on the color scheme, the supplier of the flowers, the caterer, the band, and so on. You should contact all of these people in advance, just to touch base. You may find out interesting details that will affect your timetable or how you make certain photos.

At many religious ceremonies, you can move about and even use flash—but it should really be avoided in favor of a more discreet, available-light

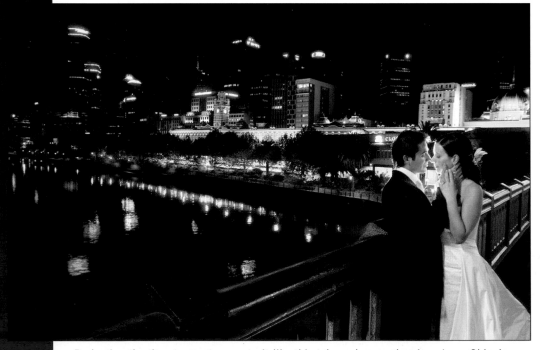

Budgeting the time to create a portrait like this takes advance planning. Jerry Ghionis created this image with a ½-second exposure, two flash exposures (one frontal and one behind the couple), and a 17mm lens at f/4.

TOP LEFT—This shot of the bride putting on her stockings was preconceived by the photographer, who arranged sufficient time to photograph the bride as she was getting ready. Parker Pfister created this image with a D1X and 85mm f/1.4 lens at ¹/₉₀ second at f/2.2. **TOP RIGHT**—Part of your post-production thinking could be to prepare a montage of prints like this one created by Joe Photo. It is the same image printed in varying intensities of green and brown. **RIGHT**—Shots made while the bride and her bridesmaids are getting ready should be arranged well in advance. If you are planning to get to the bride's house only an hour before the wedding, it may not be enough time. Photograph by Ron Capobianco.

approach. Besides, available light will provide a more intimate feeling to the images. At some churches you may only be able to take photographs from the back, in others you may be offered the chance to go into a gallery or the balcony. You should also be prepared for the possibility that you may not be able to make pictures at all during the ceremony.

Armed with information from the briefing meeting, you need to visit the couple's wedding venues if you have not been there before. Try to visit at the same times of day as the wedding and reception, so that you can check lighting, make notes of special locations, and catalog any potential problems. Also, you should make note of the walls and types of ceilings, particularly at the reception.

This will affect your ability to use bounce flash. It is useful to produce an "A" list and a "B" list of locations. On the "A" list, note the best possible spots for your images; on the "B" list, select alternate locations in case your "A" locations don't work out on the wedding day.

■ **CREATING A MASTER SCHEDULE**
Planning your schedule is essential to smooth sailing on the wedding day. The couple should know that if there are delays, adjustments or deletions will have to be made to the requested pictures. Good planning and an understanding of exactly what the bride and groom want will help prevent any problems.

You should know how long it takes for you to drive from the

bride's home to the ceremony. Inform the bride that you will arrive at least a 45 minutes to an hour before she leaves. You should arrive at church at about the same time as or a little before the groom, who should arrive about a half-hour before the ceremony. At that time you can make portraits of the groom and his groomsmen and his best man. Bridesmaids will arrive at about the same time. You need to determine approximately how long the ceremony will last. One formula is to plan to spend up to twenty minutes on groups at the church, and about the same amount of time on portraits of the couple at the reception.

If the ceremony is to take place at a church or synagogue where you do not know the customs, make sure

LEFT—In his wedding coverage, David Beckstead always takes time to get some overheads of the bride and groom. Here he stole a moment of the bride and groom dancing all by themselves. **RIGHT**—Regardless of how tight the schedule is on wedding day you must always be prepared for moments like these. Photograph by Erika Burgin.

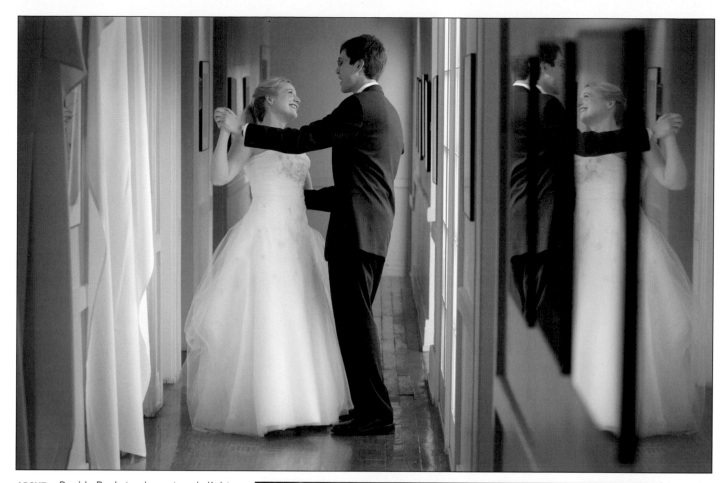

ABOVE—David Beckstead captured lightning in a bottle as the bride and groom take a moment to dance alone. RIGHT—When venues are special or unusual, it's a good idea to get a few shots for album pages or simply to supply to vendors later. Here, on site for a Charles Maring wedding, Jennifer Maring took the time to create a wonderful image of the boat house/reception hall. The image was made with a tripod-mounted Nikon D1X and a 17mm lens. The image was exposed for $\frac{1}{10}$ second at f/2.8.

you visit the minister beforehand. If you are unfamiliar with the customs, ask to attend another wedding as an observer. Such experiences will give you invaluable insight into how you will photograph the wedding.

■ YOU AND THE TEAM

As the photographer, you are part of the group of wedding specialists who will ensure that the bride and groom have a great day. Be friendly and helpful to all of the people on the team—the minister, the limo driver, the wedding coordinator, the banquet manager, the band members, the florist, and other vendors involved in the wedding. They are great sources of referrals. Get the addresses of their companies so that you can send them a print of their specialty after the wedding.

■ ASSISTANTS

An assistant is invaluable at the wedding. He or she can run interference

Working with assistants frees you up to be able to make imaginative shots like this one. If you know that the bride and groom arriving at the reception is a shot you have covered, you can go up on the roof, Like Marcus Bell did, and create a wonderful graphic image involving the amazing antique cars used for the wedding.

for you, change or download CF cards, organize guests for a group shot, help you by taking flash readings and predetermining exposure, tape light stands and cords securely with duct tape, and tackle a thousand other chores. Your assistant can survey your backgrounds looking for unwanted elements—even become a moveable light stand by holding your secondary flash or reflectors.

An assistant must be trained in your posing and lighting. The wedding day is not the time to find out

that the assistant either doesn't understand or, worse yet, *approve* of your techniques. You should both be on the same page—and a good assistant will even be able to anticipate your next need and keep you on track for upcoming shots.

Most assistants go on to become full-fledged wedding photographers. After you've developed confidence in an assistant, he or she can help with the photography, particularly at the reception, when there are too many things going on at once for

one person to cover. Most assistants try to work for several different wedding photographers to broaden their experience. It's not a bad idea to employ more than one assistant so that if you get a really big job you can use both of them—or if one is unavailable, you have a backup assistant.

Assistants also make good security guards. I have heard many stories of gear "disappearing" at weddings. An assistant is another set of eyes whose priority it should be to safeguard the equipment.

The following is a collection of tips and advice that come from accomplished wedding professionals. From helping brides into cars, to dealing with nerves and heightened emotions, to dealing with requests from guests, wedding photographers have seen it all—and figured out some very good solutions.

Helpful Tips

■ BIG GROUPS

You'll need help to persuade all the guests to pose for a photo. Make it sound fun—which it should be. The best man and ushers, as well as your assistant, can usually be persuaded to do the organizing. Have the guests put their drinks down before they enter the staging area. Try to coordinate the group so that everyone's face can be seen and the bride and groom are the center of interest. Tell the group that they need to be able to see you with both eyes to be seen in the photo. Look for a high vantagepoint, such as a balcony or second-story window, from which you can make the portrait. Or you can use the trusty stepladder, but be sure someone holds it steady—particularly if you're at the very top. Use a wide-angle lens and focus about a third of the way into the group, using a moderate taking aperture to keep everyone sharply focused.

■ THE BOUQUET

Make sure a large bouquet does not overpower your composition, particularly in your formal portrait of the bride. Make sure the bride looks comfort-

Big groups should be fun and not boring. Becker is great at shooting groups. This one was made with a 17mm rectilinear fisheye so you have very little distortion at the frame edges. Notice too that Becker did a good job of keeping hands connected to the right people. Only the kids, which is to be expected, present a hands problem. Notice that the image is split-toned—warm in the highlights, cool in the shadows.

able holding it. A small bouquet should be an important and colorful element in the composition. Give the bride some guidance as to how she should hold her bouquet for the best effect. It should be placed in front with her hands behind it, making sure it is held high enough to put a slight bend in her elbows to keep her arms slightly separated from her body.

■ THE BRIDE SHOULD BE CLOSEST

When you have a choice—and the photographer always has a choice—position the bride closest to the cam-era. This keeps the (usually) smaller bride in proper perspective and allows her dress to be better seen.

■ A CASE OF NERVES

The wedding day is usually a tense time. There is a surplus of emotion and people tend to wear those emotions on their sleeves. Your demeanor and professionalism should be a calming and reassuring presence, especially to the bride. Be calm and positive, be funny and lighthearted—and above all, don't force the situation. If you can see that demanding to make a picture is going to really upset people, have the will power to hold off until later. Remember that positive energy is contagious, and can usually save a sticky situation.

■ THE DRESS

In most cases, the bride will spend more money on her wedding dress and more time on her appearance than for any other occasion in her entire life. She will often look more beautiful than on any other day. The photographs you make will be a permanent record of how beautiful she looked on her wedding day. Do not ignore the back of the dress—dress designers incorporate as much style and elegance in the back of the dress as the front. Be sure to get the bridesmaids' gowns as well.

■ DRESS LIKE A GUEST

This is award-winning photographer Ken Sklute's advice. A suit or slacks and a sports jacket are fine for men; and for women, business attire works well—but remember that you have to lug equipment and move freely, so don't wear restrictive clothing. Many wedding photographers (both men and women) own a tux and wear it for every formal wedding.

TOP—You can never make too many images of the bride, especially ones including her veil or bouquet, which are timeless keepsakes of the day. Photograph by Charles Maring. **BOTTOM**—This wedding must have been an incredible affair. With a bed of white rose and gardenia pedals for the bride and groom to walk on, photographer Becker got down low with a 16mm lens to shoot a "worm's eye view" of the ceremony. Becker used the spot-metering mode of his D1X to minimize the effect that all of the whites might have had on the exposure metering.

ABOVE—When photographing weddings from different cultures it is important to find out as much as you can about the differences between Western weddings and faithfully record the subtleties. Claude Jodoin made this wonderful portrait of a joyful bride, being observant about all of the many details of her wedding dress. **TOP RIGHT**—Rarely will anyone spend as much money on a dress as brides do on a wedding gown. The sky is the limit on some of the designer dresses available. So it is important to capture a good number of shots that display the dress in all of its splendor. Timor Imely created an unusual portrait of the couple in which the bride seems to pause naturally in order to show off the dress. Imely used the beautiful rays of the sun to show the form and folds of the gown. **RIGHT**— By positioning the bride in front of the groom in formal portraits, you keep the size relationship consistent and use the opportunity to show off the wedding gown. Photograph by Jerry D.

■ **FLASH SYNC CHECK**

Check and recheck that your shutter speed is set to the desired setting for flash sync. This is particularly important with focal-plane shutters, because if you set a speed faster than your X-sync, you will get half-frame images—a true nightmare. It has happened to everyone who has ever shot a wedding, but it's certainly preventable with a little vigilance. Check the shutter speed every time you change film, lenses, or CF cards. If you're like most photographers, you'll check it more often—every couple of frames. Of course, if you're using a lens shutter camera, the flash syncs at every shutter speed, but it's

LEFT—A very popular shot is the wedding gown hanging on the bedroom door. Frank Cava warmed the color rendition by exposing the image by tungsten room light with the camera set to a daylight white balance setting. **RIGHT**—The bouquet should be the subject of at least one series of photographs you make on wedding day. Here, Tibor Imely wanted to show the similarity between the bouquet, which features white roses, and the white brocade roses in the wedding gown. The photograph is almost a still life. It is an award winner entitled, *Simple Beauty*.

still a good idea to make sure the shutter speed dial is where you set it.

■ GETTING THE BRIDE INTO A CAR

This tip is from Monte Zucker, who says, "I learned a long time ago how to help the bride sit in a car without wrinkling her gown. I have her lift up the back of her gown and put it around her shoulders. This forms a sort of cape. It also picks up the back of the gown, so that when the bride sits down she's not sitting on her dress and wrinkling it. Here's the final trick. She has to back into the car. Now, even if she were to pick up some dirt as she enters, it would be on the underside and never show."

■ FLOWERS

While waiting around to go upstairs to photograph the bride getting ready, don't just stare out a window. Arrange for the flowers to be delivered early and use the time to set up an attractive still life for the album while you wait.

■ HANDS-FREE

Hands are troublesome, especially with groups. They usually don't add up—there seem to be more or less hands than people. If they are particularly poorly arranged, you can't tell whose hands belong to whom. Hide as many hands as possible. Whether in a group or photographed individ-

ually, men should generally put their hands in their pockets. A variation of this is to have them put a hand in a pocket, but hitch their thumb over the outside of the pocket. Preventing the hand from going all the way into the pocket puts a space between the elbow and the torso. This creates a flattering line and helps to prevent your subject(s) from looking overly "thick." With women, try to hide their hands in their laps or behind other people in the group.

■ LATE BRIDES

If the bride is late (as brides usually are), do not hold things up further. Simply make a series of photojour-

nalistic images of her arrival and plan to make the previously arranged shots later in the day.

■ INVEST THE TIME

Most successful wedding photographers get to know the couple and their families before the wedding, so that everyone is accustomed to him or her and knows what to expect. This can involve an engagement portrait in which the photographer and couple actually work together, a handwritten note, or even a phone call. Alisha and Brook Todd successful wedding photojournalists in the San Francisco area, send out a bottle of Dom Perignon and a handwritten note the day after the contract goes out, then follow it up with monthly phone calls to check in. The more familiar the couple is with the photographer, the better the pictures will be come the wedding day!

■ THE KISS

Whether you set it up, which you may have to do, or wait for it to occur naturally, be sure to get the bride and groom kissing at least once. These are favorite shots and you will find many uses for them in the album. For the best results, get a

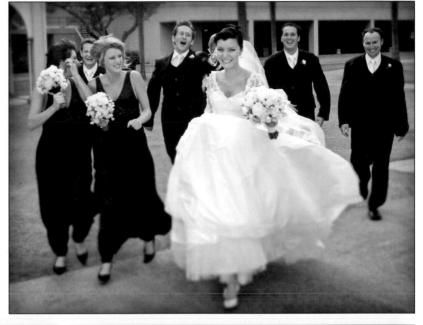

RIGHT—The bridal party will present numerous opportunities for great pictures, particularly if you forego the formal group approach and opt for something a little more trendy. Here, Marcus Bell used selective focus in Photoshop, not unlike what a view camera would do, to soften the feet. It is like the group is floating on air. **BOTTOM LEFT**—This tile atrium became a dance floor for Jeff and Kathleen Hawkins' bride and groom. The image was made with a Nikon D1X and 28mm lens at an exposure of 1/500 second at f/13. **BOTTOM RIGHT**—Charles Maring is a master at photographing the decorations on the wedding day. He realizes that not only will the bride and groom want a print, but so will the florist, the caterer, and the hotel/country club that hosted the wedding. He employs a tripod, available light, and bounce flash to shoot these. His post-production treatment involves burning in napkins and place settings so that the preparations look perfect.

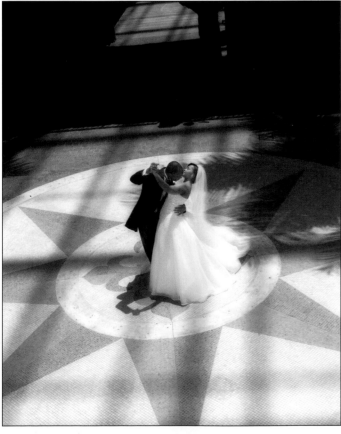

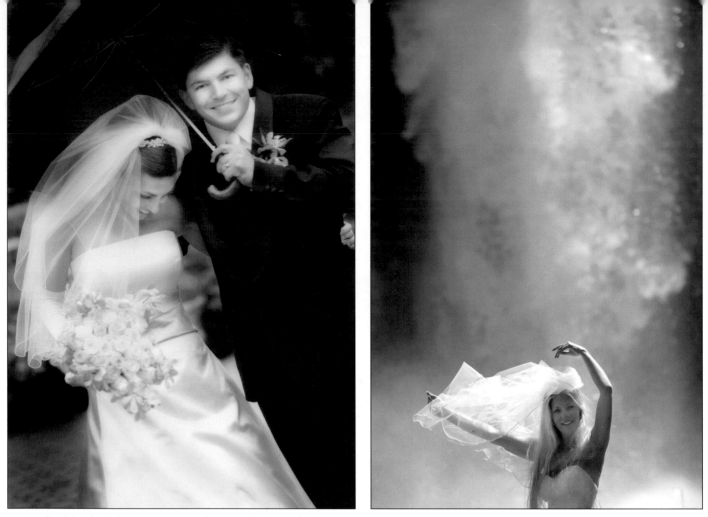

LEFT—Studying bridal magazines can show you how your brides want you to photograph their wedding. This shot by Charles Maring deftly shows off the gown but still captures the fun and fantasy of the day. RIGHT—The veil is an integral part of the wedding ensemble. David Beckstead highlighted it by backlighting the bride against a waterfall. The result is a very unusual but effective bridal portrait.

good vantagepoint and make sure you adjust your camera angle so neither person obscures the other.

■ LIGHTBULBS
Many hotels use coiled fluorescent bulbs instead of tungsten-filament bulbs in the room lamps. Be on the lookout for them because these fluorescents will not have the same warming quality as tungsten bulbs and could turn things a bit green.

■ REMEMBERING NAMES
Photographer Frank Frost believes that you should master the names of your clients. Photography is not just about the work, it also involves people skills. He says, "There can be twenty people in the wedding party and I'm able to call everybody by name. It makes a big impression and, by the end of the evening, everybody is my friend."

■ SEATED MEN
Whenever a man is seated it's a good idea to check his clothes. He should have his jacket unbuttoned to prevent it from looking tight. If wearing a tux with tails, he should also avoid sitting on the them as this will also alter the shape of the coat. If he has shirt cuffs, they should be pulled down to be visible. And if sitting cross-legged, make sure his socks are pulled up high enough so that you don't see any bare leg.

■ SPEEDING UP YOUR GROUPS
One solution for making your formal groups is to make them at the church door as the couple and bridal party emerge. Everyone in the wedding party is present and the parents are nearby. If you don't have a lot of time to make these groups, this is a great way to get them all at once—in under five minutes.

■ STUDY WEDDING MAGAZINES
Top wedding photographers constantly review the editorial photography found in both national and regional bridal magazines. Every bride looks at these magazines, dreaming that her wedding will look just like what she sees in them. Styles, tech-

niques, new trends, and "coolest" poses are all there for you to review.

Good source of poses for men are the gentlemen's magazines, like *GQ* or *Esquire*. The range of poses runs from intellectual to macho and you'll pick up some good ideas, particularly for the groom's portrait and the groom and groomsmen group.

■ THE TRAIN

Formal wedding dresses often include flowing trains. It is important to get several full-length portraits of the full train, draped out in front in a circular fashion or flowing behind. Include all of the train, as these may be the only photographs of her full wedding gown. If making a formal group, this might also be an appropriate time to reveal the full train pulled to the front. One way to make the train look natural is to pick it up and let it gently fall to the ground.

■ THE VEIL

Make sure to get some close-ups of the bride through her veil. It acts like a diffuser and produces romantic, beautiful results. Lighting should be from the side rather than head-on to avoid shadows on the bride's face caused by the patterned mesh.

Monte Zucker often uses the veil as a compositional element in portraits. To do this, lightly stretch the veil so that the corners slant down

Believe it or not, the bride and groom rarely kiss on their wedding day, yet this shot remains one of the most popular among brides. The simple reason is that they are too busy to smooch. David Beckstead always makes sure he gets plenty of these types of images because they always sell and because he believes in capturing a romantic rendition of the day's events.

toward the lower corners of the portrait, forming a loose triangle that leads the viewer's eyes up to the bride's eyes.

■ GUEST PICTURES

Guests often approach the wedding photographer to have pictures made of themselves. These images rarely produce sales and can take the photographer's attention away from the paying clients: the bride and groom. This tip for dealing with such situations is from Monte Zucker. "What I do is to discuss this with the bride

and groom prior to the wedding," he says. "I explain to them that it happens all the time, but I'd usually get stuck with the pictures afterwards, because the guest would never see it to place their order. What I finally began doing is to either make the bride and groom responsible for paying for "special-request" pictures, or I'd make financial arrangements directly with the guests before I would take the picture. Usually, they'd select the latter option."

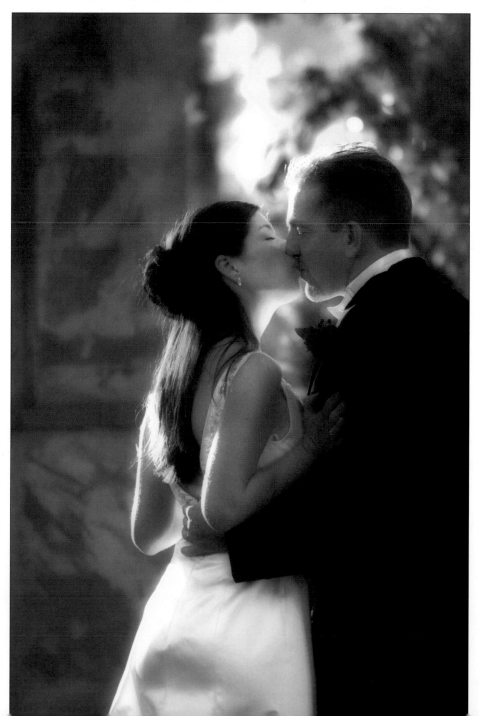

Proofing and Sales

There are many forms of proofing in use today. Regardless of the mode of presentation, though, editing is essential. Present only those proofs from the wedding that are good, high quality images. Concise editing will guarantee that the couple will be delighted with how great the pictures are. Because you're the pro, the couple will look to you for advice on those difficult picture decisions. Because you know the difference between a good pose and bad, good lighting and bad and so on, your opinion will be important to them.

■ PROOFS

Paper Proofs. Paper proofs have been the preferred method for reviewing a client's work—at least until recently. With paper proofs, you are offering a representation of the final image to the customer, but without the benefits of color correction, retouching, and print finishing. Paper proofs not only fail to reflect the quality of the final image, they are a liability in an age when everyone seems to own a scanner.

 Slides. Instead of showing paper proofs, award-winning photographer Frank Frost uses a proofless system for ordering. He tells couples that he'll

LEFT—Well handled groups, including the bride and groom and the parents, are big sellers; especially when they are handled with style and creativity as was done here. All parties will want a copy of the print and it will most likely lay the foundation for a second and third album for the parents of the bride and groom. Photograph by Melanie Nashan. **RIGHT**—It's hard to imagine the bride and groom not ordering this wonderful shot of their little flower girl with her front tooth coming in. Photograph by David Beckstead.

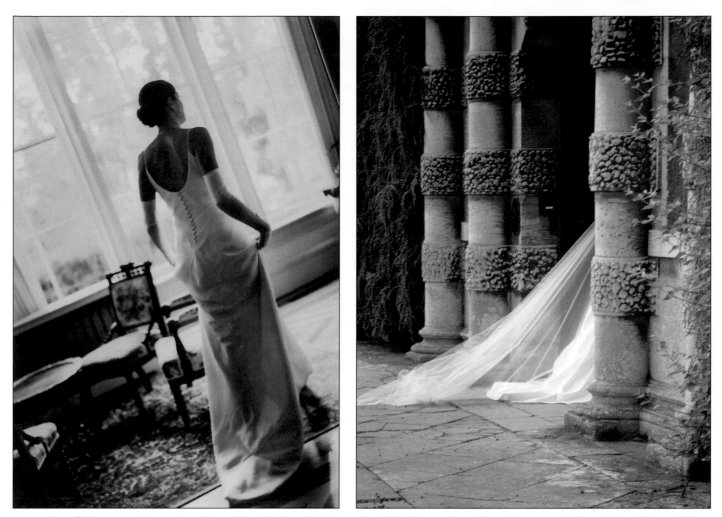

LEFT—One of the reasons to create an image like this is so that it can be sold to the couple as fine art—over and above their print and album purchases. An image like this could hang in the couple's new home or in either parent's home. Photograph by Becky Burgin. **RIGHT**—When putting images together for the wedding album, the photographer usually looks for the unusual wedding photo—one that is uncharacteristic and has impact. Such is the photo shown here by Amy Cantrell. The image was recorded with a Nikon D100 and a 70mm zoom lens setting at $\frac{1}{180}$ at f/14. A small aperture was selected to keep the pillars in sharp focus, framing the train.

call them four weeks after the wedding to schedule an appointment to come into the studio, view the wedding pictures, and place their order. In the meantime, he makes slides from the film negatives and hires a caterer to bring in a tray of food and sparkling apple cider.

Everybody sits down together to enjoy the slide show. Couples bring their parents and everybody orders on the spot. Usually, this presentation lasts about 2½ hours. Frost likes to tell the story of the wedding using a variety of sizes and poses. As he

walks them through the presentation he gently guides them toward the combinations that look best and provides advice on page layout. There is no high-pressure approach, he merely offers opinions and suggestions. Clients are always free to make their own choices.

Multimedia. Some photographers take it a step further, producing a multimedia show of the wedding proofs. Brian and Judith Shindle have a very low-pressure, understated sales technique. After the wedding, the Shindles put on an ele-

gant multimedia "premier night" party with catered food and fresh flowers and they invite guests from the wedding party. The event is held in the studio's elaborately decorated viewing room. This elegant event produces great sales success, because it doesn't resemble a sales session at all.

Other photographers use commercial software, such as the Montage® system, which produces projected images in a "suggested" album. First the album images are digitized and then brought into tem-

plates of any configuration, much like a page-layout program. The images are projected onto a large LCD screen already conceived as an album. Most couples, when they see the finished presentation, will want to buy the album with only minimal changes.

Digital Proofs. Charles Maring accepts the fact that clients copying proofs is a reality. Maring has his digital images printed by the family-owned lab, Rlab. Each 2.5 x3.5-inch photograph is numbered with the file number at the bottom right corner of the print. According to Maring, one might copy a wallet-size print, but it would be a hassle to cut out the image from the proof book. These contacts come bound in book form with matte board for the covers and the whole concept costs only $.25 per image. This system takes very little time. Instead of spending hours putting proofs in a proof album, the proofs come back deliverable and bound, book-style.

Maring then designs and prints a suggested wall portrait for the cover of the book. When they offered this concept to their couples instead of proofs, every couple preferred the smaller digital prints. No one wants to carry around a thousand full-size proofs in two full-size albums—and no photographer wants to pay for

LEFT—This image exemplifies why the successful wedding photographer is so handsomely rewarded—he or she must be an expert at many different photographic disciplines. Joe Photo makes sure to capture the place settings and table settings before the guests enter the reception area. He does this partially so he can reward the various vendors (who also help him network with other brides) with a print, but also so he can add depth and uniqueness to his albums. This lavish exposure was made with a tripod-mounted D1X and 28mm lens. The image was exposed for ¹/₆ second at f/4.5 to fully open up the shadows and record detail throughout the image. The "correct" color of the foreground table is achieved by firing a bounce flash during the long time exposure. RIGHT—Believe it or not, very few truly romantic images are made of the bride and groom on their wedding day. The reason is that the bride, groom and photographer are usually so busy that not a lot of spontaneous images are made. This image by Natasha Staszak is a definite keeper for the bride and groom.

full-size proofs or proof albums, then spend hours on end organizing the images.

Other Options. In addition to the proofing methods that were outlined above, there are also two others worth mentioning. Video proofing is inexpensive and simple. It involves using a VCR, a slide show program (offered in many browser programs), and a television monitor. A video card is needed to send your images to the VCR.

Digital projection involves a LCD projector and slide show treatment or DVD of the proofs, which is then given to the clients to take home after viewing the show. Both of the above methods involve scheduling an appointment for the bride and groom to view the proofs. Once the images have been viewed, many photographers send their clients away with a digital proof book. Using your digital files, you can print contact sheets of the images (that include the file name and number). These can be placed in a small but nice proof album for the couple to take with them.

■ PRINTING

Many photographers have the equipment and staff to print their own wedding images in house. It gives them a level of control over the process that even the best lab cannot provide.

Other photographers have devised interesting ways to save money by employing the lab's wide-format printers. David Anthony Williams, for example, uses a lab called The Edge, in Melbourne, Australia. The Edge uses a Durst Lamda Digital Laser Imager, which produces full continuous-tone images straight from Macintosh or PC files on photographic media. Williams prepares Photoshop files of finished album pages, panoramas, small prints and proofs on a 32-inch-wide file (the width of the lab's Lamda), utilizing every square inch of space. The 32 x 32-inch, 32 x 50-inch, or 32 x 70-inch files are output at one time very inexpensively. The lab even trims all of the images for Williams, thus increasing his productivity and lowering his costs.

David follows the guidelines of the lab and works in the Adobe RGB (1998) color space at the gamma recommended for either PCs or Macs. The files may be TIFFS or JPEGs at 200 or 400dpi. The Edge will even provide a calibration kit on request to better coordinate your color space to that of the lab's.

This is an example of a 32x70-inch print made by David Williams' lab, the Edge. Note how there isn't a square inch of wasted space. The print is made on a Durst Lamda at 400dpi, to deliver the best photographic quality.

The Key Shots

At every wedding, there are some key events that the bride and groom will expect to see documented in their images. Including these is important for creating an album that tells the whole story of the couple's special day. The following are a few tips on what to shoot and some ideas for making the most of each moment as it happens.

■ ENGAGEMENT PORTRAIT

The engagement portrait is usually made prior to the wedding, providing the time to get something spectacular. Many photographers use this session as an opportunity to get to know the couple and to allow the couple to get to know them. Engagement portraits may involve great creativity and intimacy and are often made in the photographer's studio or at some special location.

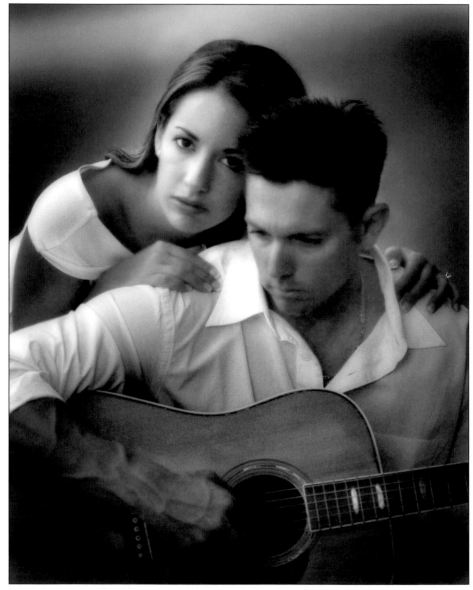

This is a very stylized version of an engagement portrait made by Jeff Hawkins Photography. The image was made with a Canon EOS 1DS and 200mm lens at an exposure of ¹/₈₀₀₀ second at f/2.5. The wide aperture blows out the background details and the image was selectively burned-in and dodged in Photoshop.

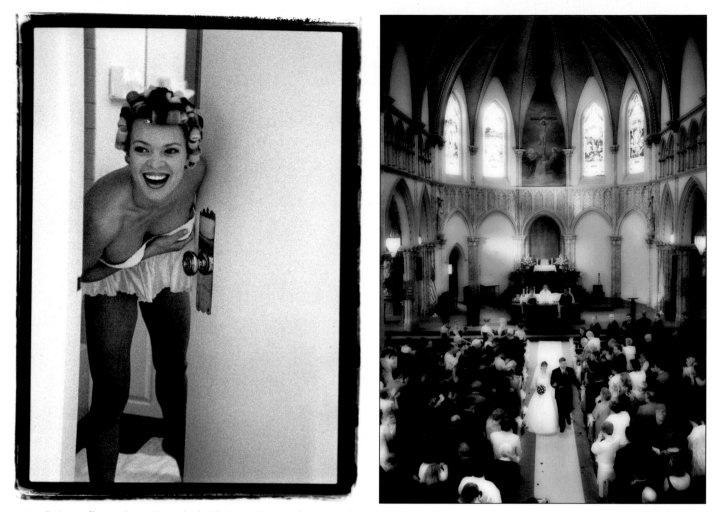

LEFT—Being a fly on the wall as the bride is getting ready can lead to great shots. Photograph by Ron Capobianco. **RIGHT**—Working as a pair or trio of photographers allows one of you to get up in the choir loft for an incredible shot like this. Photograph by Charles Maring.

■ AT THE BRIDE'S HOUSE

Typically, weddings begin with the bride getting ready. Find out what time you may arrive and be there a little early. You may have to wait a bit, as there are a million details to attend to, but you might find ample opportunity for still lifes or family shots. When you get the okay to go up to the bedrooms, realize that it may be tense in there. Try to blend in and observe. Shots will present themselves, particularly with mother and daughter or the bridesmaids.

■ BEFORE THE WEDDING

You do, of course, want to photograph the groom before the wed-

ding. Some grooms are nervous, while others are gregarious—like it's any other day. Regardless, there are ample picture opportunities before anyone else arrives. It's also a great opportunity to do formal portraits of the groom, the groom and his dad, and the groom and his best man. A three-quarter-length portrait is a good choice—and you can include the architecture of the church or building if you want.

When photographing men, always check that the ties are properly knotted. If they are wearing vests, make sure that they are correctly buttoned and that the bottom button is undone.

■ THE CEREMONY

Regardless of whether you're a wedding photojournalist or a traditionalist, you must be discrete during the ceremony. Nobody wants to hear the "ca-chunk" of a medium format camera or see a blinding flash as the couple exchange their vows. It's better by far to work from a distance with a tripod-mounted 35mm camera with the motor off (or in quiet mode, if the camera has one), and to work by available light. Work quietly and unobserved—in short, be invisible. (Of course, it should be noted that recent SLRS—especially DSLRS—are much quieter than past cameras.)

Some of the events you will need to cover are: the bridesmaids and flower girls entering the church; the bride entering the church; the parents being escorted in; the bride's dad "giving her away;" the first time the bride and groom meet at the altar; the minister or priest talking with them; the ring exchange; the exchange of vows; the kiss; the bride and groom turning to face the assembly; the bride and groom coming up the aisle; and any number of two dozen variations—plus all the surprises along the way. Note that this scenario applies only to a Christian wedding. Every religion has its own customs and traditions that you need to be thoroughly familiar with before the wedding.

Some churches don't allow any photography during the ceremony. You will, of course, know this if you've taken the time to visit the church prior to the wedding.

Regardless of your style of coverage, family groups are pictures that will be desired by all. You must find time to make the requisite group shots, but also be aware of shots that the bride may not have requested, but expects to see. The bride with her new parents and the groom with his are great shots, according to Monte Zucker, but are not ones that will necessarily be "on the list."

■ FORMALS

Following the ceremony, you should be able to steal the bride and groom

for a brief time. Limit yourself to ten minutes, or you will be taking too much of their time and the others in attendance will get a little edgy. Most photographers will get what they need in under ten minutes.

In addition to a number of formal portraits of the couple—their first pictures as man and wife—you should try to make whatever obligatory group shots the bride has asked for. This may include a group portrait of the wedding party, a portrait with the bride's family and the groom's family, and so on.

If there are too many "must" shots to do in a short time, arrange to do some after the ceremony and some at the reception. This can be all thought out beforehand.

LEFT—Marcus Bell waited for the bride and groom to exit the altar of this massive church and the three flower girls provided the perfect foreground element. He had to wait throughout most of the ceremony to get this shot. Marcus used a tungsten white balance setting and photographed the scene with an EOS 1DS and 35mm f/1.4 lens. RIGHT—Getting a good vantagepoint is as important to the wedding photographer as it is to the sports photographer. Here, Charles Maring used a 35mm lens to photograph the bride being escorted down the aisle by her father. To place emphasis more on the bride, he photographed the scene at $^1/_{2000}$ second at f/2.8, so the father would be slightly soft.

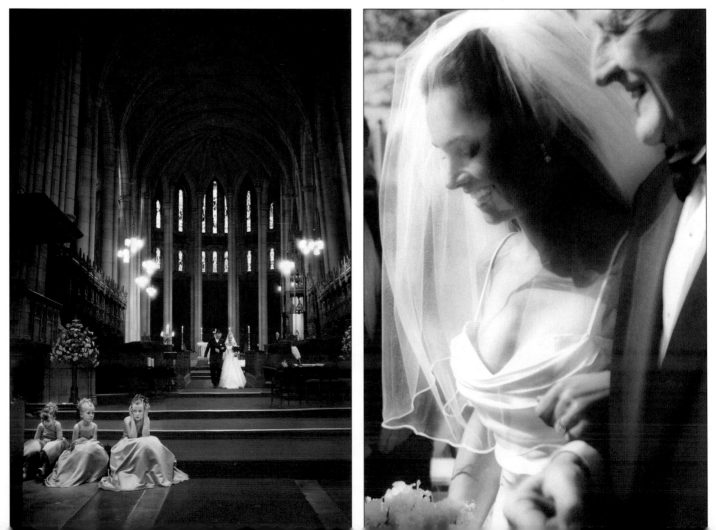

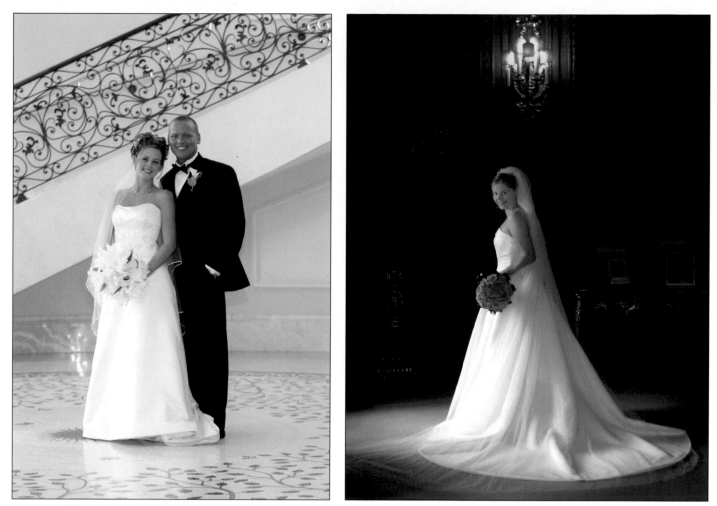

LEFT—Joe Photo always makes sure to photograph a simple portrait in a pleasant location. It isn't what he's known for, but he knows these portraits are used in a number of ways. **RIGHT**—David Worthington is the master of the formal bridal portrait. This image was made with window light and a small reflector with a Fuji FinePix S2 Pro and 37mm lens setting at ISO 200 at $1/45$ second at f/3.3. The room lights add low-key accents throughout the background.

■ THE BRIDE AND GROOM

Generally speaking, this should be a romantic pose, with the couple looking at one another. While a formal pose or two is advisable, most couples will opt for the more romantic and emotional formal portraits. Be sure to highlight the dress, as it is a crucial element to formal portraits. Take pains to show the form as well as the details of the dress and train, if the dress has one. This is certainly true for the bride's formal portrait, as well.

Make at least two formal portraits, a full-length shot and a three-quarter-length portrait. Details are important, so pose the couple. Make sure the bouquet is visible and have the bride closest to the camera. Have the groom place his arm around his bride but with his hand in the middle of her back. Have them lean in toward each other, with their weight on their back feet and a slight bend to their forward knees. Quick and easy!

■ THE BRIDE

To display the dress beautifully, the bride must stand well. Although you may only be taking a three-quarter-length or head-and-shoulders portrait, start the pose at the feet. When you arrange the bride's feet with one foot forward of the other, the shoulders will naturally be at their most flattering, one higher than the other. Have her stand at an angle to the lens, with her weight on her back foot and her front knee slightly bent. The most feminine position for her head is to have it turned and tilted toward the higher shoulder. This places the entire body in an attractive S-curve, a classic bridal pose.

Have the bride hold her bouquet in the hand on the same side of her body as the foot that is extended. If the bouquet is held in the left hand, the right arm should come in

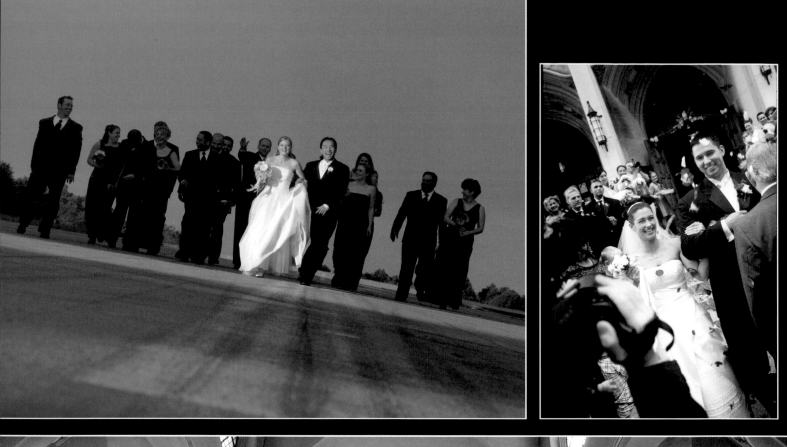
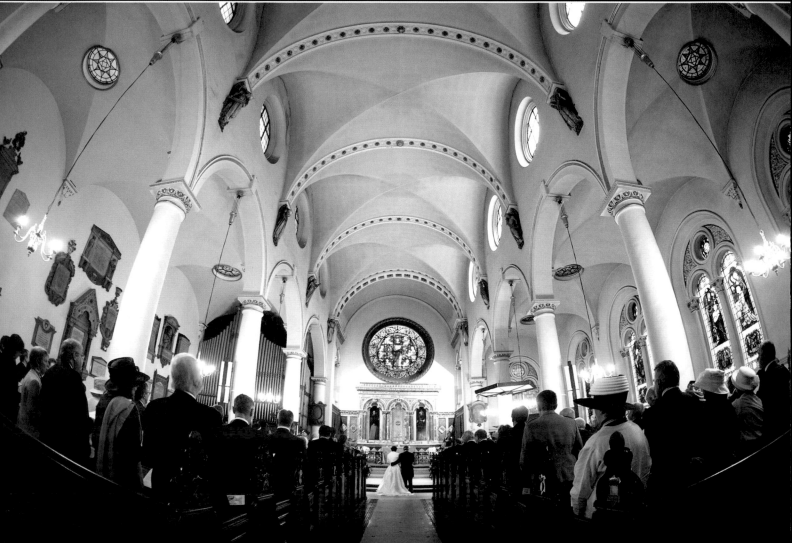

to meet the other at wrist level. She should hold her bouquet a bit below waist level to show off the waistline of the dress, which is an important part of the dress design.

Take plenty of photographs of the bride to show the dress from all angles.

■ THE WEDDING PARTY

This is one formal group that does not *have* to be formal. I have seen group portraits of the wedding party done as a panoramic, with the bride, groom, bridesmaids, and grooms-men doing a conga line down the beach, dresses held high out of the water and the men's pant legs rolled up. And I have seen elegant, formal pyramid arrangements, where every bouquet and every pose is identical and beautiful. It all depends on your client and your tastes. It should be a portrait that you have fun doing. Most photographers opt for boy–girl arrangements, with the bride and groom somewhere central in the image. As with the bridal portrait, the bridesmaids should be in front of the groomsmen in order to highlight their dresses.

■ LEAVING THE CHURCH

Predetermine the composition and exposure and be ready and waiting as the couple exits the church. If guests are throwing confetti or rice, don't be afraid to choreograph the event in advance. You can alert guests to get

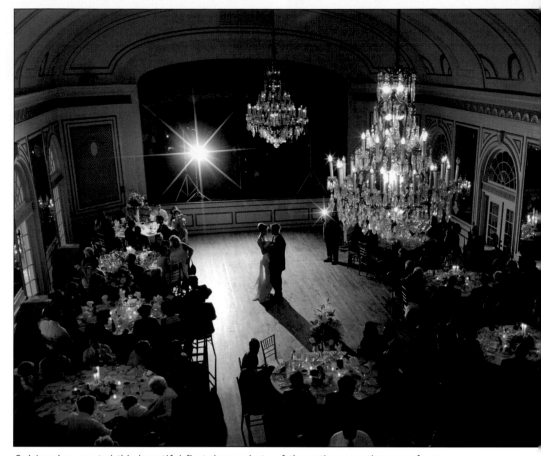

Cal Landau created this beautiful first-dance photo of the entire reception area from over-head. He used two flash units from behind to spotlight the couple and lowered his ambient-light exposure to $^1/_{25}$ second at f/5.0 to make the shot. He used a Canon EOS 10D with a 17mm lens.

ready and "release" on your count of three. Using a slow ($^1/_{30}$ second) shutter speed and flash, you will freeze the couple and the rice, but the moving objects will have a slightly blurred edge. If you'd rather just let the event happen, opt for a burst sequence using the camera's fastest frame rate—up to eight frames per second with high-end DSLRs— and a wide-angle-to-short-telephoto zoom. Be alert for the unexpected, and consider having a second shoot-

er cover events like this to better your odds of getting the key picture.

■ ROOM SETUP

Whenever possible, try to make a photograph of the reception site before the guests arrive. Photograph one table in the foreground and be sure to include the floral and lighting effects. Also, photograph a single place setting and a few other details. The bride will love them, and you'll find use for them in the album de-

FACING PAGE: TOP LEFT—In recent years, the wedding party group shots have become more fun and less formal. Cal Landau captured this scene by having the wedding party walk toward him on an abandoned airstrip. When the bride and groom reached the patch of sunlight, he fired the shutter, shooting at $^1/_{1000}$ second at f/8 at ISO 400 with a 117mm zoom-lens setting. The image was made with a Canon EOS 10D. **TOP RIGHT**—Parker Pfister got in close to the couple as they exited the church. With rose petals floating in the air and a very wide 20mm lens, Parker made the shot much like a newspaper photographer would, trying to capture a single frame that tells the whole story. **BOTTOM**— What couple would not be thrilled with this beautiful overview? Dennis Orchard made the image with a Canon EOS-1DS and 15mm lens at ISO 400 at an exposure of $^1/_{15}$ second at f/2.8. He used a custom white balance to blend the daylight and tungsten light sources.

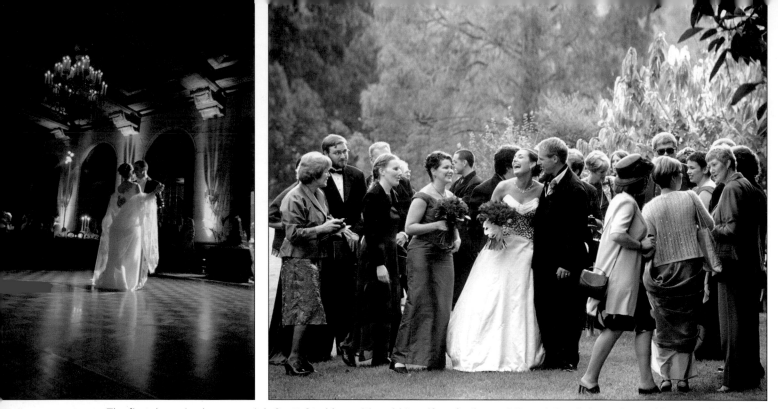

LEFT—The first dance is always special. Scott Streble positioned himself perfectly, used the existing light, and was able to get this incredible shot. **RIGHT**—Jerry Ghionis captured this spontaneous moment at an outdoor reception. Notice that everyone is involved in conversation and completely oblivious to the photographer.

sign. The caterers and other vendors will also appreciate a print that reflects their fine efforts. Some photographers try to include the bride and groom in the scene, which can be tricky. Their presence does, however, add to the shot. Before the guests enter the reception area, for instance, Ken Sklute often photographs the bride and groom dancing slowly in the background and it is a nice touch.

■ THE RECEPTION

This is the time when most of your photojournalistic coverage will be made—and the possibilities are endless. As the reception goes on and guests relax, the opportunities for great pictures will increase. Be aware of the bride and groom all the time, as they are the central players. Fast zooms and fast telephoto lenses paired with fast film or high ISO set-

tings will give you the best chance to work unobserved.

Be prepared for the scheduled events at the reception—the bouquet toss, removing the garter, the toasts, the first dance, and so on. If you have done your homework, you will know where and when each of these events will take place, and you will have prepared to light it and photograph it. Often, the reception is best lit with a number of corner-mounted umbrellas, triggered by your on-camera flash. That way, anything within the perimeter of your lights can be photographed by strobe. Be certain you meter various areas within your lighting perimeter so that you know what your exposure is everywhere on the floor.

The reception calls upon all of your skills and instincts. Things happen quickly, so don't get caught with an important event coming up and

only two frames left in the camera or with a CF card that's almost full. People are having a great time, so be cautious about intruding upon events. Try to observe the flow of the reception and anticipate the individual events before they happen. Coordinate your efforts with the person in charge, usually the wedding planner or banquet manager. He or she can run interference for you, as well as cue you when certain events are about to occur, often not letting the event begin until you are ready.

I have watched Joe Photo work a reception and it is an amazing sight. He often uses his Nikon D1X and flash in bounce mode and works quickly and quietly. His Nikon Speedlite is outfitted with a small forward-facing internal reflector that redirects some of the bounce flash directly onto his subject, making the

flash both key and fill light at once. If he is observed and noticed, he'll often walk over and show the principals the image on the LCD, offer some thoughtful compliment about how good they all look, and quickly move on. Other times he just shoots, observes, and shoots some more. His intensity and concentration at the reception are keen and he comes away with priceless images—the rewards of good work habits.

■ RINGS

The bride and groom usually love their new rings and want a shot that includes them. A close-up of the couple's hands displaying the rings makes a great detail image in the album. You can use any type of attractive pose, but remember that hands are difficult to pose. If you want a really close-up image of the rings, you will need a macro lens, and you will probably have to light the scene with flash—unless you make the shot outdoors or in good light.

■ THE CAKE CUTTING

One of the key shots at the reception is the cake cutting. Whenever Monte Zucker has to make that shot, he gets on the stepladder and gathers as many people as possible around the bride and groom—the more people

An outdoor reception with very little available light proved a challenge for capturing the bride and groom dancing. Parker Pfister wanted to record the twinkle lights in the background so he increased his ISO and lowered the exposure down to $\frac{1}{25}$ at f/4.5 with a 20mm lens on his D1X. Spotlights illuminated the couple from behind and no fill light was used to retain the romantic feeling of the photograph.

he can get into a group, the more the couple will like the photos.

■ THE FIRST DANCE

One trick you can use is to tell the couple beforehand, "Look at me and smile." That will keep you from having to circle the couple on the dance floor until you get both of them looking at you for the "first dance" shot. Or you can tell them, "Just look at each other and don't worry about me, I'll get the shot."

Often, photographers will photograph the first dance by whatever available light exists (often spot-

lights) on the dance floor. This is possible with fast lenses and fast ISOs. Just as frequently, the photographer will use bounce flash and a slow shutter speed to record the ambient light in the room and the surrounding faces watching the couple's first dance. The bounce flash will freeze the couple but there is often some blurring due to the slow shutter speed.

■ THE BOUQUET TOSS

This is one of the more memorable shots at any wedding reception. Whether you're a photojournalist or

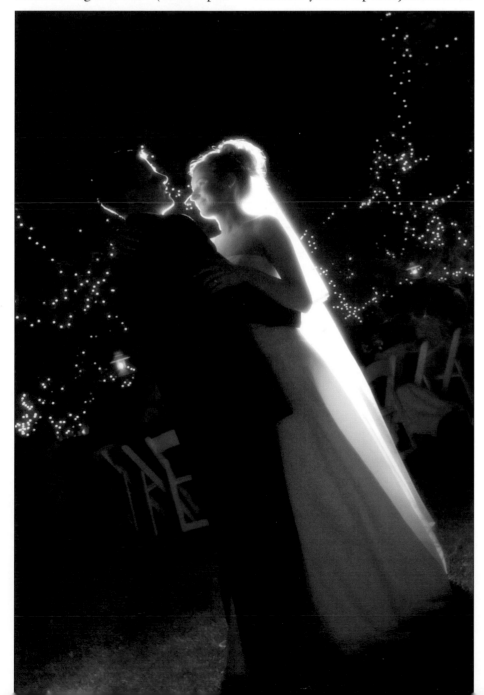

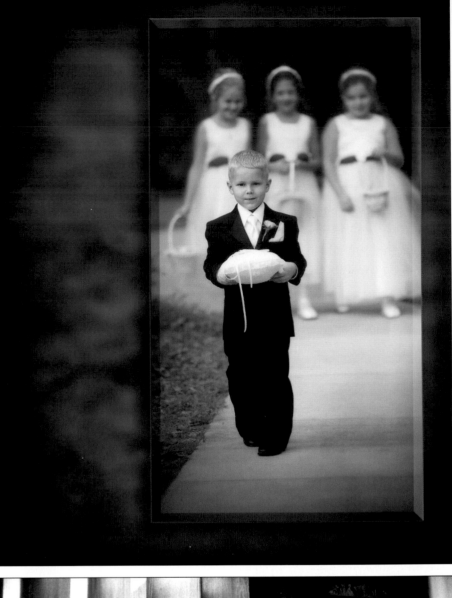

traditionalist, this shot looks best when it's spontaneous. You need plenty of depth of field, which almost dictates a wide-angle lens. You'll want to show not only the bride but also the expectant faces in the background. Although you can use available light, the shot is usually best done with two flashes—one on the bride and one on the ladies waiting for the bouquet. Your timing has to be excellent as the bride will often "fake out" the group, just for laughs. This might fake you out, as well. Try to get the bouquet as it leaves the bride's hands and before it is caught—and if your flash recycles fast enough, get a shot of the lucky lady who catches it.

■ TABLE SHOTS

Table shots don't usually turn out well, are rarely ordered, and are tedious to make. If your couple absolutely wants table shots, ask them to accompany you from table to table. That way they can greet all of their guests, and it will make the posing quick and painless. Instead of table shots, consider one big group that encompasses nearly everyone at the reception.

■ LITTLE ONES

A great photo opportunity comes from spending time with the small-

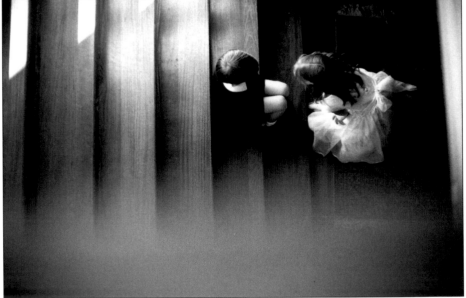

est attendees and attendants—the flower girls and ring bearers. They are thrilled with the pageantry of the wedding day and their involvement often offers a multitude of memorable shots.

The big payoff of the wedding day is the album. It's what every wedding photographer has worked so hard to produce and it is the object that the couple will cherish for a lifetime. The wedding album is changing drastically, as you will see. Still, album design is basically the same thing as laying out a book, and there are some basic design principles that should be followed.

Like any good story, a wedding album has a beginning, a middle and an end. For the most part, albums are layed out chronologically. However, there are now vast differences in the presentation, primarily caused by the digital page-layout process. Often, events are jumbled in favor of themes or other methods of organization. There must be a logic to the layout, though, and it should be apparent to everyone who examines the album.

The Changing Face of Wedding Albums

■ DESIGN ELEMENTS

Left- and Right-Hand Pages. Look at any well designed book or magazine and study the images on the left- and right-hand pages. They are decidedly different but have one thing in common. They lead the eye into the center of the book, commonly referred to as the "gutter." These layouts use the same design elements photographers use in creating effective images—lead-in lines, curves, shapes, and patterns. If a line or pattern forms a C shape, it is ideal for the left-hand page, since it draws the eye into the gutter and across to the right-hand page. If an image is a backwards C shape, it is ideal for the right-hand page. Familiar shapes like hooks or loops, triangles or circles are used in the same manner to guide the eye into the center of the two-page spread and across to the right-hand page.

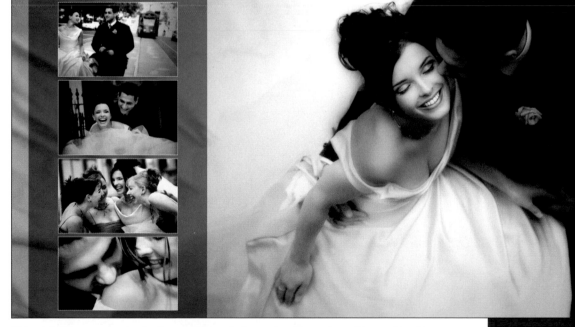

This stunning page by Australian wedding photographer Yervant combines a bleed image on the right with inset photos on the left. Yervant used the chiffon of the gown as a background for the insets. Notice how he used varying densities of the background to provide balance to the much larger image on the right.

There is infinite variety in laying out images, text, and graphic elements to create this left-to-right orientation. A series of photos can be stacked diagonally, forming a line that leads from the lower left-hand corner of the left page to the gutter. That pattern can be mimicked on the right-hand page, or it can be contrasted for variety. The idea is to create visual motion—the eye follows logically arranged lines and shapes from one point to the next across two pages.

Greater interest can be attained when a line or shape that is started on the left-hand page continues through the gutter, into the right-hand page and back again to the left-hand page. This is the height of visual movement in page design. Visual design should be playful and coax the eye to follow paths and signposts through the visuals on the pages.

Remember, in Western civilization we read from left to right. We start on the left page and finish on the right. Good page design starts the eye at the left and takes it to the right and it does so differently on every page.

Image Sizes. When you lay out your album images, think in terms of variety of size. Some images should be small, some big. Some should extend across the spread. Some, if you're daring, can even be hinged and extend outside (above or to the right or left) the bounds of the album. No matter how good the individual photographs are, the effect of an album in which all the images are the same size is monotony.

Variety. Variety can be introduced by combining black & white and color—even on the same pages. Try combining detail shots and wide-angle panoramas. How about a series of close-up portraits of the

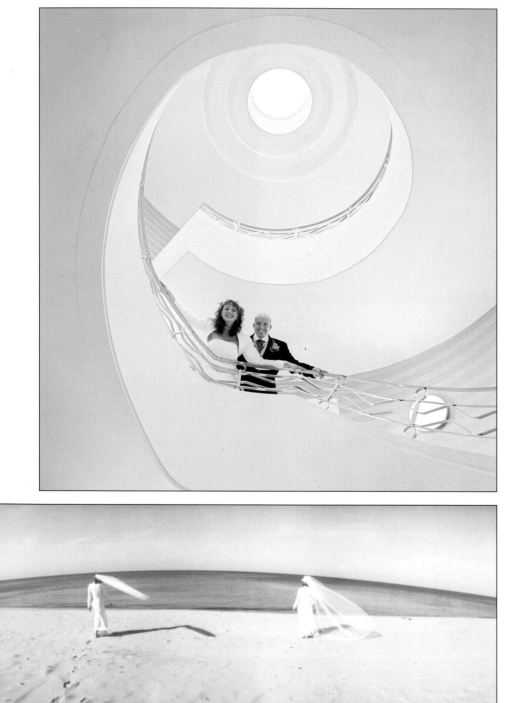

TOP—Learning to recognize shapes as page elements will make you a better designer. Here, a perfect C or inverted 9 shape makes this an ideal left-hand page. As a single image it has uniqueness and strong design, but in a layout, the eye will follow the spiral staircase through to the right-hand page. Photograph by David Worthington. BOTTOM—Photographers and album designers attempt to combine images that are unusual and create a form of visual gymnastics for the viewer. This image, while too wide for a double-truck (two-page spread), would make a beautiful top-half panoramic across the spread. Image made on a Widelux camera of two sisters at the beach. Photograph by Steven E. Gross.

TOP—Three simple images and a bold graphic set up the interplay of motion, tension, and balance. Notice how the small but bright red rose achieves visual prominence, but is balanced by the letter "G," which not coincidentally, has the same tilt as the rose. Diagonals, contrast verticals and vie for your eye's attention. Photographs and design by Yervant. **MIDDLE**—Sequences can be an effective means of telling a secondary story within the story of the wedding. This beautiful triptych was made by Becky Burgin. **BOTTOM**—Vladimir Bekker created this gatefold image of the wedding in a traditional album. The image is hinged on the back so that it bends on the fold.

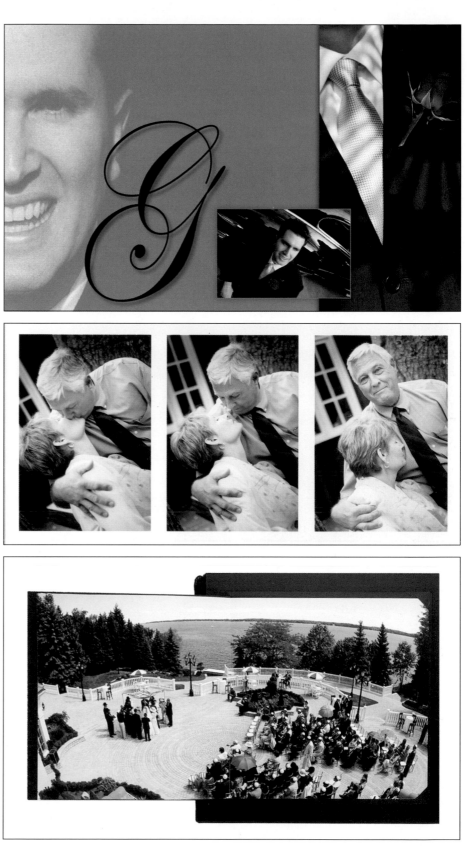

bride as she listens and reacts to the toasts on the left-hand page, and a right-hand page of the best man toasting the newlyweds? Don't settle for the one-picture-per-page theory. It's static and boring and, as a design concept, has outlived its usefulness.

Visual Weight. Learn as much as you can about the dynamics of page design. Think in terms of visual weight, not just size. Use symmetry and asymmetry, contrast and balance. Create visual tension by combining dissimilar elements (big and small, straight and diagonal, color and black & white). Try different things. The more experience you get in laying out the images for the album, the better you will get at presentation. Study the albums presented here and you will see great creativity and variety in how images are combined and the infinite variety of effects that may be created.

Tension and Balance. Just as real and implied lines and real and implied shapes are vital parts of an effective design, so are the "rules" that govern them—the concepts of tension and balance. Tension is a state of imbalance in an image—a big sky and a small subject, for example, is a situation with visual tension. Balance is where two items, which may be dissimilar in shape, create a harmony in the photograph because they are have more or less equal visual strength.

Gatefolds. One of the more interesting aspects of digital albums

is the gatefold, which is created using a panoramic size print on the right or left hand side, hinged so that it folds flat into the album. Sometimes the gatefold can be double-sided, revealing four page-size panels of images. The bindery can handle such pages quite easily but it provides a very impressive presentation, particularly if it is positioned in the center of the album.

Double-Trucks and Panoramic Pages. Regardless of which album type you use, the panoramic format can add great visual interest, particularly if using the bleed-mount digital or library-type albums (see page 115. Panoramics cannot be created as an afterthought, however, since the degree of required enlargement would be extreme. Panoramics must be planned and good camera technique is essential. If shooting a group as a panoramic, focus one-third of the way into the group for optimal depth of field and use a tripod to ensure the image is sharp. Make sure that you have enough depth of field to cover front to back in the group. If the bride and groom are the center of your panoramic shot, be sure to offset them so that they don't fall in the gutter of a panoramic or two-page spread.

■ **ALBUM TYPES**
Traditional Albums. Album companies offer a variety of different album-page configurations for placing horizontal or vertical images in tandem on a page, or combining any number of small images. Individual pages are post-mounted and the album can be as thick or thin as the number of pages.

Bound Albums. In a bound album, the images are permanently mounted to each page and the book is bound by a bookbinder. These are elegant and very popular. Since the photos are dry-mounted to each page, the individual pages can support any type of layout from "dou-

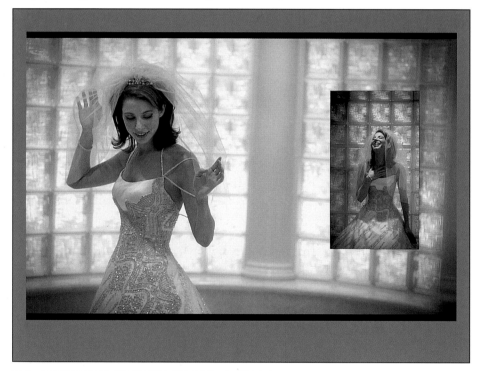

TOP—Jerry Ghionis uses a unique approach with his double-truck treatments. The pages are designed left and right to work as a spread, but Jerry uses a double border treatment on the page to create a certain unity throughout the album. **BOTTOM LEFT**—Magazine-style albums allow you to incorporate digitally designed composites on every page. Note: these pages are not bleed-mounted so that the pages can be handled more frequently without showing signs of wear. Photo courtesy of Albums Australia. **BOTTOM RIGHT**—The full-size wedding album next to the mini purse album. Both albums are by Jeff and Kathleen Hawkins.

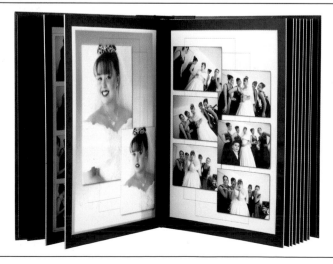

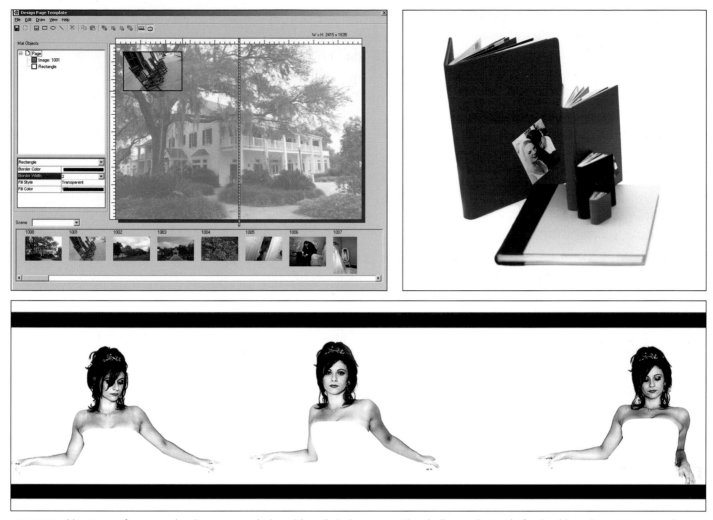

TOP LEFT—Montage software makes it a snap to design either digital or conventional albums. Instead of using hi-res images, you use "proxies" which are screen-resolution so that the design process still looks good on screen, but is fast to use. TOP RIGHT—Digital albums come in all sizes and bindings. Note the little "purse" albums, which go to work with the new bride instead of the priceless full-size album. Photo courtesy of Digicraft Albums. ABOVE—Martin Schembri is both a gifted photographer and designer; he even sells his own brand of album design templates. Here he took three images of his bride and composited them within a page for a graphically pleasing and powerful image.

ble-truck" (two bleed pages) layouts to a combination of any number of smaller images.

Library Binding. Yet another type of album uses conventional photographic prints made to the actual page size. These prints are then mounted, trimmed and bound in an elegant leather album that is actually a custom-made book. If you want to create album pages with multiple images, your lab must prepare these prints to size before submitting them to the album company for binding.

Mini Albums. Australian wedding photographer Martin Schembri creates what he calls a mini-magazine book, a miniature version of the main album that is small enough for brides to pop in their handbags to show all of their friends. Being so portable, the mini albums get far more exposure than a large, precious album. It also works as a great promotion for the photographer.

Digital Output. Digital output allows the photographer or album designer to create backgrounds, inset photos, and output the pages as complete entities. Sizing the photos does not depend on what size mats you have available, as you can size the photo infinitely on the computer. Once the page files are finalized, any number of pages can be output simply and inexpensively. Albums can be completely designed on the computer in programs like Adobe Photoshop using plug-ins that feature drag and drop templates.

■ **DESIGN TEMPLATES**

Photographer Martin Schembri has created a set of commercially avail-

able design templates that come on four different CDs and help photographers create elegant album-page layouts in Photoshop. The design templates are drag-and-drop tools that work in Photoshop and four different palettes are available: traditional, classic, elegant, and contemporary. The tools are cross-platform, meaning that they can be used for Macs or PCs, and are customizable so that you can create any size or type of album with them. More information can be found at www .martinschembri.com.au.

Yervant's Page Gallery software has 470 different templates. These incorporate artistic designs and layout options designed by Yervant, one of the most high-profile wedding and portrait photographers of Australia. All you have to do is choose an image file, then the software will crop, resize, and position the image into your choice of layout design . . . all within three minutes. Page Gallery is strictly for use by photographic studios who become registered and licensed users. It is not available to labs except by special licensing arrangement, meaning that if you purchase the software, you will be assured that every other wedding photographer on the block won't be putting out similar albums. More information can be found at www .yervant.com.

■ DETAILS

Contemporary wedding albums almost always feature many more images than a standard wedding album. These images are often combined, montage style, in an album or on a page to lend a sense of wealth and richness to the story. Image details make up the bulk of such colorful layouts. Once your mindset is established that these types of images will be part of the album, you begin to see them everywhere throughout the day. They can be of the wedding cake—a favorite—or the bride's shoes, or the bouquet, or dozens of other items seen on the wedding day. Often the details are what make a wedding an elegant affair.

■ CHARLES MARING: THE DIGITAL ALBUM

Charles Maring describes himself as a nonfiction wedding photojournalist. He's a patient, reactive photographer who records moments unfolding rather than dreaming up an idea and then acting upon it. He feels that every photographer has to please the families of the couple, so he and wife Jennifer segment a quarter to half-hour of the day for family and couples' portraiture.

His shooting style is to stay quiet and observant—but with a flair. "What separates me from other photographers is not only the photography, but also my print quality and imagination," Maring explains. By imagination, he means the digital skills of post-capture manipulation. He continues, "For example, you can sample colors from within your photograph so that every image in

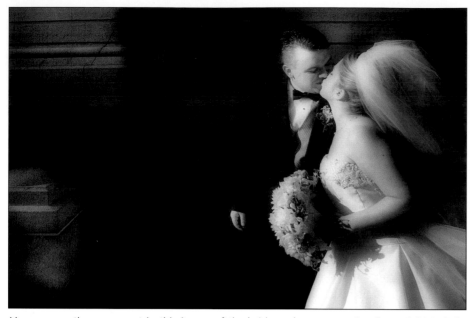

You can see the movement in this image of the bride and groom moving from right to left. It would be the perfect double-truck spread image. The negative area on the left-hand page would be ideal for inset photos, type, or some other graphic design. Photograph by Charles Maring.

your album has components of that complement. You can take the time to burn or dodge, blur or soften, 'impression-ize' or desaturate, color blend or color wash, and come up with a more personal artistic interpretation of a real moment. Portrait-quality candids will be the new standard of excellence for future years of album and print competition."

Maring relishes these new capabilities. He is able to detail his product above and beyond standard retouching and offer creative products. Today, every image that leaves his studio is digital. Whether they capture the images with Nikon DSLRs or scan the negatives taken with their Hasselblads, Maring says there is no substitute for print quality. "More than anything else, I watch my clients leave our studio feeling like they have finally received the product and the service that other studios simply failed to be able to offer." His clients are happier and so is he!

"There is only one problem—workflow. I was doing all of the work myself, and to top it off I had to pay a higher price for digital printing than analog." As a result, Charles Maring is now a graphic artist, photographer, designer, *and* printer. "A digital lab has little maintenance so I can hold my tolerances to a higher standard than a pro lab that is rushing to get orders out," he says. "Having a complete understanding of my capabilities has also raised the value of my work. The new photographer that embraces the tools of design will simply be worth more than a mere cameraman or camerawoman," he says.

Here are some goals that Maring tries to use in his album designs.

Keep it Simple. Each page should convey a simple statement or story. Don't try to clutter pages with too many photos. Instead, narrow the focus and use those that make the best statement of the moment.

Dream a Little. With digital, we have tools like motion blur, Gaussian blur, and even smart blur, and film "looks" that we could never have used before. We have old films, new films, grainy films and ultrasharp films all within one digital capture—if you dream a little. Now, Maring says he thinks more like a cinematographer—he considers the moment he sees on the computer screen and creates what it truly looked like. This is not fiction, it is design around the best depiction of the moment.

Chapters. Every story has chapters. Maring uses scene setters that open and close each one. Within the chapters, he includes a well-rounded grouping of elements such as fashion, love, relationships, preparation, behind the scenes, and ambiance. These are the key elements that he keeps in mind at all times, both when documenting the day as well as when designing the story.

Become a Painter. Charles Maring has spent time studying both new and old painters. He discovered that the rules we apply to photography get destroyed in art because in art there are no rules. In some of the most incredible paintings with depth and dimension, for example, the artist would blow out the highlights of the scene, or possibly saturate small areas of the leaves in a tree, or maybe exaggerate an element to bring a statement to life. Artists think about the details. Maring now finds himself stepping out of the photographic box and using the painterly tools to work the print to its full potential. Art has no limits and no rules and he believes that if the traditionalists could see the true

art form that is developing through digital, they would see the light of a truer art form.

Color Sampling. One of Charles Maring's tricks of the trade is to sample the colors of the images on his album pages in Photoshop. This is done by using Photoshop's eyedropper tool. When you click on an area, the eyedropper reveals the component colors in the color palette. He then uses those color readings for graphic elements on the page he designs with those photographs, producing an integrated, color-coordinated design on the album page. If using a page-layout program like QuarkXpress or In-Design, those colors can be used at 100 percent or any lesser percentage for color washes on the page or background colors that match the Photoshop colors precisely.

■ **JERRY GHIONIS: THE SIX STAGES OF A WEDDING ALBUM**

Jerry Ghionis is a highly respected Australian wedding photographer. His work is commercially successful and widely regarded as artistically impeccable. Here are the various stages of album design at Ghionis' XSight Studio.

1. Predesigning the album with TDA Albums Australia software.
2. Create an album sales order with the clients.
3. Prepare all the images from the CDs or hard drives, cleaning and color correcting each image.
4. Check cleaning, tweak color, choose various creative effects, resize images to page size.
5. Design pages, burn to disc, and send to lab.
6. Assemble the album.

Rather than having everyone on his staff produce an album from start to finish, Ghionis believe it's important that everyone does what he or she does best and continue to get better at it. Five album orders are booked every week and the workflow remains the same. Of the six tasks listed above, all but one are done by different people who specialize in that specific task. It is a division of labor that not only ensures speed and consistency, but also promotes expertise by each individual. No one person's albums are any better than another's—they are all a team effort.

Clients are quoted a ten-week production time, although the studio's internal schedule suggests that they are capable of producing an album within seven to eight weeks. They allow a buffer of two weeks in

LEFT—In the digital arena, album pages take on a completely different look as photographers are not restricted by mat size or color. Each page is an original and the color of the background can be color sampled in Photoshop from the background in the photos for a perfect color match. Photograph and design by Martin Schembri. **ABOVE**—Jerry Ghionis' XSight Studio uses Albums Australia TDA album design software, which is quite simple to use and lets you control every phase of the design process.

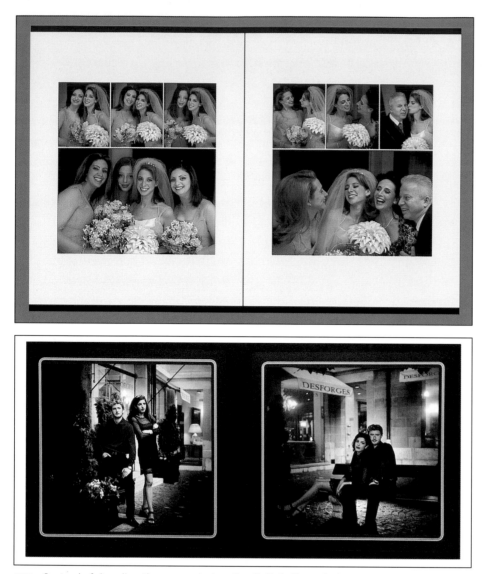

TOP—Instead of dreading the group photos, the digital album designer can group the groups for very full and festive pages. Photos and album design by Jerry Ghionis. **ABOVE**—Vladimir Bekker will often schedule a number of photo sessions with his couple before the wedding to broaden the scope of the album.

case of any delays or any unforeseen circumstances. This is so the studio doesn't upset any eager clients. "The client doesn't know about the buffer, so if everything is on time, we often pleasantly surprise the client with news that the album is ahead of schedule," says Jerry.

■ VLADIMIR BEKKER: COLLECTIONS, NOT ALBUMS

Creativity and high-quality products are the keys to this Canadian wed-

ding photographer's success. He believes in delivering the best service so clients will keep coming back and referring their friends and relatives. To create wonderful wedding albums, Vladimir uses a variety of lenses and cameras. He also shoots color, black & white, and infrared, to produce the ultimate variety in his images. "I can switch from black & white to color in seconds, because I carry an extra film back in a pouch on my belt," he says. "The subject

may have a similar pose, but the different film and focal length creates a whole new look. Suddenly, I have two different images. Hopefully, the bride will like them both. Bekker's philosophy is to give clients as much variety as possible, believing that greater variety creates greater customer satisfaction and more sales."

Clients select from two- to five-hundred proofs, depending on the coverage they buy. Some upscale, final albums contain over a hundred different-sized candid and posed images, including panoramas. Clients also have the option of purchasing "collections," rather than traditional packages. In these, the actual books are included and the album prints undergo scrupulous negative and print retouching, finished with a lacquer spray or lamination. Bekker's goal is to tell a complete wedding-day story in each bride's album, creating a priceless keepsake.

The wedding coverage usually begins at the bride's and groom's homes, followed by the ceremony. Bekker carefully plans the site of the main session. This location should reflect the couples' personalities, as well as provide a variety of images for the final book. Throughout the event, Bekker is previsualizing the final product. Instead of just shooting the candid event, he goes one step further and also captures the reaction of the crowd to the event.

■ DAVID ANTHONY WILLIAMS: A MAJESTIC APPROACH

One of the elements David Anthony Williams brings to his albums is pure life. His album pages are living, moving entities. This design philosophy

is the same as his theory about wedding photography. "If you've studied and practiced posing, observed lighting, and learned to assess an environment, you're halfway there. But how good are the images going to be if your priorities are with the technical, and not with the activity and life happening before you?"

Williams is practiced at the art of image construction. He says, "Advertising photographers deal with them every day. But still we come back to the essential of a people picture that goes far beyond technique. And that is the photographer giving life to the creation they have assembled." His image constructions, for example, might be of the many faces of the bride's emotions, with the wedding dress as a blurry backdrop and inset photos defining her many moods. Or he might do a montage of details—the ring, the flowers, the fabric of her dress—and combine them with a pensive portrait of the bride, imagining these things.

Williams also uses the technique of providing a series of eight or sixteen identically sized images across two pages—a window-frame effect. The pages are laid out in perfect, brutal symmetry. However, the motion and direction come from the elements within the pictures or the content of the pictures.

He will also contrast this symmetry by creating a series of vertical image constructions within the horizontal space of the album page. Almost like raindrops, these panels demand your attention—to examine both the content of the images and the overall flow of the design. They contrast the starkness of the white

David Williams designs unique image constructions he calls "detail minis." Here are two examples of sixteen per album page. The photographer's goal is to keep the viewer's eyes in motion and to keep the subject matter rich and interesting. He records all of these minis with a 50mm lens wide open, to keep depth of field to a minimum and to speed up his shooting.

horizontal space, giving the page a startling quality.

Williams studies the great editorial portraits of our time, citing *Vanity Fair* as the ultimate in this genre. He says these portraits teach us the importance of interaction and communication between photographer and subject. He sums up his outlook this way: "The coming together of all our abilities makes us great photographers. But the absence or minimization of life in our subjects makes us professionally adequate."

Wedding photography has undergone a complete metamorphosis in the last 25 years. Through the determination of individual photographers who refused to accept the demeaning label of "weekend warrior" and organizations like WPPI, whose primary goal was to raise the status and proficiency of wedding photography, the genre is now at the top of the heap. Photographers who are friends of mine confide that their fee structure for weddings is doubling, sometimes tripling from one year to the next.

Although some might see this prosperity as cyclical, there is no doubt that wedding photography will continue to change. The way that wedding photojournalism has evolved from strict noninterference with the events to a more directed, choreographed discipline in just a few short years is proof that the evolution will be ongoing. My guess is that editorial photography, fashion photography, and wedding photojournalism will continue to intermingle, producing new and interesting styles.

There is no doubt that the wedding day is one of the most appealing days in anyone's life. Large sums of money and many months of preparations go into making it a once-in-a-lifetime affair. And with major celebrities like Oprah sponsoring "million dollar weddings," the popularity of big, expensive weddings does not seem to be slowing down at all.

There is no doubt that digital technology is responsible for the creative explosion in today's wedding photography. One-of-a-kind digital albums have become so popular with brides and families that traditional wedding albums seem almost a thing of the past. Digital is so pervasive that only purists will continue to shoot film. Workflow models to cope with the additional time required by digital capture and design will no doubt keep pace and evolve as well, and so will the software and hardware needed to make the job easier and more efficient.

Will the wedding photographer remain among the upper echelon of the photographic elite? Nobody knows. But one thing is for sure, wedding photographers and their art form will never return to the days of second-class citizenship.

Action. In Adobe Photoshop, a series of commands that you play back on a single file or a batch of files.

Angle of incidence. The primary axis on which light travels. The angle of reflection is the secondary axis. The angle of incidence is equal to the angle of reflection.

Balance. A state of visual symmetry among elements in a photograph.

Barn doors. Black folding doors that attach to a light's reflector; used to control the width of the beam of light.

Bleed. A page in a book or album in which the photograph extends to the edges of the page.

Bounce flash. Bouncing the light of a studio or portable flash off a surface to produce indirect, shadowless lighting.

Broad lighting. Portrait lighting in which the key light illuminates the side of the face turned toward the camera.

Burning-in. A darkroom technique in which specific areas of the photograph are given additional exposure to darken them. In Adobe Photoshop, the burn tool accomplishes the same job.

Butterfly lighting. Portrait lighting pattern characterized by a high key light placed directly in line with the line of the subject's nose. This lighting produces a butterfly-like shadow under the nose. Also called Paramount lighting.

Catchlight. Specular highlights that appear in the iris or pupil of the subject's eyes reflected from the portrait lights.

Color Space. Range of colors that a device can produce.

Color temperature. The degrees Kelvin of a light source, film sensitivity, or white-balance setting. Color films are balanced for 5500°K (daylight), 3200°K (tungsten), or 3400°K (photoflood).

Cross-lighting. Lighting that comes from the side of the subject, skimming facial surfaces to reveal the texture in the skin. Also called side-lighting.

Cross-Processing. Processing color negative film in E-6 transparency chemistry or transparency film in C-41 color negative chemistry to produce altered colors, enhanced grain, and sometimes solarization. It can also be done digitally.

Depth of field. The distance that is sharp beyond and in front of the focus point at a given f-stop.

Depth of focus. The amount of sharpness that extends in front of and behind the focus point. This varies from lens to lens.

Dodging. Darkroom technique in which specific areas of the print are given less exposure by blocking the light. In Photoshop, the dodge tool accomplishes the same job.

Double Truck. A layout with an image split across two facing pages. Usually "bleeds" across the two pages.

Dragging the shutter. Using a shutter speed slower than the X-sync speed to capture the ambient light in a scene.

Feathering. (1) Misdirecting the light so that the edge of the beam illuminates the subject. (2) In Adobe Photoshop, softening the edge of a selection so that changes to it blend seamlessly with the areas around it.

Fill card. A white or silver-foil-covered reflector used to redirect light back into the shadow areas of the subject.

Fill light. Secondary light source used to fill in the shadows created by the key light.

Flash-fill. Flash technique that uses electronic flash to fill in the shadows created by the main light source.

Flash-key. Flash technique in which the flash becomes the main light source and the ambient light in the scene fills the shadows created by the flash.

Flashmeter. An incident light meter that measures the ambient light of a scene and, when connected to an electronic flash, will read flash only or a combination of flash and ambient light.

Foreshortening. A distortion of normal perspective caused by close proximity of the lens to the subject.

45-degree lighting. Portrait lighting pattern characterized by a triangular highlight on the shadow side of the face. Also known as Rembrandt lighting.

Gatefold. Double-sided foldout page in an album that is hinged or folded so that it can be opened up.

Gaussian Blur. Photoshop filter that diffuses an image.

Gutter. The inside center of a book or album.

High-key lighting. Type of lighting characterized by a low lighting ratio and a predominance of light tones.

Highlight brilliance. The specularity of highlights on the skin. An image with good highlight brilliance shows specular highlights within a major highlight area.

Hot spots. A highlight area that is overexposed and without detail.

Incident light meter. A handheld light meter that measures the amount of light falling on its light-sensitive dome.

JPEG (Joint Photographic Experts Group). An image file format with various compression levels. The higher the compression rate, the lower the image quality. Although there is a form of JPEG that employs lossless compression, the most commonly used forms of JPEG employ lossy compression algorithms, which discard varying amounts of image data in order to reduce file storage size.

Key light. The light used to establish the lighting pattern and define the facial features of the subject.

Kicker. A backlight (from behind the subject) that highlights the hair, side of the face or contour of the body.

Lead-in line. A pleasing line that leads the viewer's eye toward the subject.

Lighting ratio. The difference in intensity between the highlight side of the face and the shadow side of the face.

Loop lighting. Portrait lighting pattern characterized by a loop-like shadow on the shadow side of the face. Differs from Paramount or butterfly lighting because the main light is slightly lower and farther to the side of the subject.

Low-key lighting. Lighting characterized by a high ratio, strong scene contrast, and a predominance of dark tones.

Main light. Same as key light.

Microdrive. Storage device for portable electronic devices using the CF Type II industry standard. Current microdrive capacities range from 340MB to 1GB of storage. The benefit of a microdrive is high storage capacity at low cost. The downside is the susceptibility to shock—bumping or dropping a microdrive has been known to cause data loss.

Modeling light. Secondary light in the center of a studio flash head that gives a close approximation of the lighting that the flash tube will produce. Usually high-intensity quartz bulbs.

Overlighting. Main light is either too close to the subject, or too intense and oversaturates the skin with light, making it impossible to record detail in highlighted areas. Best corrected by feathering the light or moving it back.

Parabolic reflector. Oval-shaped dish that houses a light and directs its beam outward in an even, controlled manner.

Paramount lighting. One of the basic portrait lighting patterns. Characterized by a high-key light placed in line with the subject's nose. This lighting produces a butterfly-like shadow under the nose. Also called butterfly lighting.

Perspective. The appearance of objects in a scene as determined by their relative distance and position.

Point light source. A sharp-edged light source like the sun, which produces sharp-edged shadows without diffusion.

RAW File. A file format that records data from the sensor without applying in-camera corrections. To use the images, the files must first be processed by compatible software. This includes the option to adjust exposure, white balance, and the color of the image, while leaving the original RAW picture data unchanged.

Reflected light meter. A meter that measures the amount of light reflected from a surface or scene. All in-camera meters are of the reflected type.

Reflector. (1) Same as fill card. (2) A housing on a light that reflects the light outward in a controlled beam.

Rembrandt lighting. Same as 45-degree lighting.

Rim lighting. Portrait lighting pattern wherein the key light is behind the subject and illuminates the edges of the subject's features. Most often used with profile poses.

⅞ view. Facial pose that shows approximately ⅞ of the face. Almost a full-face view as seen from the camera.

Sharpening. In Photoshop, filters that increase the apparent sharpness of an image by increasing the contrast of adjacent pixels within an image.

Short lighting. One of two basic types of portrait lighting in which the key light illuminates the side of the face turned away from the camera.

Slave. A remote triggering device used to fire auxiliary flash units. These may be optical or radio-controlled.

Specular highlights. Sharp, dense image points on the negative. Specular highlights are very small and usually appear on pores in the skin.

Split lighting. Type of portrait lighting that splits the face into two distinct areas: shadow and highlight. The key light is placed far to the side of the subject and slightly higher than the subject's head height.

Straight flash. The light of an on-camera flash unit that is used without diffusion; i.e., straight.

TTL-balanced fill-flash. Flash exposure system that reads the flash exposure through the camera lens and adjusts flash output to relative to the ambient light for a balanced flash–ambient exposure.

Tension. A state of visual imbalance within a photograph.

¾-length pose. A pose that includes all but the lower portion of the subject's anatomy. Can be from above the knees and up, or below the knees and up.

¾ view. Facial pose that allows the camera to see ¾ of the facial area. Subject's face is usually turned 45-degrees away from the lens so that the far ear disappears from camera view.

TIFF (Tagged Image File Format). A file format commonly used for image files. TIFF files offer the option to employ lossless LZW compression, meaning that no matter how many times they are opened and closed, the data remains the same (unlike JPEG files, which are designated as lossy files, meaning that data is lost each time the files are opened and closed).

Vignette. A semicircular, soft-edged border around the main subject. Vignettes can be either light or dark in tone and can be included at the time of shooting, or created later in printing.

Watt-seconds. Numerical system used to rate the power output of electronic flash units. Primarily used to rate studio strobe systems.

White Balance. The camera's ability to correct color and tint when shooting under different lighting conditions including daylight, indoor, and fluorescent lighting.

X-sync speed. The shutter speed at which focal-plane shutters synchronize with electronic flash.

THE ART OF BRIDAL PORTRAIT PHOTOGRAPHY

Marty Seefer

Learn to give every client your best and create timeless images that are sure to become family heirlooms. Seefer takes readers through every step of the bridal shoot, ensuring flawless results. $29.95 list, 8½x11, 128p, 70 color photos, order no. 1730.

PROFESSIONAL TECHNIQUES FOR
DIGITAL WEDDING PHOTOGRAPHY, 2nd Ed.

Jeff Hawkins and Kathleen Hawkins

From selecting equipment, to marketing, to building a digital workflow, this book teaches how to make digital work for you. $29.95 list, 8½x11, 128p, 85 color images, order no. 1735.

WEDDING PHOTOGRAPHY WITH ADOBE® PHOTOSHOP®

Rick Ferro and Deborah Lynn Ferro

Get the skills you need to make your images look their best, add artistic effects, and boost your wedding photography sales with savvy marketing ideas. $29.95 list, 8½x11, 128p, 100 color images, index, order no. 1753.

POWER MARKETING FOR WEDDING AND PORTRAIT PHOTOGRAPHERS

Mitche Graf

Set your business apart and create clients for life with this comprehensive guide to achieving your professional goals. $29.95 list, 8½x11, 128p, 100 color images, index, order no. 1788.

PROFESSIONAL DIGITAL IMAGING FOR WEDDING AND

PORTRAIT PHOTOGRAPHERS

Patrick Rice

Build your business and enhance your creativity with practical strategies for making digital work for you. $29.95 list, 8½x11, 128p, 200 color photos, index, order no. 1780.

WEDDING AND PORTRAIT PHOTOGRAPHERS' LEGAL HANDBOOK

N. Phillips and C. Nudo, Esq.

Don't leave yourself exposed! Sample forms and practical discussions help you protect yourself and your business. $29.95 list, 8½x11, 128p, 25 sample forms, index, order no. 1796.

PROFESSIONAL TECHNIQUES FOR
BLACK & WHITE DIGITAL PHOTOGRAPHY

Patrick Rice

Digital makes it easier than ever to create black & white images. With these techniques, you'll learn to achieve dazzling results! $29.95 list, 8½x11, 128p, 100 color photos, index, order no. 1798.

WEB SITE DESIGN FOR PROFESSIONAL PHOTOGRAPHERS

Paul Rose and Jean Holland-Rose

Learn how to design, maintain, and update your own photography web site—attracting new clients and boosting your sales. $29.95 list, 8½x11, 128p, 100 color images, index, order no. 1756.

MASTER LIGHTING GUIDE

FOR PORTRAIT PHOTOGRAPHERS

Christopher Grey

Efficiently light executive and model portraits, high and low key images, and more. Master traditional lighting styles and use creative modi-fications that will maximize your results. $29.95 list, 8½x11, 128p, 300 color photos, index, order no. 1778.